T0244466

illness

but care un

inds us all,

ortunately

does not

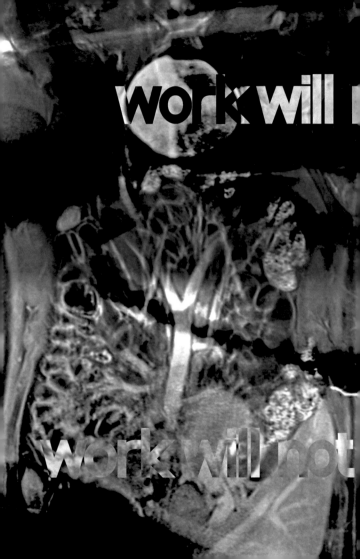

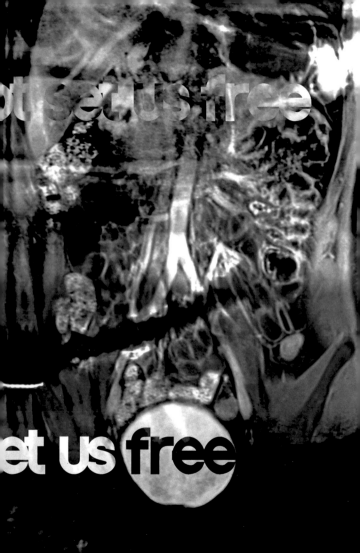

netw

CAN and S

be

rks of care

HOULD

ontagious

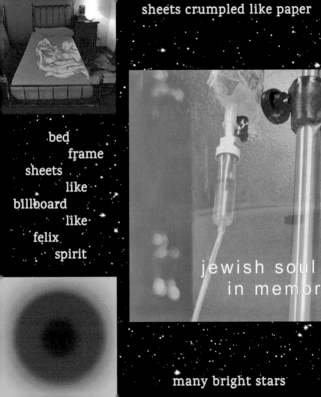

sheets crumpled like paper

bed
frame
sheets
like
billboard
like
felix
spirit

jewish soul
in memor

many bright stars

oon

first phase

otherwise

obscured

indirect

look

fire

work

pain

highest

dle, *yahrzeit*

the dead

outward sparklers

the earth

to be scare

is to be

[the]

of the sick

cared of

living

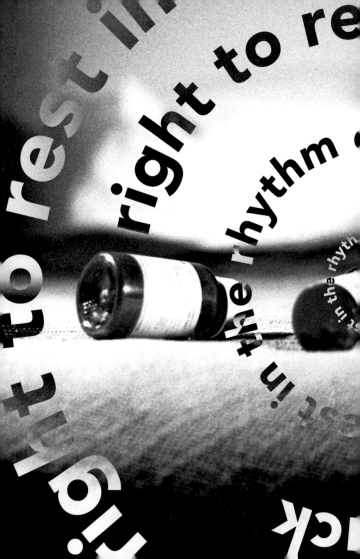

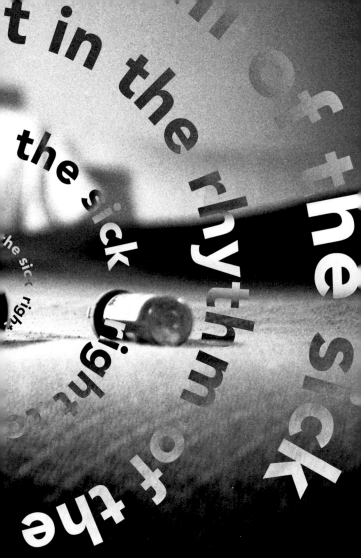

an army
can't be
defeated

f the sick

BROTHERS SICK (EZRA AND NOAH BENUS)
illness finds us all, but care unfortunately does not (mask), 2022. Digital image and text
Work Will Not Set Us Free, 2021. Dye sublimation on aluminum, 20,32 × 25,4 cm
networks of care CAN and SHOULD be contagious (mask), 2022. Digital image and text
Phases and the In-Betweens, 2021. Video still, in collaboration with danilo machado and Yo-Yo Lin
to be scared of the sick is to be scared of [the] living (mask), 2022. Digital image and text
Right to Rest in the Rhythm of the Sick, 2021. Dye sublimation on aluminum, 20,32 × 25,4 cm
an army of the sick can't be defeated (mask), 2022. Digital image and text

Museion

~~KINGDOM~~
OF THE ILL

An anthology of critical texts on
illness and health, solidarity and activism
in times of pandemic.

Eine Anthologie von Texten zu Krankheit
und Gesundheit, Solidarität und
Aktivismus in Zeiten einer Pandemie.

Un'antologia di testi critici su
malattia e salute, solidarietà e attivismo
ai tempi di una pandemia.

Hatje Cantz

INDEX
VERZEICHNIS
INDICE

Bart van der Heide

FOREWORD

According to the philosopher Judith Butler, solidarity and violence are not mutually exclusive. As violence may still be legitimized by self-defense, both go hand in hand when the protection and preservation of the nation state are concerned. In her text *The Force of Nonviolence* (2020), Butler asks herself: "Who is this 'self' defended in the name of self-defense? How is that self delineated from other selves, from history, land, or other defining relations? Is the one to whom violence is done not also in some sense part of the 'self' who defends itself through an act of violence?" [1]

Here, Butler draws attention to the familiar nuance between solidarity and equality. She follows a passivist line, explaining that violence will continue to be legitimized if the extended self remains an extension of one's own color, class, and ability—thus expelling all those marked by difference within that economy. Two years on, dealing with the impacts of the COVID-19 pandemic, Butler's hypothesis offers a poignant reflection

with contemporary relevance. The pandemic has exposed the intricate balance between free trade and human and ecological resources. At the same time, the global community has had to "self-defend" independently from the nation state, as global inter-dependency was absolute.

Solidarity was at the center of international well-being and precariousness, and with it, one's complicity in maintaining or rejecting the historical unity between health, state interests, and empire. The protection of its citizens against external invasions, especially viral ones, made public health closely aligned with ideologies of colonialism and international commerce. [2] With the exhibition ~~Kingdom~~ *of the Ill*, the curators Sara Cluggish and Pavel S. Pyś first and foremost aim to break down the division between this inside and outside, i.e. the declaration of being healthy against the self-image of not being ill. Just like the current anthology of independent critical texts, their exhibition at Museion can be read as a redefinition of solidarity after reading Susan Sontag's influential text *Illness as Metaphor* (1978). Sontag attributes dual citizenship to each human being: either living in the Kingdom of the Ill or that of the Healthy. By erasing the word ~~Kingdom~~ from their title, Cluggish and Pyś offer a contemporary revision: in the face of burnout, exhaustion, dwindling public health support, and the rampant capitalist exploitation of human and ecological resources, can one still be truly "healthy"? As such, ~~Kingdom~~ *of the Ill* brings illness out of the dark (also a reference to Sontag) and explores it as a general model for civic coexistence and nonviolent solidarity.

Indeed, this thesis might find growing support against a global health crisis, but when it comes to the

economic influence of digital capitalism and globalization on "self-defense," things remain more blurred and in the shadows. In 2016, a group of independent researchers started the Precarity Lab to investigate the proliferation of "technoprecaricy." [3] In their collectively written text *Techno Precarious* (2020), the group points out that the landscape of precarity has expended and now includes the creative class of digital producers in the "enrichment zones" of the world. This means that more people are living unsupported, "in a deflated, 'cruelly optimistic' *way* ..." [4] The one commercial class to whom this is especially relevant are the Freelancers, who offer services without any guarantee of economic stability. The text features a distant echo of Sontag's aforementioned title: "Precarity is not a metaphor [...] Surviving from gig to gig can divert you from the possibility of living any other way." The group proposes a class coalition on the premise of dissolving the division between inside and outside in terms of health and wellbeing, as the increasing levels of anxiety, toxicity and mental health problems are already a reality for those who are marginalized in society.

Activism in this context features acts of solidarity, for instance in the shape of "mutual aid," [5] but moreover highlight the hypocrisy in how wealth and privilege are still distributed despite this growing awareness, i.e. equality. Hence, Precarity Lab declares: "... What we ask of the affronted [creative] class is, instead of clutching at supremacy to numb the pain of precarity, to mobilize against engines of capitalism, which starts with an acknowledgement of shared but unevenly distributed precarity." [6]

Such an understanding closely follows the writings of critical theorist and poet Fred Moten, who states that solidarity is trivial without issuing equality. In a conversation with cultural theorist Stevphen Shukaitis, Moten interprets the civil-rights activist Fred Hampton as follows: "… Look: the problematic of coalition is that coalition isn't something that emerges so that you can come and help me […]. The coalition emerges out of your recognition that it's fucked up for us. I don't need your help. I just need you to recognize that this shit is killing you, too, however much more softly, you stupid motherfucker, you know?" [7]

Today, as capitalism continues to reduce privilege and wealth to an ever-decreasing group of global citizens, health and wellbeing are closely following suit. The degree of compliancy or disobedience is based on which "self" one is willing to defend.

[1] Judith Butler, *The Force of Nonviolence*, Verso, London/ New York, 2020, p. 24.

[2] See: Nicholas B. King, "Security, disease, commerce: ideologies of postcolonial global health", in: *Social Studies of Science*, 2002, pp. 763-789.

[3] Precarity Lab is an initiative by Goldsmith's London in collaboration with the Institute of the Humanities at the University of Michigan. Its members are: Cass Adair, Ivan Chaar-Lopez, Anna Watkins Fisher, Meryem Kamil, Cindy Lin, Silvia Lindtner, Lisa Nakamura, Cengiz Salman, Kalindi Vora, Jackie Wang, and Mckenzie Wark.

[4] *Techno Precarious*, Precarity Lab (ed.), Goldsmith Press, 2020, p. 2.

[5] Definition of "mutual aid" by the Big Door Brigade: mutual aid is a form of political participation in which people take responsibility for caring for one another and changing political conditions, not just through symbolic acts or putting pressure on their representatives in government but by actually building new social relations that are more survivable.
www.bigdoorbrigade.com/what-is-mutual-aid

[6] Precarity Lab (Note 4), p. 75.

[7] Fred Moten, "The General Antagonism: An interview with Stevphen Shukaitis," in: *The Undercommons: Fugitive Planning & Black Study*, Stefano Harley & Fred Moten (eds.), Released by Minor Compositions, Wivenhoe / New York / Port Watson, 2013, pp.140–141.

BART VAN DER HEIDE is art historian, exhibition make and director of Museion Bozen/Bolzano, where he initiate the multidisciplinary research project *TECHNO HUMANITIE* a three-year undertaking (2021–2023) comprising exhibitions publications, panel discussions, and art mediatic programs. The exhibition series focuses on pressir existential questions concerning human existence, at th intersection between ecology, technology, and economics In *TECHNO HUMANITIES*, external international research team

xplore and develop the issues addressed, while at the same ime the project provides young talents with a platform on hich to express their aspirations. A special feature is lso the promotion of local initiatives.

he exhibition *Kingdom of the Ill* represents the second hapter of the three-year project that van der Heide launched n 2021 with the exhibition *TECHNO* (September 11, 2021– arch 16, 2022).

Sara Cluggish and Pavel S. Pyś

~~KINGDOM~~ OF THE ILL:
Emergent Discourses
on Access in the Arts

The last few years since the beginning of the COVID-19 pandemic have brought all matters of health and illness into sharp relief. The novel coronavirus outbreak has not only informed debates on the national, financial, political, and ideological dimensions of healthcare provision, but shaped our very personal experiences of how we receive and provide care, guard personal space through social distancing, and make decisions on whether or not to participate in sharing physical space with others. For those who identify as ill or disabled, this physical isolation and hyperawareness of one's body is typically the norm, not the exception. Reflecting on this shift in public consciousness, writer and artist Johanna Hedva facetiously remarked: "It's funny to me that in 2020, we're all behaving as if illness is this completely foreign, brand new experience (…) we instead kind of push it out into this, this exile, this banishment (…) and I just think all of that is bullshit. Everyone gets sick. This is just a part of being alive". [1] Sickness is not a singular state of

being or moment in time but a continuum. The title of our exhibition—*Kingdom* of the Ill—invokes American writer and political activist Susan Sontag's work of critical theory *Illness as Metaphor* (1978), specifically Sontag's suggestion that we each hold dual citizenship: one to the kingdom of the well, and another to the kingdom of the sick, and that we must at one point or another identify with either. The idea that any one of us can ever truly reach the idealized "healthy" state of productivity that capitalism promotes is a fallacy. In striking out the binary separating these two "kingdoms," we resist Sontag's demarcation, instead drawing attention to the ways that wellness has become an impossible goal under advanced capitalism. [2] In the words of economists Raj Patel and Jason W. Moore: "To ask for capitalism to pay for care is to call for an end to capitalism." [3]

Kingdom of the Ill was spurred by the observation that over the past decade, artists have increasingly embraced their own diagnoses, bringing their lived experience into public view and demanding we openly and transparently give over space for discourse surrounding health and illness. Following their lead, many arts organizations have gradually shifted toward embracing programming on themes of sickness and wellness [4], exploring how we define normative understandings of what constitutes a "healthy" body. Exhibitions and public programs have asked questions such as: What are our roles as consumers of both traditional pharmaceuticals and natural therapies? How might environmental devastation and pollution affect our health? What advances in technology and speculative fiction have shifted the landscape of illness and wellness?

In her 2018 performative lecture *The Art of Dying or (Palliative Art Making in the Age of Anxiety)*, film-maker Barbara Hammer spoke to this change against the backdrop of her own experience of living with advanced cancer: "all of us—artists, curators, administrators, art lovers alike—are avoiding one of the most potent subjects we can address. I'm happy to see there is a recent change in a few organizations that are planning seminars on health, illness, death, and dying right now, and artists are coming out with transparency finally as they break the fear of coming out as ill." [5] While the topic has gained visibility, it has simultaneously become painfully evident that arts organizations lack the infrastructure or financial means to support the working modes of artists who identify as chronically ill or crip [6], much as they may want to embrace the artwork they make. The onus has often fallen to artists themselves, and as a consequence, many have been sharing their personal access riders online. [7] These customizable documents outline one's disability needs with the aim of creating "access intimacy": a term defined by justice activist Mia Mingus as "… that elusive, hard-to-describe feeling when someone else 'gets' your access needs." [8] Provided at the beginning of a working relationship, access riders can help artists to define and protect parameters of fair pay, project timelines, personal care assistants, childcare, food and dietary restrictions, travel and lodging requirements, mobility needs, and the accessibility of the venue or event taking place. Importantly, they also allow artists to define how and to whom their disability or illness is disclosed and protect artists from having to taxingly communicate and re-communicate their access needs.

Through this practice, the onus shifts from artist to institution, whereby the museum is challenged to reflect on entrenched working practices and adapt to new procedures. As is often the case, artists take it upon themselves to advance this work before institutions: in 2019, artist and writer Carolyn Lazard published *Accessibility in the Arts: A Promise and a Practice*. This freely available toolkit sets out pathways for small-scale arts nonprofits to facilitate and support relationships with artists, addressing barriers and opportunities. Within this guide, Lazard succinctly gets to the crux of the issue in addressing the artist-driven rapidly advancing discourse and the slow pace of institutions: "There is often a striking discord between an institution's desire to represent marginalized communities and a total disinvestment from the actual survival of those communities." [9]

Park McArthur's *Carried & Held* (2012) is a deceivingly simple artwork: a list that in format approximates a museum label, identifying every person who has lifted McArthur, who uses a wheelchair as she suffers from a degenerative neuromuscular disease. Friendship, community, networks of care, mutual aid: these collective efforts are at the very heart of what has energized the shift in discourse around illness, ableism, and inclusivity. The exhibitions, public programs, publications, and workshops of artist collectives—including Canaries, Feminist Healthcare Research Group, Pirate Care, Power Makes Us Sick, and Sickness Affinity Group, among others—have elevated concerns with denial of access relative to illness and disability, demonstrating how these are negotiated at the intersection of not only ability but also race, gender, sexuality, and class. Galvanized by

historical precedents—especially groups such as ACT UP, the Art Workers' Coalition, and more recently, w.a.g.e. and Decolonize This Space—the work of many of the artists and collectives cited here dovetails with activism, with a real call for increased transparency, equity, support infrastructures, as well as systemic change, both within and beyond the artworld. Through flexible membership models that can function as part support group, part activist networks, and (in some cases) part art collective, many groups have centered their focus on public-facing protests and boycotts, as well as mutual aid fundraising. Since 2017, artist Shannon Finnegan has produced two versions of their interactive installation *Anti-Stairs Club Lounge* that responds to the inaccessibility of architectural sites: the Wassaic Project Space in Maxon Mills (2017–18) and the Thomas Heatherwick designed "Vessel" in New York. In the case of the latter, together with a range of disabled and non-disabled participants, Finnegan protested the structure, calling for a permanent "Anti-Stairs Club Lounge" with a budget of $150 million (equivalent to the entire structure budget). These sites hold inherently ableist assumptions, just as modes of engaging with exhibitions and accessing museum spaces do, and artists such as Finnegan are thus crucial voices in demonstrating how these spaces must change for equitable access. In 2020, several disabled, chronically ill, and immunocompromised people rallied together to create the CRIP Fund, with the specific aim of redistributing donated funds to those same communities affected by the covid-19 pandemic. Mutual aid endeavors such as the CRIP Fund (as well as the work of the collective Sick in Quarters)

make painfully evident the need for artists to turn to collective action in the face of the inadequacy of state-run healthcare systems and the boogeyman known as the medical industrial complex. In *The Hologram* (2020), which sets forth a vision for revolutionary care centered on viral, peer-to-peer feminist health networks, artist Cassie Thornton laments this very sense of entrapment: "We don't see this as a choice because it seems impossible to sacrifice our access to our means of survival under financialized capitalism by reaching for an uncharted experience of collectivity, care, and mutual aid, abandoning the idea that we can become successful capitalist subjects." [10]

These efforts advance parallel to large social movements—racial reckoning, rallying around student debt, the #MeToo movement, climate advocacy, ongoing calls for corporate accountability—that seek an undoing of continuing injustices and violence, many of which are seeded by the logic of capitalism that perpetuates profit-hungry greed, division, and indebtitude. With so many of these activities run at a grassroots level, a valid question surfaces: when will we see meaningful change? How are discourses on health and illness informing the broader social debate? For arts institutions: will the roving museal eye soon shift its short attention elsewhere? In February 2022, the announcement was made that Purdue Pharma would dissolve and issue a $6 billion payment to settle the lawsuits associated with the opioid crisis. The company, owned by the billionaire Sackler Family, is responsible for the production and aggressive marketing of OxyContin: a highly addictive opioid, prescribed to millions of patients suffering from

minor ailments. Artist Nan Goldin and the activities of P.A.I.N. (Prescription Addiction Intervention Now) played a role in raising public awareness around Purdue Pharma's complicity in the opioid crisis, as well as the Sacklers' brazen efforts to harness their significant philanthropic support of arts institutions as a means to whitewash their reputation and money. [11] Between 2018 and 2019, Goldin and P.A.I.N. staged protests and "die-in" demonstrations (in which participants would lie lifeless on the floor) at museums that had accepted funding from the Sacklers: the Guggenheim, Harvard Art Museums, Louvre Museum, Metropolitan Museum, Smithsonian, and Victoria & Albert Museum. Littering these spaces with faux OxyContin bottles, prescription slips, and banners bearing slogans such as "Shame on Sacklers", Goldin and P.A.I.N. elevated the matter within the broad social consciousness. While certainly a judicial victory, the ruling ultimately protected the Sacklers, who remain absolved of liability and continue to be one of the richest US families. As Goldin said of the ruling: "it's been a real lesson in the corruption of this country to watch this court, that billionaires have a different justice systems than the rest of us, and that they can actually walk away unscathed." [12]

The activities of P.A.I.N. are as much about the opioid crisis, as they are about the broader health and condition of arts-funding structures. The Sacklers are just one of the many donors, whose wealth has come under increased scrutiny over the last few years. Liberate Tate, an art collective that aims to "free art from oil" were successful in demanding that the museum sever ties with BP in 2017, while protests by Decolonize This

Space contributed to Warren Kanders—whose company Safariland produces tear-gas grenades that have been used against migrants at the US–Mexico border—resigning from the Whitney board in 2019. The swell in reckonings with toxic philanthropy is symptomatic of our present moment: the health of our museums, and by extension our larger institutions, is contingent on how we remediate the ills of capitalism and instead embrace equity, fairness, and representation.

"Follow the money," as the saying goes, and it's unsurprising that the most expressibly visible changes are taking place at the level of funding. Yet, there is so much more work to be done, far beyond merely ensuring representation of those who identify as ill or disabled. While the COVID-19 pandemic has urged us to rethink the stark boundaries between the "healthy" and the "ill" as blurred, nuanced, or simply untrue, we might realize that necessary change runs much deeper. All forms of bodies—arts institutions and beyond—are seldom agile or nimble, yet change is needed that gets right to the heart of how they are funded, who staffs them, and the accessibility practices they design for the communities they serve. Beyond even this, we must learn new vocabularies, ways of communicating, of caring for one another—only then might we inch closer towards the feeling, as Mia Mingus put it, of "getting" one another's access needs.

[1] Nwando Ebizie, host. "The Mediated Body." *For All I Care*, season 1, episode 1, BALTIC Center for Contemporary Art, https://baltic.art/whats-on/podcasts/for-all-i-care.

[2] To clarify, we are in no way suggesting a collapse of the distinction between those who identify as able-bodied or disabled. We are instead refusing the hard distinction proposed by Sontag and her characterization of illness as the "night side of life" or the "more onerous citizenship." We refute the possibility of separating health and illness, and refuse the symbolic connotations of the characterizations she employs to describe illness (See Sontag, Susan. *Illness As Metaphor*, Vintage Books, New York, 1979, p. 3).

[3] Jason W. Moore & Raj Patel. *A History of the World in Seven Cheap Things: A Guide to Capitalism, Nature, and the Future of the Planet*, University of California Press, 2018, p. 113.

[4] A selection includes: *Sick Time, Sleepy Time, Crip Time: Against Capitalism's Temporal Bullying*, EFA Project Space New York (2017), toured to Bemis Center for Contemporary Arts (2018), Red Bull Arts Detroit (2019); *I wanna be with you everywhere*, Performance Space New York (2019); *When the sick rule the world*, Gebert Foundation,

SARA CLUGGISH is the Mary Hulings Rice Director and Curat of the Perlman Teaching Museum at Carleton College. S is a curator and teacher with research interests at t intersection of performance and moving image scholarshi and an emphasis on care studies and gender and sexuali studies. She holds a Master of Fine Arts (MFA) in Curati from Goldsmiths University of London and a Bachelor Fine Arts (BFA) in Photography from the Maryland Institu College of Art, Baltimore. She has held roles as an a

Rapperswil (2020); *CRIP TIME*, Museum Für Moderne Kunst Frankfurt (2021); *Take Care: Art and Medicine*, Kunsthaus Zürich (2022).

[5] Barbara Hammer. *The Art of Dying or (Palliative Art Making in the Age of Anxiety)*, The Whitney Museum of American Art, October 10, 2018, https://whitney.org/media/39543.

[6] Lauryn Youden defines "crip" in the exhibition booklet for her 2020 solo exhibition *Visionary of Knives* at Künstlerhaus Bethanien, Berlin as follows: "Crip is a term many people within disability studies and activist communities use not only in reference to people with disabilities, but also to the intellectual and art culture arising from such communities. Crip is shorthand for the word 'cripple' which has been (and is) used as an insult toward people with disabilities, but which has been re-appropriated as an intra-group term of empowerment and solidarity." An early proponent of crip's social and political potential, Carrie Sandahl (2003) describes crip as a fluid and ever-changing "…term which expanded to include not only those with physical impairments but those with sensory or mental impairments as well." (See Alison Kafer, *Feminist Queer Crip*, Indiana University Press, 2013).

story professor at the Minneapolis College of Art and sign, Minneapolis, MN; director of FD13 Residency for the ts, Minneapolis and St. Paul, MN; collection manager of e Elizabeth Redleaf Collection, Minneapolis, MN; curator Site Gallery, Sheffield, UK; and assistant curator at ttingham Contemporary, Nottingham UK. Her essays and art iticism have appeared in *ArtReview*, *ArtReview Asia*, *Frieze*, *Review*, *L'Officiel Art Italia*, and *The Third Rail*.

[7] Johanna Hedva. "Hedva's Disability Access Rider" Tumblr Blog. August 22, 2019, https://sickwomantheory.tumblr.com/post/187188672521/hedvas-disability-access-rider; Leah Clements, Alice Hattrick & Lizzy Rose. Access Docs for Artists website. March 26, 2019. https://www.accessdocforartists.com/.

[8] Mia Mingus. "Access Intimacy: The Missing Link," *Leaving Evidence*, May 5, 2011. https://leavingevidence.wordpress.com/2011/05/05/access-intimacy-the-missing-link/

[9] Carolyn Lazard. "Accessibility in the Arts: a Promise and a Practice," *Common Field and Recess*. April 25, 2019. https://www.commonfield.org/projects/2879/accessibility-in-the-arts-a-promise-and-a-practice.

[10] Cassie Thornton, *The Hologram: Feminist, Peer-to-Peer Health for a Post-Pandemic Future* (2020), Pluto Press, available online: https://vagabonds.xyz/the-hologram/

[11] Taylor Dafoe. "They Are Going to Stand by Us: Text Messages Between Members of the Sackler Family Show How They Leveraged Their Museum Philanthropy Into Positive PR." *Artnet News*, 20 December 2022, https://news.artnet.com/art-world/sackler-family-text-messages-museums-1933901.

PAVEL S. PYŚ is Curator of Visual Arts at the Walker Art Center. At the Walker, he has curated solo exhibitions with Daniel Buren, Paul Chan, Michaela Eichwald, Carolyn Lazard and Elizabeth Price, as well as the group exhibition *The Body Electric*. Between 2011 and 2015, he was the Exhibitions Displays Curator at the Henry Moore Institute in Leeds, where he contributed to exhibitions with Robert Filliou, Christine Kozlov, Katrina Palmer, Vladimir Stenberg, and Sturtevant

[12] Nan Goldin quoted by Jones, Sara. "It's a Real Lesson in the Corruption of This Country. Anti-Sackler activist Nan Goldin on the Purdue Pharma bankruptcy settlement." *New York Magazine,* September 1, 2021. https://nymag.com/intelligencer/2021/09/nan-goldin-on-purdue-pharma-sackler-settlement.html.

...d the group exhibitions *Carol Bove / Carlo Scarpa* and *The Event Sculpture*. In 2011, he was the recipient of the Zabludowicz Collection Curatorial Open and the curatorial residency at the Fondazione Sandretto Re Rebaudengo in Turin, Italy. He has published essays on artists including Trisha Baga, Carol Bove, Michael Dean, John Latham, Wilhelm Sasnal, Alina Szapocznikow, Fredrik Værslev, and Hague Yang.

Lioba Hirsch

~~KINGDOM~~ OF THE ILL

In her book *Experiments in Imagining Otherwise*, Lola Olufemi (2021, p. 32) writes "Maybe time is a many-pronged spiral: a thick and firm approach and retreat, steady and unrelenting. The place where memory and repetition are disguised and reconfigured. This speaks to me, for it certainly seems like the past is now and as if we visited the future yesterday, on our way into the present. The idea that time is linear and that we are steadfastly moving towards the future has only ever been true for some of us and has come at the expense of others. Nothing illustrates this better than the pandemic we are living through. Still. I must insist on this and repeat it: we are still living in and through and despite a pandemic. While calls for a return to normal were issued almost from day one of restrictions and lockdowns, many of us, those who have long found ourselves at the margins of normality—too sick, too poor, too illegal, too Brown, too Black, too fat, too disabled—have always wondered whether that normal

was really worth returning to? That normal has always strived on structural inequalities and injustice. That normal has lived in and sold us on the idea of the fast lane by leaving others behind. There are people for whom, due to chronic illness, it has been unsafe to enter crowded office buildings, public transport, or shopping malls since early 2020. People who have been confined to their homes for just as long. Disabled people who were long told that working from home was impossible, until suddenly it wasn't. We live in a world built on injustice and inequality. Nothing makes this clearer than a look at the present, which seems to also be a look at the past, and—dare I say it—the future?

While most European countries look like they are increasingly returning to "normal," the technocratic fixes on which governments the world over have predominantly relied to get economies "back on track" come at a huge cost, both literally and figuratively.

Literally: in 2021 Pfizer and Moderna, the two pharmaceutical giants behind the SARS-COV-2 mRNA vaccines, raised the prices per vaccine dose by a quarter and a tenth respectively while renegotiating supply contracts with European countries, which were anxious to secure additional vaccine stock for booster shots (Mancini et al, 2021). Since the beginning of vaccine approvals, the price per dose has varied widely, both within high-income countries and economic blocks, such as the EU and the US, and among high-, middle-, and low-income countries. AstraZeneca, which charges the least per jab among Western pharmaceutical companies, last year charged South Africa $5.25 for every dose, compared to $3.50 for every dose to European countries (Jimenez, 2021).

The research to develop SARS-COV-2 vaccines was largely subsidized by governments and funded by taxpayers. However, pharmaceutical companies are making an enormous profit. According to a report by The People's Vaccine Alliance, Colombia overpaid Moderna and Pfizer / BioNTech up to $375 million for 20 million doses. South Africa on the other hand probably overpaid Pfizer / BioNTech by as much as $177 million (Marriott & Maitland, 2021).

Figuratively: while the high cost of vaccines—and the profit margins, which are predominantly responsible for it—affect all countries the world over, low- and middle-income countries have smaller purchasing power and thus a lesser ability to vaccinate their populations. They cannot stockpile vaccines like European and North American countries have, and don't typically have the infrastructure in place to produce vaccines themselves. Even if they did, the production of vaccines is protected by patents. Last year, Germany among other EU countries opposed calls at the WTO for a COVID-19 vaccine waiver, which would have allowed countries the world over to produce vaccines, without having to pay pharmaceutical companies for the patent (Lopez Gonzalez, 2022). As it stands, a majority of low-income countries, and a majority of African countries, will only see widespread vaccine coverage of their populations from early 2023 onwards, if at all (The Economist Intelligence Unit, 2021). This has consequences not only for people's, nations', and regions' health, but also for individuals' ability to travel, conduct business, visit friends or family or pursue an education in high-income countries. Apart from unvaccinated travel potentially being unsafe,

EU countries for instance have imposed restrictions on who can travel there and how they must have been vaccinated (Council of the European Union, 2022). Until it scrapped all COVID-related regulations in 2022 the UK only allowed visitors to enter its borders who had been vaccinated in a country or region approved by the British government.

The inequalities and inequities underlying these structural and political differences are not random, nor are they a product of the recent past. Health—both national and global—has always been intensely political and linked to the extractive and self-protectionist politics of Western countries (read: countries with majority populations of European descent), and current inequalities largely play out along a colonizing/colonizer divide. This too is no coincidence. Global health and its precursors—colonial medicine and tropical medicine—have always been shaped by the interests of governments and populations in a few select countries to the detriment of the vast populations they have sought to rule, first formally, during colonial times, and then informally, after independence. As Randall Packard (2016) has shown, the concerns and interests of formerly colonized populations have scarcely featured in the design, decision-making, and political power play of global health, its structures and institutions. Historically, there are several dimensions to this. On the one hand, colonial medicine—the system on which contemporary global health is built—was only ever designed to protect the health and livelihood of European populations. If colonizing powers invested in health in the colonies, those infrastructures were

targeted at European colonial officials, their families, and local elites rather than the vast majority of the colonized population. In 1930s Nigeria for instance, a British colony at the time, 4,000 Europeans were served by twelve hospitals, whereas forty million Nigerians were served by fifty-two hospitals (Rodney, 1981). In a way then, and as Walter Rodney argued, colonialism lay the groundwork for current health inequalities and formerly colonized countries' inability to compete with former colonial powers for vaccines on the international market. The economic power of former colonial powers cannot be divorced from the wealth they accumulated through extractive colonization (Acemoğlu & Robinson, 2017).

On the other hand, health policies and priorities were designed to protect European populations over colonized populations too. Most colonial government spending targeted infectious diseases, which could pose a threat to the lives of European colonizers. Later on, with the onset of the two World Wars and large-scale investment in extractive industries for exportation, nutrition became an increasing focus of colonial medicine. This, was designed to keep the local workforce healthy and contribute to the military and economic success of colonizing countries. The primacy of infectious diseases as a policy focus in global health persists up to this day (Global Health 50 50, 2020). One may think that this would have prepared the world—and formerly colonized countries—for the possibility of global pandemic. However, formerly colonized countries, especially in Africa and Central and South Asia, feature among the worst in terms of epidemic preparedness (Madhav et al., 2017).

Historical inequalities, many of which can be traced back to European colonialism, reach into the future and determine differential health outcomes today. While it is easy to draw a map of these global health inequalities, it is also important to trace how the colonial aftermath shapes the lives of people of African, Asian, and Indigenous descent, in other words, people racialized as Brown and Black, in Europe and the Americas. In the US, the UK, and Brazil, Black people or people of African descent were more likely to die of coronavirus infection than their white peers, even after statistics were adjusted for age. In the US, American Indian or Alaska Native populations were over twice as likely to die of coronavirus than white Americans. Black or African Americans were 1.7 times more likely and Hispanic or Latinx people 1.8 times as likely to die of SARS-COV-2 (CDC, 2022). In Brazil, which was the biggest recipient of enslaved Africans during the Transatlantic slave trade, and subsequently has a considerable Black population, the percentage of excess deaths among the Black population was 26.3% in comparison to 15.1% among the white Brazilian population (in comparison to a 2019 baseline) (Marinho et al., 2022). Finally, in the UK, the Office for National Statistics reported that during the first coronavirus wave in spring/summer 2020, the COVID-related death rate was 3.7 times higher for people in the Black African group than White British people (ONS, 2021). In the second and subsequent waves (delta and omicron), the death rate of Bangladeshi men was highest (between 5.0 and 2.7 times greater than for white British men) (ONS, 2022). Racism and structural inequalities do not only determine differential access to

vaccines and subsequent health outcomes on a global stage, but also shape who lives and who dies within countries. Racism, colonialism's big motivator, endures beyond the nominal independence of former colonies, and structures our lives, jobs, and deaths in the present. Who could afford to work from home, who had faith in medical systems and authorities, because they had never been harmed by them and who could trust the government to take care of them, largely played out along racist lines.

Health infrastructures have long been entangled with colonial desires and have made accessing them a difficult choice for many. Similarly, vaccines are not the simple technocratic fixes they are presented as. When in 2020 Pfizer was hailed as one of the pharmaceutical companies that would save the world from the pandemic, some of us remembered that Pfizer was forced to pay an out of court settlement to several Nigerian families whose children either died or were disabled following Pfizer's experimental drug trial in Northern Nigeria in 1996 (BBC, 2011). The ability to use African populations as research labs also originated during colonial times. Louis Pasteur, for instance, benefitted in his scientific advances from access to colonized populations who were less protected by emerging ethical standards than their French or European counterparts (Latour, 1993). In the same vein, German microbiologist Robert Koch instituted so called "concentration camps" to study the progression and treatment of sleeping sickness and tuberculosis in colonial East Africa (Schwikowski, 2022). These histories repeat themselves, or maybe it is more accurate to say that they never ended. When French doctors suggested in early

2020 that experimental COVID-19 drugs should be tested in Africa because of the continent's limited adherence to the wearing of face masks and a lack of ICUs (Busari & Wojazer, 2020), it seemed, once again, that no time had passed at all.

It quite often seems we are stuck between the past and the present, in this odd place, where the future comes into shape. As it stands, in terms of health and vaccine equity at least, this future will look a lot like the present, which looks eerily like the past. While some of us, predominantly those white enough and wealthy enough, with the right passports and the right relationships to pharmaceutical and medical infrastructures, are moving on, out of this pandemic and back into the new normal, those of us who are too poor, too Brown and with homes and histories too much shaped by colonialism's nefarious effects are stuck in this cyclical place where past and present meet. Unfortunately, it increasingly looks like Olufemi (2021) is right: our memories are being disguised and reconfigured, not memories at all, but glimpses of a future in which we have not done enough to undo the harm of colonialism's past and in which we let the promise and possibility of a more just and equitable future move past us, in the fast lane: one glimpse and it's already gone. This may be the world we are condemned to inhabit, one of technocratic fixes that don't fix all that much for a majority of us, while leaving the rest of us with the illusion that everything is just fine.

References:

Acemoğlu, Daron and James Robinson. "The Economic Impact of Colonialism," VoxEU.Org (blog), January 30, 2017. https://voxeu.org/article/economic-impact-colonialism.

BBC. "Pfizer: Nigeria Drug Trial Victims Get Compensation," *BBC News*, August 11, 2011, sec. Africa. https://www.bbc.com/news/world-africa-14493277.

Busari, Stephanie and Barbara Wojazer. "French Doctors' Proposal to Test COVID-19 Treatment in Africa Slammed as 'Colonial Mentality'," CNN, April 7, 2020. https://www.cnn.com/2020/04/07/africa/france-doctors-africa-covid-19-intl/index.html.

CDC. "Cases, Data, and Surveillance," Centers for Disease Control and Prevention, February 11, 2020. https://www.cdc.gov/coronavirus/2019-ncov/covid-data/investigations-discovery/hospitalization-death-by-race-ethnicity.html.

Council of the European Union. "COVID-19: Travel from Third Countries into the EU," 2022. https://www.consilium.europa.eu/en/infographics/covid19-travel-restrictions-third-coutries-february2022/.

Global Health 50 50. "Boards for All?". 2020 https://globalhealth5050.org/.

Jimenez, Darcy. "COVID-19: Vaccine Pricing Varies Wildly by Country and Company," *Pharmaceutical Technology* (blog), October 26, 2021. https://www.pharmaceutical-technology.com/analysis/covid-19-vaccine-pricing-varies-country-company/.

Latour, Bruno. *The Pasteurization of France*. Cambridge, Mass: Harvard University Press, 1993.

Lopez Gonzalez, Laura. "Why Won't Germany Support a COVID-19 Vaccine Waiver? Anna Cavazzini Answers This and More Ahead of the EU-AU Summit | Heinrich Böll Stiftung | Brussels Office – European Union," *Heinrich-Böll-Stiftung*

(blog), February 16, 2022. https://eu.boell.org/en/2022/02/16/why-wont-germany-support-covid-19-vaccine-waiver-anna-cavazzini-answers-and-more-ahead.

Madhav, Nita, Ben Oppenheim, Mark Gallivan, Prime Mulembakani, Edward Rubin and Nathan Wolfe. "Pandemics: Risks, Impacts, and Mitigation," In *Disease Control Priorities: Improving Health and Reducing Poverty*, Dean T. Jamison, Hellen Gelband, Susan Horton, Prabhat Jha, Ramanan Laxminarayan, Charles N. Mock and Rachel Nugent (eds.), 3rd ed. Washington (DC): The International Bank for Reconstruction and Development / The World Bank, 2017. http://www.ncbi.nlm.nih.gov/books/NBK525302/.

Mancini, Donato Paolo, Hannah Kuchler and Mehreen Khan. "Pfizer and Moderna Raise EU COVID Vaccine Prices," *Financial Times*, August 1, 2021. https://www.ft.com/content/d415a01e-d065-44a9-bad4-f9235aa04c1a

Marinho, Maria Fatima, Ana Torrens, Renato Teixeira, Luisa Campos Caldeira Brant, Deborah Carvalho Malta, Bruno Ramos Nascimento, Antonio Luiz Pinho Ribeiro et al. "Racial Disparity in Excess Mortality in Brazil during COVID-19 Times," *European Journal of Public Health* 32, no. 1 (February 1, 2022): 24–26. https://doi.org/10.1093/eurpub/ckab097.

Marriott, Anne and Alex Maitland. "The Great Vaccine Robbery," The People's Vaccine Alliance [https://peoplesvaccine.org], July 29, 2021.

Olufemi, Lola. *Experiments in Imagining Otherwise*. Maidstone: Hajar Press, 2021.

ONS (Office for National Statistics). "Updating Ethnic Contrasts in Deaths Involving the Coronavirus (COVID-19), England," Office for National Statistics, April 7, 2022. https://www.ons.gov.uk/peoplepopulationandcommunity/

birthsdeathsandmarriages/deaths/articles/updatingethnic
contrastsindeathsinvolvingthecoronaviruscovid19england
andwales/10january2022to16february2022.

ONS (Office for National Statistics). "Updating Ethnic Contrasts
in Deaths Involving the Coronavirus (COVID-19), England:
24 January 2020 to 31 March 2021," Office for National
Statistics, May 26, 2021. https://www.ons.gov.uk/people
populationandcommunity/birthsdeathsandmarriages/deaths/
articles/updatingethniccontrastsindeathsinvolvingthecorona
viruscovid19englandandwales/24january2020to31march2021.

Packard, Randall M. *A History of Global Health: Interventions
into the Lives of Other Peoples*, Illustrated edition. Baltimore:
Johns Hopkins University Press, 2016.

Rodney, Walter. *How Europe Underdeveloped Africa*.
Washington, D.C.: Howard University Press, 1981.

Schwikowski, Martina. "Robert Koch's Dubious Legacy in Africa,"
DW.COM, March 24, 2022. https://www.dw.com/en/robert-
kochs-dubious-legacy-in-africa/a-61235897.

LIOBA HIRSCH is a researcher at the University of Liverpo
with an interest in the colonial and anti-Black entangl
ments of Western biomedicine and global health managemen
Her research has focused on the historical developmen
contemporary management, and colonial aftermath of Briti
health interventions in West Africa. She also does critic
work on humanitarianism, medicine, and racism. Hirsch h
a BA in Political Sciences from Sciences Po Paris a

The Economist Intelligence Unit. "Coronavirus Vaccines: Expect Delays," London: The Economist, 2021. https://pages.eiu.com/rs/753-RIQ-438/images/report%20q1-global-forecast-2021.pdf?mkt_tok=NzUzLVJJUS00MzgAAAGEeiPcSJdyPzt81jjNl52s4fUCQGhAhfcpOTmlh7dVJhYm25gwZgU2muUJSxvcPSMB79Of485NxNci9ha5-tDsT6jyFwCi-P10-I1o2PsJ6uQl4Cg.

MSc in Political Sociology from the London School of Economics. Between 2014–2015 she worked for GIZ, the German Government's international development agency in Zambia. She holds a PhD in Geography and Global Health from University College London. From November 2019 to May 2021 she was a Research Fellow at the Centre for History in Public Health at the London School of Hygiene and Tropical Medicine (LSHTM), working on a project exploring the School's colonial history.

Amy Berkowitz

A "POST-COVID" DISPATCH FROM CALIFORNIA'S COVID HOTSPOT

As we celebrate the supposed end of the pandemic while cases and deaths continue to escalate, I can't stop thinking about Chelm.

Do you know about Chelm? It's a fictional town from classic Yiddish literature that's governed by a council of "wise men," whose foolishness is the source of many amusing anecdotes.

As a kid, I had a picture book that collected several Chelm stories. Here's one I remember:

One morning, it snowed in Chelm, and the whole town was covered in a blanket of glistening white powder. The snow was so beautiful that the wise men wanted to make sure it wouldn't be disturbed by the footprints of students leaving school. So they held an emergency meeting where they devised a plan: parents would pick up their children after school and carry them home.

What did the people of Chelm make of the footprints in the snow left by all the parents? Did anyone notice them, acknowledge them?

I know Chelm is a joke, but it seems to be a warning too.

😐

There's about as much COVID going around in San Francisco as there was during the Delta surge, but now there's no more mask mandate because there's this prevailing narrative that "COVID is over."

The problem is that COVID is not over. COVID is still present, but it's harder to see. A few months ago, there were all these places to get free PCR tests. Now many of those testing sites have disappeared, so cases are going uncounted. To get a more accurate estimate of how much COVID is circulating, you have to use a clunky and hard-to-navigate wastewater surveillance website.

Now that COVID is over, talking about the ongoing pandemic has taken on a flavor of conspiracy. And believing in a conspiracy makes you feel like you're crazy.

😐

Throughout the pandemic, I've been more cautious than most of my friends. My caution is related to my chronic illness, but not in the way you might think. As far as I know, I'm not immunocompromised—I'm not more likely to get seriously sick from COVID than someone who doesn't have fibromyalgia. But I know what it's like to have a chronic illness. I already live with symptoms like brain fog and fatigue, and I can imagine how

hard it would be to have another chronic illness—long COVID—on top of the one I already have.

But people who aren't chronically ill don't understand chronic illness. Most people understand illness as something that has an end—the get well soon cards do their work and the fever goes down, the coughing stops, the surgery is successful, and then the illness is over.

And so the idea of long COVID is hard for most people to wrap their heads around. That is, if they're even aware of it.

☺

One of my friends got sick with long COVID at the very beginning of the pandemic, so for me, it was very clear that it was a real thing that happened to people. But considering it's an illness that's affecting between 10 and 30% of people who come down with COVID, it's really bizarre how little it's been covered in the media.

Every time I mention long COVID to my mom she says, "I believe you, but I hardly ever hear about it on the news."

☺

Last week a friend shared a link to a transcript of an NPR (National Public Radio) segment called "Bay Area is California's COVID Hotspot as Cases Rise Again." It said that cases had more than doubled over the past couple of weeks, but the experts they interviewed seemed oddly unconcerned.

Dr. Maria Raven, chief of emergency medicine at UCSF (University of California San Francisco),

advised: "You can go about your normal life. You have done the right things. You have gotten vaccinated. So go out. Go out to dinner. Just move on."

☺

I didn't see Fauci's speech about how the pandemic was over, but I heard about it from my mom. "He said it was over, but he made a point of saying that because he was high-risk, he was going to continue taking precautions."

"I wonder if someone was pointing a gun at him, just out of the frame."

"What?" It was a windy day and our connection was bad. My joke was too dark to repeat.

"Never mind."

☺

Something I want to mention is that I'm pregnant. I haven't written about that at all, but it seems relevant here. One reason it's relevant is that it puts me at a substantially higher risk of getting seriously ill or dying from COVID.

I started to feel the baby move on Mother's Day. How sweet of her, to wait until Mother's Day. Of course it's a coincidence, but still.

My husband's company is requiring everyone to return to the office after letting everyone work remotely for two years. It's a tech company, so there's no advantage to working in person besides the fantasy that spontaneous hallway conversations will generate revolutionary ideas that will transform the future of the organization and blah blah blah.

I remember seeing a tweet that was like, the only reason CEOs want people to return to the office is so they can look around and say, "Ah, look at all the people I own."

☺

My husband hasn't returned to the office. We're waiting to hear back about whether accommodations can be made or not.

What will we do if they refuse to accommodate our remote work request based on my pregnancy?

Maybe we could request an accommodation based on my husband's anxiety, a condition protected by ADA law (Americans with Disabilities Act). We could explain how his anxiety has been worse than usual because he's worried about getting COVID at the office and passing it to his wife, which could make her get very sick or die and cause pregnancy complications including stillbirth.

☺

I'm lucky to be able to work from home—as a freelance writer, I've been working remotely since before the pandemic. A lot of chronically ill people, pregnant people, and chronically ill pregnant people don't have the luxury of working remotely.

I posted in a chronic illness Facebook group about how surreal and alienating it is to see my friends share pics of crowded punk shows and not a mask in sight, and someone commented and said "Yeah, I work

in security at a concert venue, and no one wears masks. Even though I've been masking, I got COVID, and I'm scared to go back to work."

😐

Is there any amount of chronic illness that will make our society start taking chronic illness seriously?

COVID is proving to be a mass disabling event. In just a year, 1.2 million people became disabled due to long COVID. What if everyone affected by long COVID lets their disability radicalize them?

😐

My friend in Minneapolis tells me they're messaging local arts venues one by one, asking them to clarify their COVID protocol. It's a good thing to do, I think—venues should know that COVID policies are an access issue: if masks are optional, chronically ill people can't come to your events.

I ask them how it's going and they text back, "The very rough silver lining is that it makes it easier to know who to trust but it…isn't many people."

😐

I remember at the beginning of the pandemic we agreed that MY MASK PROTECTS YOU, YOUR MASK PROTECTS ME. Masks still work the same way, only now we're not supposed to care about protecting each other anymore.

New York Times columnist David Leonhardt asserts that our concern for the wellbeing of others is totally misguided. In an interview with the newspaper's *The Daily* podcast at the height of the Omicron surge, he urged listeners to return to their "normal" lives, briefly mentioning but quickly dismissing the risk COVID poses to immunocompromised and elderly people, failing to acknowledge that young children can't get vaccinated, and ignoring long COVID:

"Now, I know that many boosted people will say, look, I'm not worried about myself. I'm worried about infecting others. And that shows an admirable concern for others. The thing to remember is that those other people have also had the opportunity to get vaccinated. And the data suggests that for vaccinated people, Omicron looks a lot like other common respiratory illnesses... but it can be rough on elderly or immunocompromised people. So the question becomes, if COVID is starting to look like a regular respiratory virus, is it rational for us to... disrupt our lives in all these big and consequential ways?"

This is eugenics dressed up as common sense.

This is where people like my mom get their news.

☺

A thought I keep having: if they would just appoint any one of my chronically ill friends to lead the country's COVID response, things would be going so much better. If they would just appoint a fairly reasonable child. If they would put my cat in charge of COVID, things would be going better.

Maybe not my cat—she's so happy to have both of us working from home.

<center>☺</center>

I went to one group exercise class during the pandemic. I was the only participant wearing a mask and the instructor kept saying, isn't it hard to breathe with a mask on, wouldn't I be more comfortable if I took it off? Fortunately, the gym started offering online classes as cases surged. But as soon as they were allowed to resume in-person offerings, they canceled the online classes. I haven't been back since.

I walked by the other day and saw they had a new ad on the sandwich board outside the studio: "Unmask your potential—don't let fear weigh you down."

<center>☺</center>

It's frustrating how often people like the gym owner and David Leonhardt conflate the problem of "fear" with the problem of the ongoing pandemic to which caution is a rational response.

As if my husband's problem is his anxiety.

In eighth grade we had to memorize a list of logical fallacies. I'm not sure which one this is, maybe a "red herring argument."

How come other people don't recognize this clumsy sleight of rhetorical hand as a fallacy?

I guess because of how badly they want to believe that the pandemic is over.

My friend who had a baby last year texts me advice. Here's the breast pump I used, here's a registry checklist, here's the Facebook group where rich moms give away their expensive baby gear.

Last night she texted me to ask if I'd looked at daycare programs yet. No, I haven't.

My baby's not even born yet and I'm worried about her getting COVID at daycare.

While our country's COVID response is appalling, there's something depressingly familiar about it: it reminds me of our response to climate change.

Instead of addressing the problem, we decide that doing so would be impossible because it would negatively impact the economy. Instead of protecting people from harm, we invent a story about how the harm isn't real.

I haven't told my best friend from high school that I'm pregnant yet. When I told her years ago I was thinking of having a kid, she said she didn't understand how anyone could, with climate change and everything.

A few years before that I remember her describing her worldview this way: "The world is just a piece of shit swirling around the bowl."

And I mean, I get it. The planet is fucked. There is a lot of suffering and pain here on Earth. People do terrible things to each other and the world they live in.

But this piece-of-shit world is the only world I know, and I've found beauty in the swirling, and love.

☺

Before I knew the baby's sex, I made lists of boys' names and girls' names.

One of my favorite boy's names was Noah. I liked that it had "No" in it, and that it didn't feel too masculine. But then I saw that it was the second most popular boys' name of 2022.

Oh god, I realized. Of course everyone wants their son to be Noah. Everyone wants their kid to be the hero with the ark, the one to rescue us from all of our misdeeds, save us from the flood, and repair all the damage we've done.

☺

My friend who had a baby last year drapes the rain cover over her baby's stroller before she gets on the train. "It's our little COVID bubble," she jokes.

And there it is, the answer to the question that's been circling in my mind since I learned I was pregnant: how will I keep my baby safe from COVID (and, you know, everything else) when our own wise men, possessed by some perverse capitalist death drive, continue to invent fantasies instead of taking action?

I'll do what I can and hope it's enough.

AMY BERKOWITZ is the author of *Tender Points* (2nd ed. New Yor Nightboat Books, 2019). Her writing and conversations ha appeared in publications including *Bitch*, *The Believer*, *BO* and *Jewish Currents*. From 2017 to 2020, she co-coordinat the writing residency at Alley Cat Books, and in 2016, s

-organized Sick Fest in Oakland. Her work has received
pport from the Anderson Center, This Will Take Time,
all Press Traffic, and the Kimmel Harding Nelson Center
r the Arts. She lives in a rent-controlled apartment in
n Francisco, where she's writing a novel.

Artur Olesch

IN THE (GOOD) HANDS OF TECH

Humanity is moving toward brand new healthcare characterized by virtual accessibility and AI-driven perfection instead of human touch and face-to-face interactions. "Medicine to-go" is available straight from smartphones, anywhere, anytime. Democratization driven by algorithms instead of a paternalistic model held by physicians. Personalization instead of one-fits-all care. Full control of health instead of leaving our bodies and mood to fate. Like ancient idols or gods, technology promises better health and longer life. The eternal dreams for which we are willing to do anything.

ARCHIVES
Surrounded by cutting-edge tech

The COVID-19 pandemic swept across the globe like a storm, treating everyone equally, taking the greatest toll on countries that lost the selfish battle for ventilators pumping air into patients' airways or vaccines

reducing mortality. It was a time of lockdowns and isolation, funerals without farewells, daily updates on COVID-19 statistics, masks and home offices. Yet, unnoticed, 2020–2022 marked the advent of the era of Do-It-Yourself (DIY) healthcare.

At first glance, this is nothing new: innovations began entering medicine in the '90s. Electronic medical records and e-prescriptions have slowly replaced paper documents. Telecare made health-related services accessible outside the doctor's office—you just need a computer or smartphone and Wi-Fi.

The evolution is also about unlimited access to medical knowledge, which for centuries has been the domain of doctors. Every day, one billion health-related searches are submitted to Google. The world's most popular doctor, available day and night, answers 70,000 questions a minute about skin rashes, best medicines, kidney stones or natural remedies for flu symptoms. AI-driven search results evoke hopes or fears, impacting the decisions and lives of billions of people.

In this infinite universe of health technologies, there are over 500,000 mobile apps available in app stores. They assist in weight loss or mental wellness and help people living with chronic diseases. In some countries, apps and games can be prescribed by doctors, just like medicines. So swallowing a pill has been upgraded to opening an app and following its instructions. Wearables and smartwatches monitor biomarkers 24/7—fingerprints of our health.

However, there is a broader narrative beneath the surface of all these breakthrough innovations. Healthcare is no longer the place you visit. It is now a service

that sees you. Or even a service you create. This is more than tech-driven changes—this is social transformation.

ARCHETYPES
Lost in the meaning of disease and the
complexity of life

As a result of the rise of new tech-driven healthcare, the role of the physician as an omniscient oracle is being eroded.

Patients can self-diagnose with the help of artificial intelligence algorithm-based symptom checkers that know the symptoms of each of the approximately 30,000 diseases described in the medical literature. A physician with decades-long experience might know 500 of them at most, due to the limitations of experience, influenced by the patients they are used to treating.

While machines are constantly improving, doctors are overwhelmed by the rising number of patients, stress and responsibility. And so who are we more likely to trust with our health? A tired human doctor prone to making mistakes after several hours on duty or a perfect machine devoid of human weaknesses? So far, medicine has been perceived both as an art and a science. Following the progressing digitization, however, it is science that is becoming art.

You might say that technology will not replace doctors. Obviously, medicine is something more than just a pill. It is about understanding the patient, empathy and support in those difficult moments when the patient is informed about the terminal disease, facing slow and inevitable death. This last stronghold of doctors at the

forefront of omniscient computers only validates the fragility of human beings, the emotional longing to be understood by another person, and also the fear of being lonely and helpless. But machines can also be supportive.

This belief in the unique role of healthcare professionals, yet who were only able to enjoy applause for their heroism for a few months during the COVID-19 pandemic, does not take into account the slow and radical but consistently callous advances in technologies. Future healthcare will not be the outcome of a linear growth model, just as the car is not a better version of the horse.

You will experience this soon when a robot understands you better than your best friend, interprets your every little gesture and facial expression using face-recognition machine-learning algorithms, and thus being capable of conducting a conversation with supreme virtuosity, referring to your hidden fantasies and emotions. This is all due to data—the astute observer witnessing everything that is going on around us.

One might say that robots—human-looking shapes made of metal, plastic and processors—can't inspire trust. But things will get so different when a bionic man, equipped with artificial emotional intelligence (in a world where social ties are degraded), can speak with a warm voice, mirroring human behavior. Empathy can be simulated. Feelings can be programmed. Consciousness can be faked. Humans already talk to primitive computers when they are too slow or tell smart vacuum cleaners where exactly they are supposed to clean. It doesn't matter if the machines don't listen yet. Robot doctors will be like new synthetic beings driven

by algorithms that translate human life into machine behavior. It's not a hoax—it's a new being.

QUARKS
The primary nuances of survival

Between dystopian and utopian visions dominated by super-intelligent algorithms analyzing big data collected by ubiquitous sensors, ultra-fast quantum computers making new scientific discoveries, robot nurses with white mechanical bodies, can a human being find a helping hand in weakness? A human being composed of a body and a soul, a sophisticated "I" that makes rational decisions based on knowledge, but also torn by feelings and emotions formed in the process of evolution over thousands of years. With an unstoppable fear of the existential threat of disease, which every form of medicine—conventional or unconventional—seeks to eliminate or minimize.

Things are no different in the new, better world of modern medicine, carrying on its flags a new form of hope born out of a fascination with technology and instinctive panic about the unknown written in the genes—despair, doubt, anxiety, fear, and concern of losing health.

The first pandemic of the digital age, COVID-19, has suddenly become a global laboratory for data-driven and virtual healthcare. One hundred and two years after the last great Spanish Flu epidemic, people are no longer so vulnerable, with an array of medical and laboratory technologies, modern hospitals, and advanced medicines at their disposal. And yet they are still driven by self-survival instincts, as they crowd the stores for food

supplies in defiance of all facts and figures, or protect themselves contrary to their own beliefs, looking for a simple explanation to incomprehensible phenomena in conspiracy theories.

This clash between the front of rational technology and irrational human nature accelerated scientific advances but also fanned the flames of anti-vaccine movements, declining trust in public health institutions, and increasing social polarization. Some celebrated the invention of the revolutionary mRNA vaccines— a triumph of life sciences over the virus, promise to end the pandemic—while others sank into the new-age conspiracy theories of COVID-19 dictatorship, chips injected with vaccines or an Illuminati plot led by Bill Gates and other world leaders.

Paradoxically, despite the fantastic achievements of life sciences, as a society, we are facing a crisis of rational thinking. With access to knowledge like never before in the history of humankind, social media have become an incubator for fake news. These are not just the harmless fantasies of a minority. Disinformation has undermined the scientific authority of experts and scientific institutions, prompting people to ignore health recommendations and, as a result, causing deaths. These are often generated by bots programmed to impact societies and elections. The infodemic, the digital disease of the 21st century, is becoming one of the greatest global threats.

Meanwhile, the fight against the pandemic accelerated socio-technological transformation. In real time, we might helplessly observe the exponential spread of a tiny, 0.1 µm in diameter virus, illustrated by ever-expanding

red spots on the world map. Coronavirus tests developed weeks after the pandemic outbreak helped limit the virus's transmission. During the HIV pandemic in the '80s, it took three years to develop reliable tests—long enough for a germ of insecurity, intolerance, distrust and social aggression to increase.

Monitoring and testing allowed better pandemic surveillance, avoiding the collapse of overburdened healthcare systems and the need for an ethically controversial, unhuman triage. The flattening of the pandemic curve became a symbol of social solidarity. At the same time, the collaborative efforts of international teams of scientists led to the development of a vaccine in less than one year. Prior to 2020, it would have taken more than ten years.

BYTES
New normal out of same humans but under different circumstances

The fight against the pandemic forced a shift in the existing healthcare systems. Humans began to avoid health centers for fear of infection. The sick, on the other hand, confined to isolation, were left to their own devices. In-person medical visits became replaced by new forms of communication: by telephone, video chat or email.

They were both frustrating—when the virtual visit was interrupted by technical glitches—and gratifying—when a patient received a prescription in a matter of seconds without having to go to the clinic and wait in a crowded waiting room. The feeling of security that always accompanies the crossing of the threshold of a

doctor's surgery became replaced by "Can you hear me OK?" or "Can you see me properly?"

The multilevel construct of relational care that includes elements of psychological care and even religion has been replaced by a transactional one: symptoms in exchange for diagnosis and medicines. Although high-speed internet connected patients' homes with doctors' offices, computer and smartphone screens filtered out the nonverbal communication elements, leaving the patient alone with their thoughts and emotions. The physicians have been stripped of their halos—experienced during the in-person visit but non-detectable in images made up of pixels.

During the coronavirus pandemic, whether they liked it or not, patients were suddenly confronted with solutions the adoption of which would have taken years in a non-pandemic setting. Not because of a lack of technological gaps, but because of people's resistance to change. But urgency ate that culture for breakfast.

The technologies used by early adopters became mainstream: telemedicine solutions measuring blood oxygen, chatbots answering questions about the coronavirus or COVID-19 tracking apps designed to break the chain of infections. They have one thing in common—they subtly shift the responsibility for health from the healthcare system to the patient.

In the digitally enabled democratization of health, the patient becomes an empowered consumer. But on the other hand, we witness the IKEAization of medicine progresses: The individual gets a toolbox full of devices to maintain (prevention) or regain health (therapy), with a confusing instruction manual included.

Health is not created by the doctor but by the patient. And this seems inevitable in the world of health workforce shortages and rising demand for health services, driven by an aging society and epidemics of non-communicable diseases. We want perfect healthcare. Instead, all we get is a faulty compromise between economists, doctors, politicians, and scientists.

Will algorithms bridge the gap between missing or limited capabilities—knowledge, funding or people—and endless health needs? No, since reality is more complex than we would like it to be.

A new generation Z wants Instagrammable health. Easy as Uber rides, quickly delivered as Amazon Prime orders, individualizable as Tinder dates. And Big Tech is starting to make this dream come true. Apple, Samsung, Google or Facebook (Meta) have nothing to do with the healthcare sector, but in the new digital ecosystem, they don't need to. For them, healthcare is a business model with a steady growth rate, a source of data required to keep developing artificial intelligence algorithms—the building blocks of even better digital services. So in exchange for the promise of better health and wellbeing, they turn people into data incubators.

CODES
Design your health and body, put together
your own mood

People do not want more health to be fixed, but planned and new technologies have started addressing this perfectly. After all, old gods have always been replaced by new, better ones.

Synthetic biology promises to make human cells programmable like IT systems in order to eliminate the boundary between the human body and high-performance processors. Quantum computers will soon surpass the human brain's calculating capabilities millions of times over. Avatars with artificial empathy, deceptively reminiscent of doctors, will no longer be cold machines with metallic voices but trusted personal assistants. Injectable sensors will save us from errors in imperfect human anatomy or genes formed randomly. It's a paradox that disease- and injury-prone bodies and brains, limited by the computational power of neurons, are slowly becoming a disability compared to the nearly limitless capabilities of algorithms. What used to be a fascinating creation of nature or gods is starting to be a limit on us.

Today's measuring of pulse rates or footsteps is just a ridiculous precursor of a new health technoreligion called the "quantified self," based on the axiom "you can only improve what you measure." Each person will have a "digital twin"—a digital copy created of data to test new drugs and treatments on, or even prevention scenarios to protect our bodies from ineffective medicines and unnecessary side effects. Finally, our avatar—not ourselves—will visit the doctor in the metaverse. The home—not the hospital—will be the place to provide healthcare services. Every individual—not the doctor's surgery—will be the source of health data. The body will become a quantifiable data set with no room for randomness. No room for what cannot be described by the laws of physics and mathematical formulas.

Digitization means personalization. And the greater the individualization, the higher the expectations.

In the current model of "one—medicine, therapy, or approach—fits all," the general public settles for an average that is not always ideal but the same for all. Only those who have enough money can buy the extra options. In a "one fits one" system, there is no general public but an individual who demands what's best.

But it's hard to be naïve enough to persist with idealistic images of the fusion of technology and man. The history of humankind and healthcare has always been marked by enormous inequalities. These might soon explode. Israeli historian and philosopher Yuval Noah Harari forecasts a future in which technologies make healthy people even healthier.

Health inequities will get upgraded to a new scale. Between humans and digital health services, there is a new techno-economic vector: smartphones, smart sensors, smart houses, smart cars, and smart everything—all interconnected within the Internet of Things. Without financial resources and digital literacy—a new determinant of health, as important as genetic or environmental factors—many people will be doomed to social exclusion and discrimination in digital-driven healthcare. Without access to technology, some people will be at risk of "data poverty." That lack of data means relegation to an outdated model of analog healthcare.

In awe of fantastic AI algorithms, shiny wearables, and exciting big data, are we slowly drifting toward prioritizing health over freedom? Or has it always been this way as we quietly submit to the doctors' diagnoses?

Today, the doctor trusts the patient to follow their instructions. Tomorrow, the doctor (or an algorithm) may have access to data showing the patient's

compliance—facts instead of unreliable declarations, often a far cry from the truth. We are only one step away from the dark scenarios of a healthcare dictatorship. I wouldn't be so sure that the tech-society of the future would refuse to pay such a price in the eternal quest for immortality or at least for getting close to it.

QUBITS
Technology only reflects our worries
and confusion

The technologization of healthcare restores people's sense of control over their health, which previously lay in the hands of the gods, fate and nature, or just being controlled from the outside by healthcare professionals.

Bio-feedback, real-time monitoring of an individual's body chemistry is like a never-ending doctor's visit. It provides a sense of security, which is critical for happiness. The modern health renaissance is about calculating oneself, including one's emotions and well-being. It is an attempt at understanding oneself and withstanding the forces of a disease that reduces humans to the level of defenseless beings. There is no margin left for the randomness factor. *Techno homo sapiens* is a quantifiable, controllable, programmable, and repairable organism.

This tech-driven cultural transformation is supposed to address humanity's biggest threats: the COVID-19 pandemic, climate crisis, social disparities in health and economic crises. Unfortunately, this new age of healthcare may prove to be a refuge that provides only an illusory sense of security.

Medicine is the art of giving hope amid a disease, a pandemic, or the transience of life. And technological advances embrace it so perfectly.

ARTUR OLESCH is a Berlin-based freelance journalist, digit
health futurist and opinion leader. He is the founder
aboutDigitalHealth.com: a discussion forum on health future
An author of 1000+ articles on new technologies in healthca
and their impact on societies today and tomorrow, conte
writer, speaker, moderator, lecturer and an influenti

ice on social media, he is an advocate of innovations for
cessible, affordable, and equitable healthcare. A member
 the SCIANA Healthcare Leaders Network, he is editor-in-
ief of several e-health magazines in Europe. Olesch also
ntors medtech startups and guides healthcare organizations
wards their digital transformation.

LYNN HERSHMAN LEESON, MARY MAGGIC, AND P. STAFF IN CONVERSATION

The following discussion offers an exchange between three artists who share common ground in their interest in biohacking, the relationship between art and activism, issues of toxicity and the environment, and the role of interdisciplinary collaboration. The intergenerational conversation features Lynn Hershman Leeson, who for over six decades has been working at the intersection of art and technology, and early career artists P. Staff and Mary Maggic, whose artworks, workshops, and public programs have often explored the porosity of our bodies, with a particular focus on hormones, endocrine disruptors, and the environment.

Sara Cluggish and Pavel S. Pyś (S&P): Let's start by talking about the role of activism in your lives and practices.

Mary Maggic (MM): I'm not a self-identifying activist, but my biohacking work has been placed in that framework. I do see bringing knowledge production outside

of the institution as inherently political and the act of collectively gaining new knowledges and subjectivities as a very subversive act, especially when we're trying to redefine very entrenched notions of body and gender.

P. Staff (PS): When I was younger, it felt very important to me that the work I do as an artist be a form of activism. I'm a bit more comfortable now with understanding what I do is something different. It's necessary for me to be quite specific about what we call activism—grassroots community organizing, political organizing—which I'm personally not deeply involved in. I'm more interested in putting work into the world that generates a set of exchanges and reactions that you can't control or know the results of per se. But I deeply agree with Mary that you can't really wade into the territories that our work does without butting up against the inherently political act of resisting dominance.

Lynn Hershman Leeson (LHL): When I moved to California in 1963, it was the time of the first version of the free speech movement. The women's movement didn't start until maybe five years later; it started very slowly with people realizing that they weren't represented in history. In the mid-'60s, I borrowed a video camera and recorded interviews with women. The dynamic changed; there was an understanding that a movement was happening. I made videotapes from 1967 to 2008, which is how *!Women Art Revolution* (2010) came about. I didn't think of myself as an activist till much later; I can't pinpoint exactly when. I knew when I was doing the hotel rooms [*The Dante Hotel*, 1972–73], I felt like that was really

my first work because it wasn't what people expected. It was a completely new form, fighting for the idea of using media that had never been used in art.

S&P How would you describe your respective environmentally driven interests in the body and gender politics? How do you think of the porosity of the body, of ideas, of contamination, and disease?

MM I'm really interested in the way that bodies are categorized as it relates to the broader planetary body, the way that we map out territories and calculate what we can extract from the environment. Is there a way to deterritorialize our bodies in the planetary body? Is there a way to create taxonomies without the violent process of othering? There is a linkage between how we define toxicity and taxonomy. Toxicity is naming the toxin, the other, the poison. Taxonomy has that same effect of putting boundaries between two different bodies or two different species: thus a hierarchy emerges.

It is very clear that there is no fixed and stable body or gender: how do you categorize something that's constantly shape-shifting? *Genital(*)Panic* targets the anogenital distance (the distance between the genitals and the anus): a measurement by which scientists assess reproductive toxicity. Male bodies are supposed to have twice the distance of female bodies. Yet, because we are exposed to phthalates and microplastics, male bodies are exhibiting the same length as female bodies. The construction of sex and gender is falling apart if you base it only on genital morphology. *Genital(*)Panic* proposes a queer feminist population study, performing

science in a way where all of this genital data is crowd-sourced by collecting 3D scanned genitals and basic demographic data that prioritizes your gender identity versus your gender assigned at birth. So far, I haven't seen any population study omitting the gender assigned at birth. The project tries to separate the tool of patriarchal science, separate the anogenital distance from its symbolic power.

LHL I began using sound as when I was pregnant, I went into heart failure and had to stay under an oxygen tent alone for several months in a hospital. All I could hear was breathing, it became this major element of my life. It came out of an illness into survival. That experience is really a dominant one that has shaped the work I do, because whether it's one's own personal survival from heart failure at age twenty-three or eighty-one, thinking about the planet's survival and the impact of toxins needs to be addressed. Toxins in the form of pollution, in the form of the limited scope of the future. That's partly what the *Anti-Bodies* (2014–) are about: a metaphor for finding toxins, not just in one's body but those that are in the environment, and addressing them in different ways to cure them, to find a different way of overriding them.

S&P Throughout your works, there is a questioning of what is toxic to us? How do we understand toxicity?

LHL In the '70s, I began a series called *Water Women* of bodies based on Roberta's [Bretimore], filled with water drops. The work was about evaporation and

decomposing ourselves over time. I continued to make them for forty or fifty years. *Twisted Gravity* used the *Water Women* images; they became lit up in different ways to show a new process that could rid water of plastic pollutants. We worked with the Wyss Institute, which had created the AquaPulse, capable of purifying water one liter a minute. They hadn't patented it yet, but they were going to send it out for emergencies, such as earthquakes. Harvard, along with the Wyss Institute, wrote that they wouldn't have come up with the ideas if I hadn't been working with them, because even though I wasn't a scientist, I was asking questions that they had to answer. For me, it was easier to look at and analyze something and come up with the way of thinking that they weren't familiar with because it wasn't logical.

PS Eva Hayward's work points us towards increased attention to toxicity and pollution in the current, deeply reactionary panic around sex and gender. In her essay *Toxic Sexes* (written with Malin Ah-King) Eva points towards how the sex changes in animals as a consequence of environmental endocrine pollution might help us think through toxicity as one of the defining conditions of sex in the present moment. I think this is an increasingly important pivot to how we approach understanding the toxic. It's interesting to note though that in this debate, why is sex more central than cancer, auto-immune disease, and even death? And why is something like reduced sperm count seen as the crisis rather than the damaging capitalist practices that have led to it?

MM Our bodies are changing much faster than the cultural discourse around toxicity. There is sex panic in the media, grounded in homophobia, transphobia, and xenophobia. Our bodies have always been and always are queer. There's something really problematic when we have empathy for the ill, for the sick, but that empathy is selective. It's only for certain bodies, ones which are deemed worth existing and living.

PS In this knottiness of life and one's art practice, this toxicity disturbs multiple boundaries of sex, gender, race, geography, and species. *Acid Rain for Museion Bolzano* approaches this, albeit more loosely. The work's material is a fluid piping system around the ceilings and partially down the walls of the institution. At certain points, it leaks, dripping lactic acid into the exhibition space that is gradually collected in large steel barrels. The work has a very particular ambient threat: you're constantly echo-located by the sound of the drip in the museum. You can always orient yourself in relation to this volatile material. I was driven to thinking about it partially from thinking about how acid rain was such a prominent news story in my childhood. In Europe, in the '80s/'90s, there was this idea that industry was entering this process of precipitation; there was this violent intrusion leading to acid rain. As a child, I felt like, "If I go outside in the rain, my fucking face is going to be burnt off, or this liquid from the sky is going to be burning holes in everything." In reality, acid rain was really ruinous for limestone and sandstone buildings, which, in the UK, primarily meant houses, schools, churches, and prisons. These various institutions were being eroded. In some ways, the work

engages a certain poetics of violence, disquieting the experience of being in shared space.

MM I really like how the lactic acid is described as an ambient threat. This ambient threat is not some mutation to nature; it is nature. We need to come up with strategies that are beyond just "We just need to return to this pure nature." But actually, we need to say: "No. The toxicity that we are entangled in now: this is the starting point from which we should build all our new strategies."

S&P You all have a shared interest in alternative communities, of people working outside of the official channels. How do you choose your collaborators?

MM Around 2014, I got introduced to the Hackteria network: a global online network of hackers, artists, tinkerers, and geeks. A lot of my workshop practices emerge out of working with the Hackteria community as the process is based on removing the hierarchy between the lay person and the expert, a sort of public amateurism which comes out of the practices of Critical Art Ensemble. My workshop practices started off pretty didactic: I would just teach how to extract hormones from the urine. Over time, I started to involve a lot more performative practices, generating a space of this radical unknowingness. It's a very co-generative and co-productive process of worldmaking that you would never have if you were just working as a solo artist alone. You're able to really embrace this messy entanglement with others. It's also a strategy against purity because a lot of the way that knowledge is produced in scientific methods

is in this very controlled and very sterile environment. We have to cross-contaminate with each other to really come up with something substantial and new.

LHL For me, it's often accidental. I knew I wanted to cast Tilda Swinton in *Teknolust* (2002) having seen her in *Orlando*, and I tried to contact her agent with no luck. Then, by chance, I sat next to a friend of hers who then told her about the project when she called. You put out mental energy of what you need to do, and then it's almost like the people come to you in order to get you to accomplish that. I didn't know about Thomas Huber before going to Basel, but I knew what I wanted to do there. I certainly didn't know about the Wyss Institute. A lot of it comes from research, like finding the guy who did the very first bioprinting of an organ when I was working on Infinity Engine, or finding George Church who defines synthetic DNA. It took me three years to get him to talk to me, but it's just a matter of being persistent. And then convincing them you understand what he is saying. I had an advantage as I studied Biology in college.

PS You realize how often the alternative community is situated or presented as this really holistic space. And that a lot of the time, in my experience, I realize that we come into community with other people often not through that much choice. Maybe I am in community with other trans people in the geographic locale that I'm in often out of necessity, often out of a need. But what I often find happens is that in that moment of being in community with each other, we're often far more deeply troubled by each other, by being together than we

really give account for. We imagine that the self-selecting community is somehow escaping trouble. Whereas, in my experience, where I actually feel kinship, togetherness or whatever is way more plastic and troubled; it's kind of bumpy rather than smooth. I went through a more formal art education and had a desire to be in the workshop to produce knowledge differently with other people who had been through academia, and who similarly felt the sterility of that. Together with Candice Lin, I have done a number of workshops. Often, both of us just like feeling like troublemakers; we both want to be a little badly behaved. So if we can somehow get a bunch of people to inhale a load of "toxic fumes" with us before we have our discussion or something, there's just a playful desire to disrupt. Sometimes it can feel really good to be bad.

MM I definitely see it as a provocation because ultimately, what it comes down to is every person has their own way of being. When you put a bunch of people together, then there is a continuous process of negotiation, with conflictual thoughts and conflictual worlds. But that's the beauty of it, of provoking each other, of provoking structures and institutions. I see it as a very necessary process for collective reimagining.

PS I think it really boils down to resistance to the privatization of all social forms, whether that's the privatized family structure, the privatized domestic sphere, the privatization of all our social exchanges. The idea of the workshop is purely about making connections, making meaning outside of a dominantly privatized world.

MM I see molecules, toxicities as also provoking us and also experimenting with us. I think the world is also kind of theorizing; it's also making mistakes and adapting from those mistakes. I think the molecules are doing the same thing with us, with our bodies, with our environments. I think that molecules are morphing us as much as we are morphing them. And it's this constant process of theorizing and experimentation.

PS What could be more potent and more politicizing than realizing that you are nowhere near as stable as you think you are, that you are nowhere near as discreet as you think you are? Discreet in the sense of a singular thing. It's deeply in the realm of the political, which is to say the realm of the unknown.

MM Yes. Being interconnected is a political act, for sure.

Over the last five decades, artist and filmmaker LYN HERSHMAN LEESON has been internationally acclaimed for her art and films. Cited as one of the most influential media artists, Hershman Leeson is widely recognized for her innovative work investigating issues now acknowledged as key to the workings of society: the relationship between humans and technology, identity, surveillance, and the use of media as a tool of empowerment against censorship and political repression. Over the last fifty years, she has made pioneering contributions to the fields of photography, video, film, performance, artificial intelligence, bio art, installation and interactive as well as net-based media art. ZKM | Center for Art and Media Karlsruhe, Germany, mounted the first comprehensive retrospective of her work titled *Civic Radar*. A substantial publication, which Holland Cotter named in *The New York Times* "one of the indispensable art books of 2016." She was featured in the 2022 Venice Biennale where she was awarded a Special Prize.

MARY MAGGIC is a nonbinary artist, researcher and mother working within the fuzzy intersections of body and gender politics and capitalist ecological alienations. Their interdisciplinary projects span amateur science, participatory performance, installation, documentary, and speculative fiction. Since 2015, Maggic has frequently used biohacking as a xeno-feminist methodology and collective practice of care that serves to demystify invisible lines of molecular biopower. Maggic is current member of the online network Hackteria: Open Source Biological Art; the laboratory theater collective Aliens in Green; the Asian feminist collective Mai Ling, as well as contributor to the radical syllabus project Pirate Care and the CyberFeminism Index collections.

STAFF is an artist based in Los Angeles, USA and London, . Staff's work in video, sculpture, and poetry explores e registers of violence that underpin the making of a human bject, interrogating what is at stake in the conditions queer and trans life. Their notable solo presentations clude Serpentine Galleries, UK (2019); MOCA, USA (2017); and isenhale Gallery, UK (2015). They have been part of a number significant group shows such as *British Art Show 8*, touring nues (2016); *Trigger*, New Museum, New York (2017); *Made in .A.*, Hammer Museum (2018); *Bodies of Water*, 13th Shanghai ennial (2021); *Prelude*, Luma Arles, France (2021–2022); and e *Milk of Dreams*, 59th Venice Biennale (2022).

Bart van der Heide

VORWORT

Nach Ansicht der Philosophin Judith Butler schließen sich Solidarität und Gewalt nicht gegenseitig aus. Da Gewalt noch immer durch Selbstverteidigung legitimiert werden kann, gehen beide Hand in Hand, wenn es um Schutz und Erhaltung des Nationalstaats geht. In ihrem Text *Die Macht der Gewaltlosigkeit* (2020) stellt sich Butler die Frage: „Wer ist dieses ‚Selbst', das im Namen der Selbstverteidigung verteidigt wird? Wie wird dieses Selbst von anderen Selbsten abgegrenzt, von der Geschichte, vom Land, von seinen sonstigen definierenden Bezügen? Gehört derjenige, dem Gewalt widerfährt, nicht irgendwie auch zum ‚Selbst', das sich in einem Akt der Gewalt selbst verteidigt?"[1]

In diesem Zusammenhang lenkt Butler die Aufmerksamkeit auf den bekannten feinen Unterschied zwischen Solidarität und Gleichheit. Sie vertritt eine passivistische Position, indem sie erklärt, dass Gewalt nach wie vor legitimiert ist, wenn das erweiterte Selbst eine Erweiterung der eigenen Hautfarbe, Klassenzugehörigkeit

und Fähigkeiten bleibt – und damit all jene ausschließt, die innerhalb dieser Ökonomie durch Unterschiede gekennzeichnet sind. Zwei Jahre später stellt Butlers Hypothese, angesichts der Auswirkungen der COVID-19-Pandemie, eine treffende Analyse mit aktueller Aussagekraft dar. Die Pandemie hat das komplizierte Gleichgewicht zwischen freiem Handel und menschlichen und ökologischen Ressourcen offengelegt. Gleichzeitig musste sich die Weltgemeinschaft unabhängig vom Nationalstaat „selbst verteidigen", da die globale gegenseitige Abhängigkeit absolut war.

Die Solidarität stand im Mittelpunkt des internationalen Wohlergehens und der Prekarität und damit auch die Mitverantwortung des Einzelnen für die Aufrechterhaltung oder Verwerfung der historischen Einheit von Gesundheit, staatlichen Interessen und Weltreich. Der Schutz der Bürger vor Invasionen von außen, insbesondere vor Viren, führte dazu, dass das öffentliche Gesundheitswesen eng mit Ideologien des Kolonialismus und des internationalen Handels verbunden war. [2] Mit der Ausstellung *Kingdom of the Ill* wollen die Kuratierenden Sara Cluggish und Pavel S Pyś in erster Linie die Trennung zwischen diesem Innen und Außen überwinden, das heißt zwischen der Behauptung, gesund zu sein, und dem Selbstbild, nicht krank zu sein. Wie die vorliegende Anthologie unabhängiger kritischer Texte kann auch die Ausstellung der beiden im Museion als eine Neudefinition von Solidarität nach der Lektüre von Susan Sontags richtungsweisendem Essay *Krankheit als Metapher* (1978) interpretiert werden. Sontag attestiert jedem Menschen eine doppelte Staatsbürgerschaft: Entweder lebt er im Königreich der Kranken oder in

dem der Gesunden. Indem sie das Wort „Königreich" im Titel durchstreichen, bieten Cluggish und Pyś eine zeitgemäße Neudeutung an: Kann man angesichts von Burnout, Erschöpfung, einer abnehmenden Unterstützung des öffentlichen Gesundheitswesens und der ungezügelten kapitalistischen Ausbeutung menschlicher und ökologischer Ressourcen noch wirklich „gesund" sein? Auf diese Weise holt *Kingdom of the Ill* die Krankheit aus der Dunkelheit hervor (auch hier ein Verweis auf Sontag) und setzt sich mit ihr als allgemeinem Modell für zivilgesellschaftliches Zusammenleben und gewaltfreie Solidarität auseinander.

 Diese These mag zwar angesichts einer globalen Gesundheitskrise wachsende Zustimmung finden, doch wenn es um den wirtschaftlichen Einfluss des digitalen Kapitalismus und der Globalisierung auf die „Selbstverteidigung" geht, bleiben diese Aspekte eher verschwommen und im Dunkeln. Im Jahr 2016 gründete eine Gruppe unabhängiger Forscher das Precarity Lab, um die Ausbreitung der „Technoprecaricy", der Techno-Prekarität, zu untersuchen. [3] In ihrem gemeinsam verfassten Text *Techno Precarious* (2020) weist die Gruppe darauf hin, dass das Ausmaß der Prekarität zugenommen hat und nun auch die Klasse der kreativen digitalen Produzenten in den „Anreicherungszonen" der Welt umfasst. Das bedeutet, dass mehr Menschen ohne Unterstützung leben, „auf eine deflationäre, ‚grausam optimistische' Art und Weise". [4] Diejenige wirtschaftliche Klasse, auf die dies besonders zutrifft, sind die Freiberufler, die Dienstleistungen ohne jegliche Garantie auf wirtschaftliche Stabilität anbieten. In dem Text findet sich ein entfernter Nachhall von

Sontags oben erwähntem Titel: „Prekarität ist keine Metapher (…). Das Überleben von einem Auftritt zum nächsten kann dich ablenken vom Gedanken an die Möglichkeit, auf eine andere Art zu leben." Die Forschungsgruppe schlägt eine Koalition der einzelnen Bevölkerungsschichten unter der Prämisse vor, die Trennung zwischen Innen und Außen in Bezug auf Gesundheit und Wohlbefinden aufzulösen, da der zunehmende Grad an Angst, Toxizität und psychischen Problemen für diejenigen, die in der Gesellschaft marginalisiert sind, bereits Realität ist.

In diesem Zusammenhang manifestiert sich der Aktivismus in solidarischen Handlungen, zum Beispiel in Form von „gegenseitiger Hilfe", [5] aber vor allem lenkt er die Aufmerksamkeit auf die Scheinheiligkeit, mit der Reichtum und Privilegien trotz dieses wachsenden Bewusstseins im Hinblick auf die Gleichstellung immer noch verteilt werden. Daher erklärt das Precarity Lab: „Was wir von der betroffenen [kreativen] Klasse verlangen, ist, dass sie sich, anstatt sich an die Vorherrschaft zu klammern, um den Schmerz der Prekarität zu betäuben, ihre Kräfte gegen die Motoren des Kapitalismus mobilisiert, was mit der Einsicht beginnt, dass die Prekarität zwar geteilt, aber ungleich verteilt ist." [6]

Diese Auffassung ist eng an die Schriften des kritischen Theoretikers und Dichters Fred Moten angelehnt, der die Meinung vertritt, dass Solidarität belanglos ist, wenn sie nicht zu Gleichheit führt. In einem Gespräch mit dem Kulturtheoretiker Stevphen Shukaitis interpretiert Moten den Bürgerrechtsaktivisten Fred Hampton wie folgt: „Schauen Sie: Die Problematik eines Bündnisses besteht darin, dass ein Bündnis nicht

etwas ist, das entsteht, damit Sie kommen und mir helfen können (…). Die Koalition erwächst aus deiner Erkenntnis, dass unsere Lage beschissen ist. Ich brauche deine Hilfe nicht. Ich will nur, dass du erkennst, dass dieser Scheiß auch dich umbringt, wenn auch viel sanfter, du dummes Arschloch, verstehst du?" [7]

[1] Butler, Judith, *Die Macht der Gewaltlosigkeit*, Berlin (Suhrkamp) 2020, S. 20.

[2] Siehe King, Nicholas B., „Security, Disease, Commerce: Ideologies of Postcolonial Global Health", in: *Social Studies of Science*, 2002, S. 763-789.

[3] Precarity Lab ist eine Initiative des Goldsmiths Institute der University of London in Zusammenarbeit mit dem Institut für Geisteswissenschaften der University of Michigan. Ihre Mitglieder sind: Cass Adair, Ivan Chaar-López, Anna Watkins Fisher, Meryem Kamil, Cindy Lin, Silvia Lindtner, Lisa Nakamura, Cengiz Salman, Kalindi Vora, Jackie Wang und Mckenzie Wark.

BART VAN DER HEIDE ist Kunsthistoriker, Ausstellungsmach und Direktor des Museion Bozen. Dort initiierte er *TECH HUMANITIES*, ein zunächst auf drei Jahre (2021-202 angelegtes, multidisziplinäres Forschungsprojekt m Ausstellungen, Publikationen, Diskussionsveranstaltung und Vermittlungsprogrammen. Im Focus der Ausstellungsrei stehen drängende, existenzielle Fragen des Menschseins Spannungsfeld zwischen Ökologie, Technologie und Wirtscha Bei *TECHNO HUMANITIES* verstärken internationale exter

[4] Precarity Lab (Hrsg.), *Techno Precarious*, London (Goldsmiths Press) 2020, S. 2.

[5] Die Definition von „gegenseitiger Hilfe" durch die Big Door Brigade lautet: Gegenseitige Hilfe ist eine Form der politischen Beteiligung, bei der die Menschen Verantwortung dafür übernehmen, sich umeinander zu kümmern und die politischen Verhältnisse zu verändern, und zwar nicht nur durch symbolische Handlungen oder Druck auf ihre Vertreter in der Regierung, sondern indem sie tatsächlich neue soziale Beziehungen aufbauen, die überlebensfähiger sind. Vgl. online www.bigdoorbrigade.com/what-is-mutual-aid

[6] Precarity Lab (wie Anm. 4), S. 75.

[7] Moten, Fred, „The General Antagonism: An Interview with Stevphen Shukaitis", in: Stefano Harley und Fred Moten (Hrsg.), *The Undercommons: Fugitive Planning & Black Study*, Wivenhoe, New York, Port Watson (Minor Compositions) 2013, S. 140f.

cherteams die Authentizität der behandelten Themen, dem bietet die Reihe jungen Talenten eine Plattform für re Ambitionen. Ein besonderer Aspekt ist das Einbeziehen kaler Initiativen.

e Ausstellung *Kingdom of the Ill* ist das zweite Kapitel ines Langzeitprojekts, das er 2021 mit der Ausstellung *CHNO* (11. September 2021–16. März 2022) lancierte.

Sara Cluggish und Pavel S. Pyś

~~KINGDOM~~ OF THE ILL:
Aktuelle Diskurse über den Zugang in den Künsten

Die vergangenen Jahre seit Ausbruch der COVID-19-Pandemie rückten alle Fragen rund um Gesundheit und Krankheit deutlich in den Vordergrund. Der Ausbruch des neuartigen Coronavirus beeinflusste nicht nur die Debatten über die nationalen, finanziellen, politischen und ideologischen Dimensionen der Gesundheitsversorgung, sondern prägte auch unsere ganz persönlichen Erfahrungen, wie wir Pflege erhalten und leisten, unseren persönlichen Raum durch Abstandswahrung schützen und Entscheidungen darüber treffen, ob wir an der gemeinsamen Nutzung des physischen Raums mit anderen teilhaben wollen oder nicht. Für diejenigen, die sich als krank oder behindert betrachten, ist diese körperliche Isolation und das übersteigerte Bewusstsein für den eigenen Körper typischerweise die Norm, nicht die Ausnahme. Die Schriftstellerin und Künstlerin Johanna Hedva kommentierte diese Veränderung des öffentlichen Bewusstseins mit einem Augenzwinkern: „Ich finde es lustig, dass wir uns im Jahr 2020 alle so verhalten, als sei

Krankheit eine völlig fremde, brandneue Erfahrung (…). Wir verdrängen sie stattdessen in dieses Exil, diese Verbannung (…). Ich bin einfach der Meinung, dass das alles Quatsch ist. Jeder wird krank. Das ist nun mal ein Teil des Lebens."[1] Krankheit ist kein singulärer Seinszustand oder ein Moment in der Zeit, sondern ein Kontinuum. Der Titel unserer Ausstellung – *Kingdom of the Ill* (Königreich der Kranken) – bezieht sich auf die kritische Theorie der amerikanischen Schriftstellerin und politischen Aktivistin Susan Sontag *Krankheit als Metapher* (1978), insbesondere auf deren These, dass jeder von uns eine doppelte Staatsbürgerschaft besitzt: die des Königreichs der Gesunden und die des Königreichs der Kranken, und dass wir uns früher oder später mit beiden identifizieren müssen. Die Vorstellung, dass irgendjemand von uns jemals tatsächlich den idealisierten „gesunden" Zustand der Produktivität erreichen kann, den der Kapitalismus propagiert, ist ein Trugschluss. Indem wir die binäre Trennung zwischen diesen beiden „Reichen" aufheben, weisen wir Sontags Grenzziehung zurück und lenken stattdessen die Aufmerksamkeit auf die Art und Weise, wie Gesundheit im fortgeschrittenen Kapitalismus zu einem unmöglichen Ziel geworden ist. [2] Um es mit den Worten der Ökonomen Raj Patel und Jason W. Moore auszudrücken: „Den Kapitalismus zu bitten, für die Pflege zu zahlen, bedeutet, das Ende des Kapitalismus zu fordern." [3]

Den Anstoß für *Kingdom of the Ill* bildete die Erkenntnis, dass sich Kunstschaffende in den letzten zehn Jahren zunehmend mit ihren eigenen Diagnosen auseinandersetzten, indem sie ihre Lebenserfahrungen öffentlich machten und forderten, dem Diskurs über

Gesundheit und Krankheit auf eine offene und transparente Art und Weise mehr Raum zu geben. Ihrem Beispiel folgend gingen viele Kunstorganisationen allmählich dazu über, Programme zu Themen wie Krankheit und Gesundheit [4] anzubieten und zu untersuchen, wie wir normative Vorstellungen davon definieren, was einen „gesunden" Körper ausmacht. Im Rahmen von Ausstellungen und öffentlichen Programmen wurden Fragen wie die folgenden gestellt: Welche Rolle spielen wir als Konsumentinnen und Konsumenten von herkömmlichen Arzneimitteln und natürlichen Therapien? Inwiefern können sich Umweltzerstörung und -verschmutzung auf unsere Gesundheit auswirken? Welche Fortschritte in Technologie und spekulativer Fiktion veränderten die Vorstellungen von Krankheit und Gesundheit?

In ihrem performativen Vortrag *The Art of Dying or (Palliative Art Making in the Age of Anxiety)* aus dem Jahr 2018 sprach die Filmemacherin Barbara Hammer über diesen Wandel vor dem Hintergrund ihrer eigenen Erfahrungen mit einer fortgeschrittenen Krebserkrankung: „Wir alle – Künstler*innen, Kuratoren*innen, Verwaltungsangestellte und Kunstliebhaber*innen gleichermaßen – weichen einem der wichtigsten Themen aus, mit dem wir uns auseinandersetzen könnten. Ich freue mich, dass es in letzter Zeit einige Organisationen gibt, die gerade jetzt Seminare über Gesundheit, Krankheit, Tod und Sterben planen, und dass Kunstschaffende endlich mit Transparenz an die Öffentlichkeit gehen und die Angst überwinden, sich als krank zu outen." [5] Obwohl das Thema an Sichtbarkeit gewann, wurde gleichzeitig schmerzhaft deutlich, dass Kunstorganisationen nicht

über Infrastruktur oder finanzielle Mittel verfügen, um die Arbeitsweise von Kunstschaffenden zu unterstützen, die sich als chronisch krank oder „Crip" (Krüppel) [6] bezeichnen, so sehr sie vielleicht auch die von diesen geschaffenen Werke zu schätzen wissen. Die Verantwortung liegt oft bei den Künstlerinnen und Künstlern selbst, und deshalb veröffentlichten viele von ihnen ihre persönlichen Zugangsvoraussetzungen und individuellen Bedarfe online, und zwar in Form sogenannter „Access Riders". [7] Diese individuell anpassbaren Dokumente umreißen die Bedürfnisse einer Person mit Behinderung mit dem Ziel, eine „Zugangsintimität" zu schaffen: ein Begriff, der von Mia Mingus, Aktivistin für Behindertengerechtigkeit, definiert wird als „jenes schwer fassbare, schwer beschreibbare Gefühl, wenn jemand anderes deine Zugangsbedarfe ,begreift'". [8] Wenn sie zu Beginn einer Arbeitsbeziehung zur Verfügung gestellt werden, können Access Riders den Künstlerinnen und Künstlern helfen, die Parameter für eine faire Bezahlung, den zeitlichen Rahmen des Projekts, persönliche Betreuungsassistenz, Kinderbetreuung, Lebensmittel- und Diätvorschriften, Anforderungen an Reisen und Unterkunft, Mobilitätsbedürfnisse und die Zugänglichkeit des Veranstaltungsorts oder der Veranstaltung zu definieren und zu gewährleisten. Wichtig ist auch, dass die Kunstschaffenden selbst bestimmen können, wie und gegenüber wem sie ihre Behinderung bzw. Krankheit offenlegen, und dass sie sich davor bewahren können, ihre Zugangsbedarfe mühsam immer wieder aufs Neue mitteilen zu müssen. Durch diese Praxis verlagert sich die Last der Verantwortung vom Kunstschaffenden auf die Institution, wodurch das

Museum sich der Herausforderung stellen muss, über eingefahrene Arbeitsweisen nachzudenken und sich an neue Verfahren anzupassen. Wie so oft nehmen es Künstlerinnen und Künstler selbst in die Hand, diese Aufgabe zeitlich gesehen vor Institutionen vorzubringen: 2019 veröffentlichte die Künstlerin und Autorin Carolyn Lazard das Buch *Accessibility in the Arts: A Promise and a Practice*. Dieses kostenlos erhältliche Toolkit zeigt Wege auf, wie kleine gemeinnützige Kunstvereine die Beziehungen zu Künstlerinnen und Künstlern erleichtern und unterstützen können, indem sie Barrieren und Chancen ansprechen. In ihrem Leitfaden bringt Lazard den Kern des Problems treffend auf den Punkt, indem sie den von Kunstschaffenden geführten, schnell voranschreitenden Diskurs und das langsame Tempo der Institutionen thematisiert: „Häufig besteht ein eklatanter Widerspruch zwischen dem Wunsch einer Institution, marginalisierte Communities zu repräsentieren, und einer völligen Desinvestition in die tatsächlichen Überlebensstrategien dieser Communities." [9]

Park McArthurs *Carried & Held* (ab 2012) ist ein scheinbar simples Kunstwerk: eine Liste, die im Format einem Museumsetikett ähnelt und jede Person auflistet, von der McArthur, die aufgrund einer degenerativen neuromuskulären Erkrankung einen Rollstuhl benutzt, angehoben wurde. Freundschaft, Gemeinschaft, Fürsorgenetzwerke, gegenseitige Hilfe: Diese kollektiven Bestrebungen sind der Kern dessen, was den Diskurs über Krankheit, Behindertenfeindlichkeit und Inklusion in Gang brachte. Die Ausstellungen, öffentlichen Programme, Publikationen und Workshops von Künstlerkollektiven – darunter Canaries, Feminist Healthcare

Research Group, Pirate Care, Power Makes Us Sickness und Sickness Affinity Group – rückten die Problematik der Verweigerung des Zugangs im Zusammenhang mit Krankheit und Behinderung in den Vordergrund und zeigten, wie diese nicht nur an der Schnittstelle von Fähigkeiten, sondern auch von Rasse, Geschlecht, Sexualität und Klasse behandelt wird. Angeregt durch historische Präzedenzfälle – insbesondere Gruppen wie Act Up, Art Workers' Coalition und in jüngerer Zeit W.A.G.E. oder Decolonize This Space –, ist die Arbeit vieler der hier zitierten Kunstschaffenden und Kollektive eng mit Aktivismus verknüpft, mit einer konkreten Forderung nach mehr Transparenz, Gleichberechtigung, Unterstützungsinfrastrukturen sowie systemischen Veränderungen, sowohl innerhalb als auch außerhalb der Welt der Kunst. Mithilfe flexibler Mitgliedschaftsmodelle, die teils als Selbsthilfegruppe, teils als Aktivistennetzwerk und (in einigen Fällen) auch als Kunstkollektiv fungieren können, legten viele Gruppen ihren Schwerpunkt auf öffentlichkeitswirksame Proteste und Boykotte sowie auf das Sammeln von Spendengeldern.

Seit 2017 schuf die Künstlerin Shannon Finnegan zwei Versionen ihrer interaktiven Installation *Anti-Stairs Club Lounge*, die auf die Unzugänglichkeit von architektonischen Orten reagiert: den Wassaic Project Space (ein Artist-in-Residence-Programm) in Maxon Mills (2017–2018) und das von Thomas Heatherwick entworfene „Vessel" in New York. Im Falle des Letzteren protestierte sie zusammen mit einer Reihe von behinderten und nicht behinderten Teilnehmenden gegen das 16-stöckige Bauwerk aus kreisförmigen Treppenstufen und Aussichtsplattformen und forderte eine

permanente „Anti-Stairs Club Lounge" (Clublounge ohne Stufen) mit einem Budget von 150 Millionen Dollar (was dem Gesamtbudget des Luxusbaus entspricht). Diese Gebäude sind inhärent behindertenfeindlich ausgerichtet, genau wie es bei manchen Ausstellungen oder beim Zugang zu Museumsräumen der Fall ist. Künstlerinnen wie Finnegan sind daher ein enorm wichtiges Sprachrohr, wenn es darum geht, aufzuzeigen, wie diese Räume für einen gleichberechtigten Zugang verändert werden müssen.

Im Jahr 2020 schlossen sich mehrere behinderte, chronisch kranke und immungeschwächte Menschen zusammen, um den Crip Fund („Krüppel-Fonds") zu gründen und die gespendeten Mittel an die von der COVID-19-Pandemie betroffenen Communities weiterzuleiten. Gegenseitige Hilfsaktionen wie der Crip Fund (aber auch die Arbeit des Kollektivs Sick in Quarters) machen auf schmerzliche Weise deutlich, dass Künstlerinnen und Künstler angesichts der Unzulänglichkeit staatlicher Gesundheitssysteme und jenes Schreckgespenstes, das als Medizinisch-Industrieller Komplex bekannt ist, zu kollektiven Maßnahmen greifen müssen. Die Künstlerin Cassie Thornton beklagt in *The Hologram* (2020), das eine Vision für eine revolutionäre Gesundheitsversorgung entwirft, welche sich auf virale feministische Peer-to-Peer-Gesundheitsnetzwerke stützt, genau dieses Gefühl des Gefangenseins: „Wir betrachten dies nicht als eine Wahlmöglichkeit, weil es unmöglich scheint, unseren Zugang zu unseren Mitteln zum Überleben in einem vom Finanzsektor dominierten Kapitalismus zu opfern, indem wir nach einer unerforschten Erfahrung von Kollektivität, Fürsorge

und gegenseitiger Unterstützung Ausschau halten und dabei die Vorstellung aufgeben, dass wir erfolgreiche kapitalistische Subjekte werden können." [10]

Diese Bestrebungen finden parallel zu den großen gesellschaftlichen Bewegungen statt – der Rassenfrage, dem Kampf gegen die Verschuldung Studierender, der #MeToo- und der Klimabewegung, den anhaltenden Forderungen nach Rechenschaftspflicht von Unternehmen –, die darauf abzielen, fortwährende Ungerechtigkeiten und Gewalt zu beseitigen, von denen viele auf die Logik des Kapitalismus zurückzuführen sind, der fortgesetzt Profitgier, Spaltung und Verschuldung aufrechterhält. Da so viele dieser Aktivitäten an der Basis passieren, stellt sich die berechtigte Frage: Wann werden wir einen wirklich bedeutenden Wandel erleben? Inwiefern fließen die Diskurse über Gesundheit und Krankheit in die breitere gesellschaftliche Debatte ein? Was die Kultureinrichtungen betrifft: Wird das umherschweifende museale Auge seine kurzfristige Aufmerksamkeit schon bald woanders hinlenken?

Im Februar 2022 wurde bekannt, dass das pharmazeutische Unternehmen Purdue Pharma in Insolvenz gehen werde und eine Zahlung von 6 Milliarden Dollar leisten müsse, um Klagen im Zusammenhang mit der amerikanischen Opioid-Krise beizulegen. Das Unternehmen im Besitz der Milliardärsfamilie Sackler ist für die Herstellung und aggressive Vermarktung von OxyContin verantwortlich: ein stark süchtig machendes Opioid, das Millionen von Patienten verschrieben wird, die lediglich an leichten Beschwerden leiden. Die Künstlerin Nan Goldin und die Aktivitäten von P.A.I.N. (Prescription Addiction Intervention Now) [11] spielten

eine Rolle bei der Sensibilisierung der Öffentlichkeit für die Mitschuld von Purdue Pharma an der Opioid-Krise sowie für die dreisten Bemühungen der Sacklers, ihre beträchtliche philanthropische Unterstützung von Kultureinrichtungen als Mittel zum „Whitewashing", also zur Reinwaschung ihres Rufs und ihres Geldes, zu nutzen. [12]

Zwischen 2018 und 2019 veranstalteten Goldin und P.A.I.N. Proteste und „Die-in"-Demonstrationen (bei denen sich Teilnehmende wie tot auf den Boden legten) in Museen, die Gelder von den Sacklers angenommen hatten: das Guggenheim, die Harvard Art Museums, das Louvre Museum, das Metropolitan Museum, das Smithsonian und das Victoria & Albert Museum. Indem sie diese Orte mit nachgemachten OxyContin-Fläschchen, Rezeptverschreibungen und Bannern mit Slogans wie „Shame on Sacklers" (Schande über die Sacklers) übersäten, rückten Goldin und P.A.I.N. das Thema in das breite gesellschaftliche Bewusstsein. Obwohl es sich zweifellos um einen Sieg vor Gericht handelte, schützte das Urteil letztlich die Sacklers, die, auch weiterhin von jeglicher Haftung entbunden, nach wie vor zu den reichsten Familien der USA gehören. Goldin äußerte sich zu dem Urteil wie folgt: „Es war eine echte Lektion in Sachen Korruption in diesem Land, dieses Gericht dabei zu beobachten, dass Milliardäre über ein anderes Justizsystem verfügen als der Rest von uns, und dass sie tatsächlich ungeschoren davonkommen können." [13]

Bei den Aktivitäten von P.A.I.N. geht es ebenso um die Opioid-Krise wie um die allgemeine Gesundheit und den Zustand der Finanzierungsstrukturen von Kunst. Die Sacklers sind nur ein Glied in einer ganzen

Reihe von Spendenden, deren Reichtum in den letzten Jahren zunehmend ins Visier geriet. Liberate Tate, ein Kunstkollektiv, das sich zum Ziel setzte, „die Kunst vom Öl zu befreien", forderte 2017 mit Erfolg, dass sich das Museum vom international tätigen Mineralölkonzern BP (British Petroleum) trennen sollte, während Proteste von Decolonize This Space dazu beitrugen, dass Warren Kanders – dessen Firma Safariland gegen Migrantinnen und Migranten an der Grenze zwischen den USA und Mexiko eingesetzte Tränengasgranaten herstellt – 2019 aus dem Whitney-Vorstand ausschied. Die zunehmende Auseinandersetzung mit „toxischer Philanthropie" ist symptomatisch für unsere Gegenwart: Das Wohlergehen unserer Museen und im weiteren Sinne auch unserer übergeordneten Institutionen hängt davon ab, dass wir die Übel des Kapitalismus beseitigen und uns stattdessen für Gleichheit, Fairness und Repräsentation einsetzen.

„Folgen Sie dem Geld", heißt es so schön – daher ist es nicht überraschend, dass die am deutlichsten sichtbaren Veränderungen auf der Ebene der Finanzierung stattfinden. Es gibt jedoch noch so viel mehr zu tun, weit über die Gewährleistung der Repräsentanz von Menschen hinaus, die sich als krank oder behindert bezeichnen. Obwohl die COVID-19-Pandemie uns dazu veranlasste, die strikten Grenzen zwischen „gesund" und „krank" als verschwommen, kaum wahrnehmbar oder schlichtweg unwahr zu betrachten, sollten wir uns im Klaren sein, dass der notwendige Wandel viel tiefer gehen muss. Einrichtungen jeder Art – Kunstinstitutionen und viele andere – sind nur in seltensten Fällen flexibel und beweglich. Allerdings ist ein Wandel dringend erforderlich bezüglich der Art und Weise, wie

sie finanziert werden, wer sie mit Personal ausstattet, und welche Zugangsmöglichkeiten sie für die Communities vorsehen, denen sie dienen sollten. Darüber hinaus müssen wir ein neues Vokabular erlernen sowie neue Möglichkeiten der Kommunikation und gegenseitigen Fürsorge – nur so können wir dem Gefühl näher kommen, dass wir, wie Mia Mingus es formulierte, die Zugangsbedarfe der anderen „begreifen".

[1] Ebizie, Nwando (Moderatorin), „The Mediated Body", in: *For All I Care*, Staffel 1, Folge 1, BALTIC Center for Contemporary Art. Online: https://baltic.art/whats-on/podcasts/for-all-i-care

[2] Zur Klarstellung: Wir schlagen keineswegs vor, die Unterscheidung zwischen denjenigen, die sich als körperlich gesund, und denjenigen, die sich als behindert identifizieren, aufzuheben. Wir lehnen vielmehr die von Sontag vorgeschlagene strenge Unterscheidung und ihre Charakterisierung von Krankheit als „Schattenseite des Lebens" bzw. „sehr zur Last fallendes Bürgersein" ab. Wir weisen die Möglichkeit zurück, Gesundheit und Krankheit zu trennen, und lehnen die symbolischen Konnotationen der von ihr zur Beschreibung von Krankheit verwendeten Charakterisierungen ab. Vgl. Sontag, Susan, *Krankheit als Metapher*, München und Wien (Hanser) 1978, S. 3.

[3] Moore, Jason W., und Raj Patel, *A History of the World in Seven Cheap Things: A Guide to Capitalism, Nature, and the Future of the Planet*, Berkeley (University of California Press) 2018, S. 113.

[4] Nur eine kleine Auswahl: *Sick Time, Sleepy Time, Crip Time: Against Capitalism's Temporal Bullying*, EFA Project Space, New York (2017, weitere Stationen: Bemis Center for Contemporary Arts, Omaha, Nebraska, 2018, und Red Bull Arts Detroit, 2019); *I wanna be with you everywhere*, Performance Space New York (2019); *When the Sick Rule the World*, Gebert Stiftung für Kultur, Rapperswil (2020); *CRIP TIME*, Museum für Moderne Kunst, Frankfurt am Main (2021); *Take Care: Art and Medicine*, Kunsthaus Zürich (2022).

[5] Hammer, Barbara, *The Art of Dying or (Palliative Art Making in the Age of Anxiety)*, The Whitney Museum of American Art, New York, 10. Oktober 2018. Online: https://whitney.org/media/39543

[6] Lauryn Youden definiert den Begriff „Crip" in der Broschüre zu ihrer Einzelausstellung *Visionary of Knives* im Jahr 2020 im Künstlerhaus Bethanien, Berlin, wie folgt: „Crip ist ein Begriff, den viele Menschen in der Behindertenforschung und in aktivistischen Gemeinschaften nicht nur in Bezug auf Menschen mit Behinderungen verwenden, sondern auch hinsichtlich der intellektuellen und künstlerischen Kultur, die aus solchen Gemeinschaften hervorgeht. Crip ist eine Abkürzung für das Wort ‚Krüppel', das als Beleidigung für Menschen mit Behinderungen verwendet wurde (und wird), das aber als gruppeninterner Ausdruck für Empowerment und Solidarität wieder aufgegriffen wurde." Carrie Sandahl (2003), eine frühe Befürworterin des gesellschaftlichen und politischen Potenzials von Crip, beschreibt ihn als einen fließenden und sich ständig verändernden „Begriff, der sich nicht nur auf Menschen mit körperlichen Beeinträchtigungen, sondern auch auf solche mit sensorischen oder geistigen Beeinträchtigungen bezieht". Vgl. Kafer, Alison, *Feminist Queer Crip*, Bloomington (Indiana University Press) 2013.

[7] Hedva, Johanna, „Hedva's Disability Access Rider". Tumblr Blog, 22. August 2019. Online: https://sickwomantheory.tumblr.com/post/187188672521/hedvas-disability-access-rider Clements, Leah, Alice Hattrick und Lizzy Rose, Access Docs for Artists, Website, 26. März 2019. Online: https://www.accessdocsforartists.com/

[8] Mingus, Mia, „Access Intimacy: The Missing Link", in: *Leaving Evidence*, 5. Mai 2011. Online: https://leavingevidence.wordpress.com/2011/05/05/access-intimacy-the-missing-link/

[9] Lazard, Carolyn, „Accessibility in the Arts: A Promise and a Practice", in: *Common Field and Recess*, 25. April 2019. Online: https://www.commonfield.org/projects/2879/accessibility-in-the-arts-a-promise-and-a-practice

[10] Thornton, Cassie, *The Hologram: Feminist, Peer-to-Peer Health for a Post-Pandemic Future* (2020), London (Pluto Press) 2020. Online: https://vagabonds.xyz/the-hologram/

[11] Prescription Addiction Intervention Now („Intervention gegen verschreibungspflichtige Suchtmittel jetzt"). Das Akronym P.A.I.N bedeutet englisch „Schmerz".

SARA CLUGGISH ist Mary Hulings Rice Director und Kurator des Perlman Teaching Museum am Carleton College Northfield, Minnesota. Als Kuratorin und Dozentin bewegt s sich an der Schnittstelle von Performance- und Bewegtbil Wissenschaft mit Schwerpunkt Care Studies sowie Gender- u Sexualitätsstudien. Master of Fine Arts (MFA) in Kuratier der Goldsmiths University of London und Bachelor of Fi Arts (BFA) in Fotografie des Maryland Institute College Art, Baltimore. Stationen: Professorin für Kunstgeschich am Minneapolis College of Art and Design, Minneapoli

[12] Dafoe, Taylor, „They Are Going to Stand by Us: Text Messages Between Members of the Sackler Family Show How They Leveraged Their Museum Philanthropy Into Positive PR", in: *Artnet News*, 20. Dezember 2021. Online: https://news.artnet.com/art-world/sackler-family-text-messages-museums-1933901

[13] Nan Goldin, zit. nach Jones, Sara, „It's a Real Lesson in the Corruption of This Country. Anti-Sackler activist Nan Goldin on the Purdue Pharma bankruptcy settlement", in: *New York Magazine*, 1. September 2021. Online: https://nymag.com/intelligencer/2021/09/nan-goldin-on-purdue-pharma-sackler-settlement.html

nesota; Direktorin der FD13 Residency for the Arts, nneapolis und St. Paul, Minnesota; Sammlungsleiterin Elizabeth Redleaf Collection, Minneapolis, Minnesota; atorin der Site Gallery, Sheffield, Großbritannien, und llvertretende Kuratorin bei Nottingham Contemporary, tingham, Großbritannien. Ihre Essays und Kunstkritiken chienen in renommierten Zeitschriften wie *ArtReview*, *tReview Asia*, *Frieze*, *InReview*, *L'Officiel Art Italia* *The Third Rail*.

PAVEL S. PYŚ ist Kurator für Bildende Kunst am Walk
Art Center, Minneapolis, Minnesota. Dort kuratierte
Einzelausstellungen von Daniel Buren, Paul Chan, Michae
Eichwald, Carolyn Lazard und Elizabeth Price sowie «
Gruppenausstellung *The Body Electric*. 2011–2015 Kurat
für Ausstellungen und Displays am Henry Moore Institute
Leeds (Großbritannien), wo er an Einzelausstellungen n
Robert Filliou, Christine Kozlov, Katrina Palmer, Vladir

enberg und Sturtevant und den Gruppenausstellungen *Carol Bove / Carlo Scarpa* und *The Event Sculpture* mitwirkte. 1 Zabludowicz Collection Curatorial Open in London und ratorische Künstlerresidenz der Fondazione Sandretto Rebaudengo in Turin. Publikationen über Künstlerinnen 1 Künstler wie Trisha Baga, Carol Bove, Michael Dean, an Latham, Wilhelm Sasnal, Alina Szapocznikow, Fredrik rslev und Hague Yang.

Lioba Hirsch

~~KINGDOM~~ OF THE ILL –
KÖNIGREICH DER KRANKEN

In ihrem Buch *Experiments in Imagining Otherwise* schreibt Lola Olufemi (2021, S. 32): „Vielleicht ist die Zeit so etwas wie eine mehrgliedrige Spirale: ein starkes und festes Annähern und ein Rückzug, beständig und unnachgiebig. Der Ort, an dem Erinnerung und Wiederholung verschleiert und neu konfiguriert werden." Das spricht mir aus der Seele, denn es erscheint mir in der Tat so, als sei Vergangenheit das Jetzt, und als hätten wir die Zukunft gestern auf dem Weg in die Gegenwart besucht. Die Vorstellung, dass die Zeit linear verlaufe und wir uns stetig auf die Zukunft zu bewegen, galt immer nur für einige von uns und ging auf Kosten anderer. Nichts veranschaulicht dies besser als die Pandemie, die wir gerade durchleben. Nach wie vor. Ich muss darauf bestehen und es wiederholen: Wir leben immer noch in einer, durch eine und trotz einer Pandemie. Während fast vom ersten Tag der Restriktionen und Lockdowns an Rufe nach einer Rückkehr zur Normalität laut wurden, haben sich viele von uns, die sich seit Langem am Rande

der Normalität bewegen – zu krank, zu arm, zu illegal, zu braun, zu schwarz, zu dick, zu behindert –, stets gefragt, ob es sich wirklich lohnt, zu dieser Normalität zurückzukehren. Eine Normalität, die sich schon immer auf strukturelle Ungleichheiten und Ungerechtigkeit stützte. Eine Normalität, die uns die Vorstellung eines Lebens auf der Überholspur weismachte, indem sie andere zurückließ. Es gibt Menschen, für die es aufgrund einer chronischen Krankheit seit Anfang 2020 unsicher ist, überfüllte Bürogebäude, öffentliche Verkehrsmittel oder Einkaufszentren zu betreten. Menschen, die bereits ebenso lange an ihr Zuhause gebunden sind. Menschen mit Behinderungen, denen man lange Zeit versichert hatte, Arbeiten von zu Hause aus sei unmöglich, bis dies plötzlich nicht mehr der Fall war. Wir leben in einer Welt, die auf Ungerechtigkeit und Ungleichheit aufgebaut ist. Nichts macht dies deutlicher als ein Blick in die Gegenwart, der auch ein Blick in die Vergangenheit zu sein scheint und – wie ich zu behaupten wage – in die Zukunft.

Während es in den meisten europäischen Ländern den Anschein hat, als würden sie zunehmend zur „Normalität" zurückkehren, haben die technokratischen Lösungen, auf die sich die Regierungen weltweit überwiegend verließen, um ihre Volkswirtschaft „wieder auf Kurs" zu bringen, einen enormen Preis, sowohl im wörtlichen als auch im übertragenen Sinne.

Im wörtlichen Sinne: Im Jahr 2021 haben Pfizer und Moderna, die beiden Pharmariesen, die hinter den SARS-COV-2-MRNA-Impfstoffen stehen, die Preise pro Impfstoffdosis um ein Viertel bzw. ein Zehntel erhöht, während sie die Lieferverträge mit den europäischen

Ländern neu aushandelten, die sich zusätzliche Vakzinvorräte für Auffrischungsimpfungen sichern wollten (Mancini u. a. 2021). Seit Beginn der Impfstoffzulassungen schwanken die Preise pro Dosis stark, sowohl innerhalb von Ländern mit hohem Einkommen und Wirtschaftsblöcken, wie der EU und den USA, als auch zwischen solchen mit hoher, mittlerer und niedriger Finanzkraft. AstraZeneca, das unter den westlichen Pharmaunternehmen den niedrigsten Preis pro Impfung aufruft, stellte Südafrika im vergangenen Jahr 5,25 Dollar pro Dosis in Rechnung, während die europäischen Länder 3,50 Dollar pro Dosis zahlen mussten (Jimenez 2021). Die Forschung zur Entwicklung von SARS-COV-2-Impfstoffen wurde größtenteils von den Regierungen subventioniert und damit von den Steuerzahlern finanziert, wobei die Pharmaunternehmen enorme Gewinne machen. Laut einem Bericht der People's Vaccine Alliance, eines Zusammenschlusses von Hilfs- und Nichtregierungsorganisationen, zahlte Kolumbien Moderna und Pfizer/BioNTech für 20 Millionen Dosen bis zu 375 Millionen Dollar zu viel, Südafrika wiederum Pfizer/BioNTech wahrscheinlich bis zu 177 Millionen Dollar (Marriott und Maitland 2021).

Im übertragenen Sinne: Während die hohen Kosten für Impfstoffe – und die Gewinnspannen, die hauptsächlich dafür verantwortlich sind – alle Länder der Welt betreffen, besitzen solche mit niedrigem und mittlerem Einkommen eine geringere Kaufkraft und sind damit auch im geringeren Maße fähig, ihre Bevölkerung zu impfen. Sie können keine Vakzine auf Vorrat kaufen wie die europäischen und nordamerikanischen Länder und verfügen in der Regel auch nicht über die Infrastruktur,

um selbst Impfstoffe herzustellen. Und selbst wenn sie es könnten, ist deren Produktion durch Patente geschützt. Letztes Jahr wehrte sich Deutschland zusammen mit anderen EU-Ländern bei der WTO erfolgreich gegen die Forderung nach einer Ausnahmeregelung für COVID-19-Impfstoffe, die es Ländern auf der ganzen Welt erlaubt hätte, diese herzustellen, ohne Pharmaunternehmen für das Patent bezahlen zu müssen (Lopez Gonzalez 2022). Wie es aussieht, wird die Mehrheit der Länder mit geringer Wirtschaftskraft, und damit die meisten afrikanischen Länder, wenn überhaupt, erst ab Anfang 2023 eine flächendeckende Impfstoffversorgung ihrer Bevölkerung erreichen (The Economist Intelligence Unit 2021). Dies hat nicht nur Folgen für die Gesundheit der betroffenen Menschen, Nationen und Regionen, sondern auch für die Fähigkeit der dort lebenden Individuen, in Länder mit hohem Einkommen zu reisen, dort Geschäfte zu tätigen, Freunde oder Verwandte zu besuchen oder eine Ausbildung zu absolvieren. Abgesehen davon, dass Reisen ohne Impfung potenziell riskant ist, führten die EU-Länder zudem Beschränkungen dafür ein, wer dorthin reisen darf, und wie er geimpft sein muss (Council of the European Union 2022). Bis zur Abschaffung aller COVID-Vorschriften im Jahr 2022 gestattete das Vereinigte Königreich nur solchen Besuchern die Einreise, die in einem von der britischen Regierung zugelassenen Land bzw. einer Region geimpft worden waren.

Die Ungleichheiten und Ungerechtigkeiten, die diesen strukturellen und politischen Unterschieden zugrunde liegen, basieren weder auf Zufall, noch sind sie ein Produkt der jüngsten Vergangenheit. Gesundheit – sowohl auf nationaler als auch auf globaler Ebene –

war schon immer höchst politisch und eng mit der auf Ausbeutung und Selbstschutz ausgerichteten Politik der westlichen Länder (sprich: jener mit einer mehrheitlich europäischstämmigen Bevölkerung) verbunden. Die gegenwärtigen Ungleichheiten spielen sich weitgehend entlang der Kluft zwischen Kolonisierenden und Kolonisierten ab. Auch dies ist wiederum kein Zufall. Das globale Gesundheitswesen und seine Vorläufer – die Kolonial- und die Tropenmedizin – waren seit jeher von den Interessen der Regierungen und Bevölkerung einiger weniger ausgewählter Länder geprägt, zum Nachteil der großen Bevölkerungsgruppen, die sie zu beherrschen versuchten, zunächst formell während der Kolonialzeit, später informell nach der Unabhängigkeit.

Wie Randall Packard (2016) darlegte, spielten Anliegen und Interessen der ehemals kolonisierten Bevölkerungen bei Gestaltung und Entscheidungsfindung sowie den politischen Machtspielen des globalen Gesundheitssystems, seiner Strukturen und Institutionen kaum eine Rolle. Historisch gesehen hat dies mehrere Dimensionen. Zum einen war die koloniale Medizin – das System, auf dem die heutige globale Gesundheitspolitik aufbaut – immer darauf ausgerichtet, Gesundheit und Existenzgrundlage der europäischen Bevölkerung zu schützen. Wenn die Kolonialmächte in ihren Kolonien in die Gesundheit investierten, dann waren diese Infrastrukturen für die europäischen Kolonialbeamten, deren Familien und die lokalen Eliten bestimmt und nicht für die große Mehrheit der kolonisierten Bevölkerung. Im Nigeria der 1930er-Jahre beispielsweise, das damals britische Kolonie war, wurden 4.000 Europäer*innen von

zwölf Krankenhäusern versorgt, während für vierzig Millionen Nigerianer*innen nur 52 Hospitäler zur Verfügung standen (Rodney 1981). In gewisser Weise legte der Kolonialismus also, wie der Historiker Walter Rodney argumentiert, den Grundstein für die heutigen Ungleichheiten im Gesundheitswesen und die mangelnde Fähigkeit der einst kolonisierten Länder, mit den ehemaligen Kolonialmächten auf dem internationalen Markt um Impfstoffe zu konkurrieren. Die wirtschaftliche Macht dieser einstigen Kolonialmächte lässt sich nicht von jenem Reichtum trennen, den sie durch Ausbeutung ihrer Kolonien anhäuften (Acemoğlu und Robinson 2017).

Andererseits waren Gesundheitspolitik und Prioritäten darauf ausgerichtet, die europäische Bevölkerung auch gegenüber den Kolonisierten zu schützen. Die meisten Ausgaben der Kolonialregierung betrafen Infektionskrankheiten, die eine Bedrohung für das Leben der europäischen Kolonisierenden darstellen konnten. Später, mit Ausbruch der beiden Weltkriege und umfangreichen Investitionen in die für den Export aufgebauten Rohstoffindustrien, rückte auch die Ernährung verstärkt in den Mittelpunkt der Kolonialmedizin. Damit sollte die Gesundheit der einheimischen Arbeitskräfte erhalten und so zum militärischen und wirtschaftlichen Erfolg der kolonisierenden Länder beigetragen werden. Das Hauptaugenmerk der globalen Gesundheitspolitik auf Infektionskrankheiten hält bis heute an (Global Health 50 50, 2020). Man sollte meinen, diese Tatsache hätte die Welt – und die ehemaligen Kolonien – gut auf die Möglichkeit einer globalen Pandemie vorbereitet müssen. Doch stehen die ehemals kolonisierten Länder, insbesondere in Afrika sowie Zentral- und Südasien, im

Gegenteil hinsichtlich der Vorbereitung auf Epidemien an letzter Stelle (Madhav u. a. 2017).

Historische Ungleichheiten, von denen viele auf den europäischen Kolonialismus zurückgehen, reichen bis in die Zukunft und sind heute für unterschiedliche Phänomene im Gesundheitsbereich verantwortlich. Natürlich ist es einfach, eine Karte dieser globalen gesundheitlichen Ungleichheiten zu erstellen, doch ist es auch wichtig zu erkennen, wie die kolonialen Nachwirkungen das Leben von Menschen afrikanischer, asiatischer und indigener Abstammung in Europa und Amerika prägen, mit anderen Worten: jener, die man als „braun" und „schwarz" rassifiziert. In den USA, Großbritannien und Brasilien starben Schwarze oder Menschen afrikanischer Abstammung mit größerer Wahrscheinlichkeit an einer Coronavirus-Infektion als ihre weißen Altersgenossen, selbst wenn die Statistiken altersbereinigt waren. In den USA war die Wahrscheinlichkeit, an einer Coronavirus-Infektion zu sterben, bei den indigenen Volksgruppen oder den Ureinwohner*innen Alaskas mehr als doppelt so hoch wie bei der weißen Bevölkerung. Schwarze oder Afroamerikaner*innen hatten ein 1,7-mal höheres, hispanische oder Latinx-Einwohner*innen sogar ein 1,8-mal höheres Risiko, an SARS-COV-2 zu sterben (CDC 2022). In Brasilien, das während des transatlantischen Sklavenhandels eine besonders große Zahl versklavter Afrikaner*innen aufgenommen hatte und daher heute über eine beträchtliche schwarze Bevölkerungsgruppe verfügt, lag der Prozentsatz übermäßiger Todesfälle (im Vergleich zum Ausgangswert von 2019) unter der schwarzen Bevölkerung bei 26,3% im Vergleich zu 15,1% bei der weißen (Marinho u. a. 2022).

Im Vereinigten Königreich schließlich berichtete das Office for National Statistics (ONS), dass während der ersten Corona-Welle im Frühjahr/Sommer 2020 die virusbedingte Todesrate bei Menschen aus der schwarz-afrikanischen Bevölkerungsgruppe 3,7-mal höher lag als in der weißen (ONS 2021). In der zweiten und den folgenden Wellen (Delta und Omikron) lag die Todesrate bei Männern aus Bangladesch am höchsten (zwischen 5,0- und 2,7-mal so hoch wie bei weißen britischen Männern; ONS 2022).

Rassismus und strukturelle Ungleichheiten bestimmen nicht nur den unterschiedlichen Zugang zu Impfstoffen und die daraus resultierenden gesundheitlichen Konsequenzen auf globaler Ebene, sondern sie entscheiden auch, wer innerhalb eines Landes überlebt oder stirbt. Rassismus, die große Triebfeder des Kolonialismus, besteht also über die nominelle Unabhängigkeit der ehemaligen Kolonien hinaus fort und strukturiert unser Leben, unsere Arbeit und unser Sterben noch in der Gegenwart. Die Frage, wer es sich leisten konnte, von zu Hause aus zu arbeiten, wer Vertrauen in das medizinische System und die Behörden besaß, weil er nie von ihnen benachteiligt worden war, und wer darauf vertrauen konnte, dass die Regierung sich um ihn kümmern würde, wurde weitgehend nach rassistischen Gesichtspunkten entschieden.

Die Infrastruktur des Gesundheitswesens ist seit Langem eng mit kolonialen Begehrlichkeiten verknüpft und erschwert vielen Menschen den Zugang dazu. Ebenso sind Impfstoffe nicht einfach technokratische Lösungen, als die sie dargestellt werden. Als man Pfizer im Jahr 2020 als eines der Pharmaunternehmen pries,

das die Welt vor der Pandemie retten würde, erinnerten sich einige von uns daran, dass das gleiche Unternehmen einst außergerichtlich gezwungen worden war, eine Entschädigung an mehrere nigerianische Familien zu zahlen, deren Kinder nach einer experimentellen Arzneimittelstudie von Pfizer im Norden Nigerias 1996 starben oder Behinderungen davontrugen (BBC 2011). Die Möglichkeit, die afrikanische Bevölkerung als Forschungslabor zu nutzen, geht ebenfalls zurück bis in die Kolonialzeit. Der Franzose Louis Pasteur zum Beispiel profitierte bei seinen wissenschaftlichen Erkenntnissen vom Zugang zu kolonisierten Bevölkerungsgruppen, die von den damals aufkommenden ethischen Standards weniger geschützt waren als ihre französischen oder europäischen Pendants (Latour 1993). In gleicher Weise richtete der deutsche Mikrobiologe Robert Koch sogenannte „Konzentrationslager" ein, um den Verlauf und die Behandlung von Schlafkrankheit und Tuberkulose im kolonialen Ostafrika zu untersuchen (Schwikowski 2022). Diese Geschichten wiederholen sich also, oder vielleicht ist es zutreffender zu sagen, dass sie nic wirklich aufhörten. Als französische Ärzte Anfang 2020 vorschlugen, experimentelle COVID-19-Medikamente in Afrika zu testen, weil sich die Menschen auf diesem Kontinent nur bedingt an das Tragen von Gesichtsmasken hielten und es an Intensivstationen mangelte (Busari und Wojazer 2020), wirkte es wieder einmal so, als sei die Zeit buchstäblich stehen geblieben.

Oft scheint es, als würden wir zwischen Vergangenheit und Gegenwart feststecken, an diesem sonderbaren Ort, an dem die Zukunft Gestalt annimmt. Wie es aussieht, wird diese Zukunft zumindest in Bezug

auf Gesundheit und Impfstoffgleichheit ganz ähnlich sein wie die Gegenwart, die wiederum der Vergangenheit auf gespenstische Weise gleicht. Während einige von uns, vor allem diejenigen, die weiß und wohlhabend genug sind, die über die richtigen Pässe und die richtigen Beziehungen zur pharmazeutischen und medizinischen Infrastruktur verfügen, ihr Leben weiter führen, aus dieser Pandemie heraus und zurück in die neue Normalität, stecken diejenigen, die zu arm und zu braun sind, deren Heimat und Geschichte zu sehr von den schändlichen Auswirkungen des Kolonialismus geprägt sind, an diesem zyklischen Ort fest, an dem Vergangenheit und Gegenwart aufeinandertreffen. Leider sieht es zunehmend danach aus, als hätte Lola Olufemi (2021) recht: Unsere Erinnerungen werden verschleiert und neu konfiguriert, dabei handelt es sich gar nicht um Erinnerungen, sondern um Einblicke in eine Zukunft, in der wir nicht genug getan haben, um den Schaden der kolonialen Vergangenheit ungeschehen zu machen, und in der wir das Versprechen und die Möglichkeit einer gerechteren und ausgewogeneren Zukunft an uns vorbeiziehen lassen, auf der Überholspur: Ein flüchtiger Blick, und schon ist sie wieder verschwunden. Dies könnte die Welt sein, in der zu leben wir verdammt sind. Eine Welt der technokratischen Verbesserungen – die für die Mehrheit von uns nicht viel verbessert, während sie den Rest von uns in der Illusion belässt, alles sei in Ordnung.

Quellentexte:

Acemoğlu, Daron, und James Robinson, „The Economic Impact of Colonialism", in: *VoxEU.Org* (Blog), 30. Januar 2017. Online: https://voxeu.org/article/economic-impact-colonialism

BBC, „Pfizer: Nigeria Drug Trial Victims Get Compensation", in: *BBC News*, 11. August 2011, Abt. Africa.

Online: https://www.bbc.com/news/world-africa-14493277

Busari, Stephanie, und Barbara Wojazer, „French Doctors' Proposal to Test COVID-19 Treatment in Africa Slammed as ‚Colonial Mentality'", in: CNN, 7. April 2020. Online: https://www.cnn.com/2020/04/07/africa/french-doctors-africa-covid-19-intl/index.html

CDC (Centers for Disease Control and Prevention), „Cases, Data, and Surveillance", 11. Februar 2020. Online: https://www.cdc.gov/coronavirus/2019-ncov/covid-data/investigations-discovery/hospitalization-death-by-race-ethnicity.html

Council of the European Union, „COVID-19: Travel from Third Countries into the EU", 2022.

Global Health 50 50, „Boards for All?", 2020. Online: https://globalhealth5050.org/Jimenez, Darcy, „COVID-19:

LIOBA HIRSCH, Forscherin an der University of Liverpoo beschäftigt sich mit den kolonialen und gegen Schwar gerichteten Implikationen westlicher Biomedizin u globaler Gesundheitswirtschaft. Ihre Forschungsarbe konzentriert sich auf die historische Entwicklung, d heutige Vorgehen und die kolonialen Nachwirkungen britisch Gesundheitsinterventionen in Westafrika. Zudem setzt s sich kritisch mit den Themen Humanitarismus, Medizin u Rassismus auseinander. Bachelor in Politikwissenschaft der Hochschule Sciences Po (Institut d'Études Politiques

Vaccine Pricing Varies Wildly by Country and Company", in: *Pharmaceutical Technology* (Blog),

26. Oktober 2021. Online: https://www.pharmaceutical-technology.com/analysis/covid-19-vaccine-pricing-varies-country-company/

Latour, Bruno, *The Pasteurization of France*, Cambridge, Mass. (Harvard University Press), 1993.

Lopez Gonzalez, Laura, „Why Won't Germany Support a COVID-19 Vaccine Waiver? Anna Cavazzini Answers This and More Ahead of the EU-AU Summit | Heinrich-Böll-Stiftung | Brussels Office – European Union", in: *Heinrich-Böll-Stiftung* (Blog), 16. Februar 2022. Online: https://eu.boell.org/en/2022/02/16/why-wont-germany-support-covid-19-vaccine-waiver-anna-cavazzini-answers-and-more-ahead

Madhav, Nita, Ben Oppenheim, Mark Gallivan, Prime Mulembakani, Edward Rubin und Nathan Wolfe, „Pandemics: Risks, Impacts, and Mitigation", in: Dean T. Jamison, Hellen Gelband, Susan Horton, Prabhat Jha, Ramanan Laxminarayan, Charles N. Mock und Rachel Nugent (Hrsg.), *Disease Control Priorities: Improving Health and Reducing Poverty*,

ris) und Master of Science in Politischer Soziologie der ndon School of Economics. 2014–2015 Arbeit für die GIZ eutsche Gesellschaft für Internationale Zusammenarbeit), e internationale Entwicklungsagentur der deutschen gierung in Sambia. Doktortitel in Geografie und Global alth des University College London. Von November 2019 s Mai 2021 Forschungsstipendiatin am Centre for History Public Health der London School of Hygiene and Tropical dicine (LSHTM), arbeitete sie an einem Projekt zur forschung der kolonialen Vergangenheit der Schule.

3. Ausgabe, Washington, D. C. (The International Bank for Reconstruction and Development/The World Bank), 2017. Online: http://www.ncbi.nlm.nih.gov/books/NBK525302/

Mancini, Donato Paolo, Hannah Kuchler und Mehreen Khan, „Pfizer and Moderna Raise EU COVID Vaccine Prices", in: *Financial Times*, 1. August 2021. Online: https://www.ft.com/content/d415a01e-d065-44a9-bad4-f9235aa04c1a

Marinho, Maria Fatima, Ana Torrens, Renato Teixeira, Luisa Campos Caldeira Brant, Deborah Carvalho Malta, Bruno Ramos Nascimento, Antonio Luiz Pinho Ribeiro u. a., „Racial Disparity in Excess Mortality in Brazil during COVID-19 Times", in: *European Journal of Public Health*, 32, Nr. 1 (1. Februar 2022), S. 24–26. Online: https://doi.org/10.1093/eurpub/ckab097

Marriott, Anne, und Alex Maitland, „The Great Vaccine Robbery", The People's Vaccine Alliance [https://peoplesvaccine.org], 29. Juli 2021.

Olufemi, Lola, *Experiments in Imagining Otherwise*, Maidstone (Hajar Press) 2021.

ONS (Office for National Statistics), „Updating Ethnic Contrasts in Deaths Involving the Coronavirus (COVID-19), England", 7. April 2022. Online: https://www.ons.gov.uk/peoplepopulationandcommunity/birthsdeathsandmarriages/deaths/articles/updatingethniccontrastsindeathsinvolvingthecoronaviruscovid19englandandwales/10january2022to16february2022

ONS (Office for National Statistics), „Updating Ethnic Contrasts in Deaths Involving the Coronavirus (COVID-19), England: 24 January 2020 to 31 March 2021", 26. Mai 2021. Online: https://www.ons.gov.uk/peoplepopulationandcommunity/birthsdeathsandmarriages/deaths/articles/updatingethniccontrastsindeathsinvolvingthecoronaviruscovid19england

andwales/24january2020to31march2021

Packard, Randall M., *A History of Global Health: Interventions into the Lives of Other Peoples*, Baltimore (Johns Hopkins University Press) 2016.

Rodney, Walter, *How Europe Underdeveloped Africa*, Washington, D. C. (Howard University Press), 1981.

Schwikowski, Martina, „Robert Koch's Dubious Legacy in Africa", in: DW.COM, 24. März 2022. Online: https://www.dw.com/en/robert-kochs-dubious-legacy-in-africa/a-61235897

The Economist Intelligence Unit, „Coronavirus Vaccines: Expect Delays", London (The Economist) 2021. Online: https://pages.eiu.com/rs/753-RIQ-438/images/report%20q1-global-forecast-2021.pdf?mkt_tok=NzUzLVJJUS00MzgAAAGEeiPcSJdyPzt81jjNl52s4fUCQGhAhfcpOTmlh7dVJhYm25gwZgU2muUJSxvcPSMB79Of485NxNci9ha5-tDsT6jyFwCiP10-I1o2PsJ6uQl4Cg

Amy Berkowitz

EIN „POST-COVID"-LAGEBERICHT AUS DEM COVID-HOTSPOT KALIFORNIENS

Jetzt, da wir das vermeintliche Ende der Pandemie feiern, während gleichzeitig die Zahl der Erkrankungen und Todesfälle immer weiter ansteigt, muss ich immer wieder an Chelm denken.

Kennen Sie Chelm? Es ist eine fiktive Stadt aus der klassischen jiddischen Literatur, regiert von einem Rat von „Weisen", deren Dummheit Quelle vieler amüsanter Anekdoten ist.

Als Kind besaß ich ein Bilderbuch, in dem verschiedene Geschichten über Chelm gesammelt waren. Hier eine von ihnen, an die ich mich erinnere:

Eines Morgens schneite es in Chelm, sodass die ganze Stadt in eine Decke aus glitzerndem weißem Pulverschnee gehüllt war. Der Schnee war so schön, dass die Weisen sicherstellen wollten, dass er nicht durch die Fußabdrücke der Schülerinnen und Schüler zerstört würde, wenn diese die Schule verließen. Also hielten sie eine Krisensitzung ab, bei der sie einen Plan ausheckten: Die Eltern sollten ihre Kinder nach der Schule abholen und sie nach Hause tragen.

Was hielten die Einwohnerinnen und Einwohner von Chelm von den Fußspuren, die all die Eltern im Schnee hinterließen? Hat irgendjemand sie überhaupt bemerkt, sie zur Kenntnis genommen?

Ich weiß, Chelm ist nur eine humorvolle Anekdote, doch es erscheint mir zugleich wie eine Warnung.

<center>☺</center>

In San Francisco ist COVID nicht weniger stark im Umlauf als während der Delta-Welle, doch jetzt gibt es keine Maskenpflicht mehr, denn es herrscht das Narrativ, dass „COVID vorbei ist".

Problematisch ist allerdings, dass es nicht wirklich vorbei ist. Es ist noch immer gegenwärtig, doch schwieriger zu erkennen. Vor ein paar Monaten noch gab es all diese Orte, an denen man kostenlose PCR-Tests machen lassen konnte. Jetzt sind viele dieser Teststellen verschwunden, sodass die Zahl der Krankheitsfälle nicht mehr erfasst wird. Um eine genauere Schätzung der Verbreitung von COVID zu erhalten, muss man eine langsame und nur schwer navigierbare Website zur Abwasserüberwachung nutzen.

Jetzt, da COVID „vorbei" ist, gewann das Reden über die anhaltende Pandemie den Beigeschmack einer Verschwörungstheorie. Und wenn man an eine Verschwörung glaubt, fühlt man sich selbst verrückt.

<center>☺</center>

Während der Pandemie war ich vorsichtiger als die meisten meiner Freunde. Diese Vorsicht hängt mit

meiner chronischen Krankheit zusammen, doch nicht so, wie Sie vielleicht denken. Soweit ich weiß, habe ich kein geschwächtes Immunsystem. Das heißt, es ist nicht wahrscheinlich, dass ich durch COVID ernsthafter krank werde als jemand, der keine Fibromyalgie hat. Doch ich weiß, wie es ist, an einer chronischen Krankheit zu leiden. Ich lebe bereits mit Symptomen wie Brain Fog (Konzentrations- und Fokussierungsschwierigkeiten) und Fatigue (Müdigkeit, Erschöpfung) und kann mir vorstellen, wie schwer es wäre, durch Long COVID mit einer weiteren chronischen Erkrankung konfrontiert zu sein – zusätzlich zu der, die ich schon habe.

Allerdings verstehen Menschen, die nicht davon betroffen sind, chronische Krankheiten nicht. Die meisten betrachten Krankheit als etwas, das ein Ende hat – Karten mit Genesungswünschen erfüllen ihren Zweck, das Fieber sinkt, der Husten hört auf, die Operation ist erfolgreich, und schließlich ist die Krankheit überstanden.

Daher ist die Vorstellung des Krankheitsbilds Long COVID für die meisten schwer begreifbar. Das heißt, wenn sie sich dessen überhaupt bewusst sind.

☺

Jemand aus meinem Freundeskreis erkrankte gleich zu Beginn der Pandemie an Long COVID. Daher war für mich völlig klar, dass dies eine reale Sache ist, die Menschen passiert. Doch wenn man bedenkt, dass 10 bis 30% all derer, die an COVID erkranken, von dieser Krankheit betroffen sind, ist es wirklich verwunderlich, wie wenig darüber in den Medien berichtet wird.

Jedes Mal, wenn ich meine Mutter auf Long COVID anspreche, sagt sie: „Ich glaube dir ja, aber in den Nachrichten höre ich so gut wie nie etwas davon."

☺

Letzte Woche erhielt ich einen Link zum Transkript eines National-Public-Radio-Beitrags zum Thema „Die Bay Area ist Kaliforniens COVID-Hotspot, jetzt, da die Zahl der Krankheitsfälle wieder steigt". Darin hieß es, dass sich die Zahl der Fälle in den letzten Wochen mehr als verdoppelt habe, doch die befragten Expertinnen und Experten schienen merkwürdig unbesorgt zu sein.

Dr. Maria Raven, Leiterin der Notfallmedizin an der University of California San Francisco (UCSF), sprach folgenden Ratschlag aus: „Sie können Ihr normales Leben weiterführen. Sie haben das Richtige getan. Sie haben sich impfen lassen. Also gehen Sie aus. Gehen Sie zum Essen aus. Leben Sie einfach weiter."

☺

Ich habe die Rede des Immunologen Dr. Anthony Fauci, Berater des US-Präsidenten in Fragen der Gesundheitspolitik, über das Ende der Pandemie nicht gesehen, doch ich hörte davon von meiner Mutter. „Er sagte, sie sei vorbei, doch er betonte, er selbst werde weiterhin Vorsichtsmaßnahmen ergreifen, weil er ein Hochrisikopatient sei."

„Ich frage mich, ob jemand außerhalb des Bildausschnitts eine Waffe auf ihn gerichtet hatte."

„Wie bitte?" Es war ein windiger Tag und unsere Verbindung schlecht. Doch mein Scherz schien mir zu düster, um ihn zu wiederholen.

„Egal."

Was ich noch erwähnen möchte, ist, dass ich schwanger bin. Davon habe ich noch gar nicht geschrieben, doch hier erscheint es mir von Bedeutung. Ein Grund dafür ist, dass ich dadurch einem wesentlich höheren Risiko ausgesetzt bin, ernsthaft zu erkranken oder sogar an COVID zu sterben.

Die ersten Bewegungen meines Babys spürte ich am Muttertag. Wie süß von ihr, dass sie bis dahin gewartet hat. Natürlich ist das ein Zufall, aber trotzdem.

Die Firma meines Mannes verlangt von allen Mitarbeiterinnen und Mitarbeitern, jetzt ins Büro zurückzukehren, nachdem sie zwei Jahre lang alle von zu Hause aus arbeiten konnten. Es handelt sich um ein Technologieunternehmen, das keinerlei Vorteile davon hat, wenn sich alle Angestellten vor Ort im Büro aufhalten, abgesehen von der Vorstellung, spontane Gespräche auf dem Flur könnten revolutionäre Ideen hervorbringen, die die Zukunft des Unternehmens verändern würden und so weiter und so fort.

Ich erinnere mich an einen Tweet, in dem es hieß: Der einzige Grund, warum CEOS möchten, dass ihre Angestellten ins Büro zurückkehren, ist, dass sie sich umschauen und feststellen können: „Ah, seht nur all die Leute, die unter mir arbeiten."

Mein Mann ist bisher nicht ins Büro zurückgekehrt. Wir warten noch auf eine Rückmeldung, ob Kulanz unter speziellen Umständen möglich ist oder nicht.

Was sollen wir tun, wenn sie sich weigern, unserem Antrag auf Homeoffice aufgrund meiner Schwangerschaft stattzugeben?

Vielleicht könnten wir ein Entgegenkommen aufgrund der Angstzustände meines Mannes beantragen, ein Sachverhalt, der durch das ADA-Gesetz (Americans with Disabilities Act) zur Gleichstellung von Menschen mit Behinderungen garantiert ist. Wir könnten erklären, dass seine Angst schlimmer ist als sonst, weil er befürchtet, sich im Büro mit COVID anzustecken und es an seine Frau weiterzugeben, was wiederum dazu führen könnte, dass diese sehr krank wird oder stirbt und es zu Schwangerschaftskomplikationen bis hin zu einer Totgeburt kommen könnte.

Ich habe das Glück, von zu Hause aus arbeiten zu können – als freiberufliche Autorin war ich schon vor der Pandemie im Homeoffice tätig. Viele chronisch kranke Menschen, Schwangere und chronisch kranke Schwangere genießen allerdings nicht diesen Luxus.

Ich habe in einer Facebook-Gruppe für chronisch Kranke gepostet, wie surreal und befremdlich es ist, wenn meine Freundinnen und Freunde Bilder von überfüllten Punk-Konzerten teilen, auf denen weit und breit keine Maske zu sehen ist. Jemand hat dies

kommentiert und festgestellt: „Nun, ich arbeite im Sicherheitsdienst einer Konzert-Location, und niemand trägt dort eine Maske. Obwohl ich selbst dies tat, habe ich mich mit COVID angesteckt, und ich habe Angst, wieder zur Arbeit zu gehen."

☻

Existiert irgendeine Fallzahl chronischer Erkrankungen, die unsere Gesellschaft dazu bringen würde, diese ernst zu nehmen?

COVID erweist sich als ein Phänomen, das zu einem massenhaften Anstieg an gesundheitlichen Einschränkungen führt. In nur einem Jahr wurden 1,2 Millionen Menschen durch Long COVID massiv behindert. Was wäre, wenn alle, die davon betroffen sind, dazu übergingen, sich von dieser Einschränkung radikalisieren zu lassen?

☻

Eine Freundin aus Minneapolis erzählte mir, dass man dort nacheinander örtliche Kulturveranstaltende kontaktiert und sie bittet, ihr COVID-Protokoll darzulegen. Ich denke, das ist eine gute Sache – die Veranstaltungsorte sollten wissen, dass COVID-Richtlinien die Zugangsmöglichkeiten definieren: Wenn Masken optional sind, können chronisch kranke Menschen nicht dorthin kommen.

Ich frage meine Freundin, wie es läuft, und sie antwortet: „Der sehr vage Silberstreif am Horizont bedeutet, dass es einfacher ist, zu wissen, wem man

vertrauen kann. Allerdings … sind das nicht allzu viele Leute."

☺

Ich erinnere mich, dass sich zu Beginn der Pandemie alle auf die Maxime einigten: MEINE MASKE SCHÜTZT DICH und DEINE MASKE SCHÜTZT MICH. Die Masken funktionieren noch immer auf dieselbe Weise, nur dass wir uns jetzt nicht mehr darum kümmern sollen, uns gegenseitig zu schützen.

David Leonhardt, Kolumnist der *New York Times*, behauptet, unsere Sorge um das Wohlergehen der anderen sei völlig fehlgeleitet. In einem Interview mit dem *The-Daily*-Podcast seiner Zeitung forderte er auf dem Höhepunkt der Omikron-Welle die Zuhörer auf, zu ihrem „normalen" Leben zurückzukehren. Zwar erwähnte er kurz das Risiko, das COVID für immungeschwächte und ältere Menschen darstellt, tat dies aber schnell wieder ab, wobei er unterschlug, dass kleine Kinder nicht geimpft werden können, und Long COVID ignorierte:

„Ich weiß, dass viele geboosterte Menschen sagen werden: Ich mache mir keine Sorgen um mich. Ich mache mir Sorgen um die Ansteckung anderer. Und das zeigt eine bewundernswerte Fürsorge für die Mitmenschen. Man darf jedoch nicht vergessen, dass diese auch die Möglichkeit hatten, sich impfen zu lassen. Und die Daten deuten darauf hin, dass Omikron bei Geimpften ähnlich verläuft wie andere häufige Atemwegserkrankungen … Allerdings kann es für ältere oder immungeschwächte Menschen sehr schlimm werden. Es stellt sich also die Frage:

Wenn COVID anfängt, wie ein gewöhnliches Atemwegs-
virus auszusehen, ist es dann vernünftig, dass wir … unser
Leben auf so gravierende und folgenschwere Weise zum
Erliegen bringen?"

Das ist Eugenik, getarnt als gesunder Menschen-
verstand.

Und aus dieser Quelle erhalten Leute wie meine
Mutter ihre Nachrichten.

☺

Ein Gedanke, der mir ständig durch den Kopf geht: Wenn
sie doch nur einer Person aus meinem chronisch kran-
ken Freundeskreis die Leitung der COVID-Maßnahmen
des Landes anvertrauen würden, würde alles viel besser
laufen. Wenn sie einfach ein halbwegs vernünftiges Kind
dazu bestimmen könnten. Selbst wenn sie meine Katze
mit der Leitung der COVID-Bekämpfung betrauen wür-
den, ginge alles viel besser.

Oder vielleicht doch lieber nicht meine Katze –
sie ist so glücklich, dass wir beide gemeinsam im
Homeoffice sind.

☺

Während der Pandemie nahm ich an einem Sportkurs
in der Gruppe teil. Ich war die Einzige, die dabei eine
Maske trug, und die Kursleitung fragte immer wieder,
ob es nicht mühsam sei, mit der Maske zu atmen?
Ob es nicht angenehmer sei, wenn ich sie abnähme?
Glücklicherweise begann das Fitnessstudio Online-
kurse anzubieten, als sich die Krankheitsfälle häuften.

Sobald jedoch wieder Veranstaltungen mit persönlicher Anwesenheit möglich wurden, strich man sie wieder. Seitdem bin ich nicht mehr dort gewesen.

Als ich neulich vorbeikam, entdeckte ich eine neue Anzeige auf der Reklametafel vor dem Studio: „Demaskiere dein Potenzial – lass dich nicht niederdrücken von der Angst."

<center>☺</center>

Es ist frustrierend, wie oft Leute wie die Fitnessstudio-Betreibenden oder David Leonhardt das Problem der „Angst" mit dem der anhaltenden Pandemie verwechseln, auf die Vorsicht eine rationale Antwort bietet.

Als ob das Problem meines Mannes seine Angst wäre.

In der 8. Klasse mussten wir eine Liste mit logischen Irrtümern auswendig lernen. Ich bin mir nicht sicher, um welchen von ihnen es sich hierbei handelt. Vielleicht ist es ein „Ablenkungsmanöver"?

Wie kommt es, dass andere Leute diesen plumpen rhetorischen Trick nicht als Trugschluss erkennen?

Ich vermute, weil sie unbedingt glauben wollen, dass die Pandemie vorbei ist.

<center>☺</center>

Meine Freundin, die letztes Jahr ein Baby bekam, schickte mir eine Nachricht mit Ratschlägen: Hier ist die Milchpumpe, die ich benutzt habe, hier eine Checkliste für die Registrierung, hier eine Facebook-Gruppe, in der wohlhabende Mütter ihre teuren Babyartikel verschenken.

Gestern Abend fragte sie mich, ob ich mir schon Programme von Kitas angeschaut hätte. Nein, das habe ich nicht.

Mein Baby ist noch nicht einmal geboren, und ich mache mir jetzt schon Sorgen, dass es sich in der Kita mit COVID anstecken könnte.

<p style="text-align:center">☺</p>

Die Reaktion unseres Landes auf COVID ist zwar erschreckend, doch sie kommt mir auf deprimierende Weise bekannt vor: Denn sie erinnert mich an unsere Reaktion auf den Klimawandel.

Anstatt das Problem anzugehen, beschließen wir, dass genau dieses Handeln unmöglich sei, denn es würde sich negativ auf die Wirtschaft auswirken. Anstatt die Menschen vor Schaden zu bewahren, erfinden wir ein Narrativ, dass dieser Schaden nicht real sei.

<p style="text-align:center">☺</p>

Ich habe meiner besten Freundin aus der High School noch nicht erzählt, dass ich schwanger bin. Als ich ihr vor Jahren mitteilte, dass ich über ein Kind nachdenke, erklärte sie, sie verstehe nicht, wie man das tun könne, angesichts des Klimawandels und allem anderen.

Ich erinnere mich, dass sie vor ein paar Jahren ihre Weltanschauung so beschrieb: „Die Welt ist nur ein Stück Scheiße, das in der Kloschüssel herumwirbelt."

Okay, ich habe es verstanden. Der Planet ist im Arsch. Es gibt viel Leid und Schmerz hier auf der

Erde. Die Menschen tun sich und der Welt, in der sie leben, schreckliche Dinge an.

Doch diese beschissene Welt ist die einzige, die ich kenne, und ich habe in all dem Herumgewirbelten Schönheit gefunden – und Liebe.

<center>☺</center>

Bevor ich das Geschlecht meines Babys erfuhr, erstellte ich Listen mit Jungen- und Mädchennamen.

Einer meiner Lieblingsnamen für Jungen war Noah. Mir gefiel, dass er ein „No" (Nein) enthält und nicht zu männlich wirkt. Doch dann stellte ich fest, dass es der zweitbeliebteste Jungenname des Jahres 2022 ist.

Oh Gott, wurde mir klar. Natürlich will jede*r, dass ihr/sein Sohn Noah heißt. Dass er der Held mit der Arche ist, derjenige, der uns von all unseren Missetaten befreit, uns vor der Flut rettet und all den Schaden repariert, den wir angerichtet haben.

<center>☺</center>

Meine Freundin, die letztes Jahr ein Baby bekam, zieht einen Regenschutz über den Kinderwagen, bevor sie in einen Zug einsteigt, und scherzt: „Das ist unsere kleine COVID-Blase."

Und da ist sie, die Antwort auf die Frage, die mir im Kopf herumschwirrt, seit ich erfuhr, dass ich schwanger bin: Wie kann ich mein Baby vor COVID (und, Sie wissen schon, vor allem anderen) schützen, wenn unsere eigenen weisen Männer, von einem perversen

kapitalistischen Todestrieb besessen, sich auch weiterhin in Fantasien ergehen, anstatt zu handeln?

Ich werde tun, was ich kann, und ich hoffe, dass es ausreicht.

AMY BERKOWITZ ist Autorin der Erzählung *Tender Poi* (2. Aufl. New York, Nightboat Books, 2019). Ihre Tex und „Gespräche" erschienen in Magazinen wie *Bitch*, *Believer*, *BOMB* und *Jewish Currents*. 2016 Mitorganisator des Sick Fest in Oakland und 2017–2020 beteiligt an c

rdination der Writing Residency bei Alley Cat Books.
ihrer Arbeit erhielt sie Unterstützung durch das Anderson
ter, This Will Take Time, Small Press Traffic und das
mel Harding Nelson Center for the Arts. Berkowitz lebt
San Francisco, wo sie gerade an einem Roman arbeitet.

DE050

Artur Olesch

IN DEN (GUTEN) HÄNDEN DER TECHNOLOGIE

Die Menschheit bewegt sich zu auf eine völlig neue Gesundheitsfürsorge, gekennzeichnet durch virtuelle Zugänglichkeit und KI-gesteuerte Perfektion anstelle von menschlicher Berührung und persönlicher Interaktion. „Medizin to-go" ist direkt über das Smartphone verfügbar, überall und zu jeder Zeit. Demokratisierung durch Algorithmen anstelle eines paternalistischen Modells, das von Ärztinnen und Ärzten beherrscht wird. Ganz nach dem Motto: Personalisierung statt Einheitsversorgung. Aber auch: vollständige Kontrolle über die Gesundheit, statt unseren Körper und unsere Stimmungslage dem Schicksal zu überlassen. Wie antike Idole oder Götter verspricht die Technologie eine bessere Gesundheit und ein längeres Leben. Ewige Träume, für die wir bereit sind, alles zu tun.

ARCHIVE
Umgeben von Spitzentechnologie

Die COVID-19-Pandemie fegte wie ein Sturm über den Globus, der jeden gleichermaßen betraf, den größten

Tribut jedoch von jenen Ländern forderte, die den egoistischen Kampf um Beatmungsgeräte, die Sauerstoff in die Atemwege der Patienten pumpen, oder um Impfstoffe, die die Sterblichkeit verringern, verloren hatten. Es war eine Zeit der Lockdowns und der Isolation, der Beerdigungen ohne Abschiednehmen, von täglichen Updates der COVID-19-Statistiken, der Masken und des Homeoffice. Allerdings markierten die Jahre 2020 bis 2022 unbemerkt zugleich den Beginn der Ära einer Do-It-Yourself-Gesundheitsfürsorge (DIY).

Auf den ersten Blick ist dies nichts Neues: Bereits in den 1990er-Jahren hielten Innovationen Einzug in die Medizin. Elektronische Krankenakten und E-Rezepte ersetz(t)en nach und nach Dokumente auf Papier. Die Telemedizin ermöglichte den Zugang zu gesundheitsbezogenen Dienstleistungen außerhalb der Arztpraxis – man benötigt dazu nur WLAN sowie Computer oder Smartphone.

Diese Entwicklung bedeutet aber auch unbegrenzten Zugang zu medizinischem Wissen, das jahrhundertelang Ärztinnen und Ärzten vorbehalten war. Jeden Tag werden bei Google eine Milliarde gesundheitsbezogene Suchanfragen eingegeben. Der „beliebteste Arzt der Welt", der Tag und Nacht erreichbar ist, beantwortet 70.000 Fragen pro Minute zu Hautausschlägen, den besten Medikamenten, Nierensteinen oder natürlichen Heilmitteln gegen Grippesymptome. KI-gesteuerte Suchergebnisse wecken Hoffnungen oder Ängste, beeinflussen Entscheidungen und Leben von Milliarden Menschen.

In diesem unendlich weiten Universum der Gesundheitstechnologien gibt es über 500.000 Handy-

Apps in den App-Stores. Sie unterstützen bei der Gewichtsabnahme oder in Bezug auf mentales Wohlbefinden und helfen Menschen mit chronischen Krankheiten. In einigen Ländern können Apps und Spiele sogar von Ärztinnen und Ärzten verschrieben werden, genau wie Medikamente. Das Schlucken einer Pille wurde also durch das Öffnen einer App samt Befolgen ihrer Anweisungen ergänzt. Wearables (Computertechnologien, die man am Körper trägt) und Smartwatches überwachen rund um die Uhr die Biomarker – als Fingerabdrücke unserer Gesundheit.

Unter der Oberfläche all dieser bahnbrechenden Innovationen verbirgt sich jedoch ein weitaus komplexeres Narrativ. Das Gesundheitswesen ist nicht länger ein Ort, den man aufsucht. Es wurde zu einer Dienstleistung, die sich an Sie wendet. Wenn nicht sogar zu einem Service, den Sie selbst kreieren. Dies ist weit mehr als ein von der Technologie vorangetriebener Wandel – es bedeutet eine grundlegende gesellschaftliche Transformation.

ARCHETYPEN
Verloren angesichts der Bedeutung von
Krankheit und der Komplexität des Lebens

Mit Aufkommen der neuen technologiegestützten Gesundheitsfürsorge wird die Rolle der Ärztin und des Arztes als allwissendes Orakel zunehmend aufgeweicht. Patientinnen und Patienten können mithilfe von Symptom-Prüfprogrammen, die auf Algorithmen künstlicher Intelligenz basieren, die Symptome jeder der rund 30.000 in der medizinischen Fachliteratur

beschriebenen Krankheiten erkennen, eine Selbstdiagnose stellen. Eine Ärztin oder ein Arzt mit jahrzehntelanger Erfahrung hingegen kennt vielleicht höchstens 500 davon, da ihre/seine Erfahrung begrenzt ist durch die Zahl der Patientinnen und Patienten, die sie/er für gewöhnlich behandelt.

Während die medizinischen Geräte immer besser werden, werden Ärztinnen und Ärzte von einer steigenden Zahl von Patientinnen und Patienten, Stress und Verantwortung buchstäblich erschlagen. Wem würden wir also eher unsere Gesundheit anvertrauen? Müden menschlichen Ärztinnen oder Ärzten, die nach mehreren Stunden Dienst zu Fehlern neigen, oder einer perfekten Maschine, die frei von menschlichen Schwächen ist? Bislang wurde die Medizin gleichermaßen als Kunst wie als Wissenschaft betrachtet. Mit fortschreitender Digitalisierung jedoch wird die Wissenschaft zur Kunst.

Nun könnte man vielleicht einwerfen, dass Technologie Ärztinnen und Ärzte nie ersetzen kann. Denn ganz offensichtlich ist Medizin mehr als nur eine Pille. Es geht darum, Patientinnen und Patienten zu verstehen, Einfühlungsvermögen zu zeigen und sie in jenen schwierigen Momenten zu unterstützen, in denen sie etwa von einer unheilbaren Krankheit erfahren und einem langsamen, unausweichlichen Tod entgegensehen. Diese letzte Bastion der Ärztinnen und Ärzte gegenüber dem allwissenden Computer ist lediglich eine Bestätigung für die Zerbrechlichkeit des Menschen, für die emotionale Sehnsucht, von einem anderen Menschen verstanden zu werden, aber auch für die Angst, einsam und hilflos zu sein. Allerdings können Maschinen auch unterstützend wirken.

Der Glaube an die einzigartige Rolle medizinischer Fachkräfte, die während der COVID-19-Pandemie doch nur wenige Monate lang Beifall für ihren heroischen Einsatz ernten konnten, berücksichtigt nicht die langsamen und radikalen, aber durchweg herzlosen Fortschritte der Technologien. Das Gesundheitswesen der Zukunft wird nicht Ergebnis eines linearen Wachstumsmodells sein, ebenso wenig wie das Auto eine bessere Version des Pferdes ist.

Sie werden dies schon bald erleben, wenn ein Roboter Sie besser versteht als Ihre beste Freundin oder Ihr bester Freund, wenn er, jede noch so kleine Geste und Mimik mittels Algorithmen des maschinellen Lernens zur Gesichtserkennung interpretierend, in der Lage ist, ein Gespräch mit höchster Kunstfertigkeit zu führen und darin auf Ihre verborgenen Fantasien und Gefühle einzugehen. Das alles ist technischen Daten zu verdanken – jenen scharfsinnigen Beobachtern, die alles mitbekommen, was um uns herum vor sich geht.

Man könnte hier entgegnen, dass Roboter – menschlich aussehende Gebilde aus Metall und Kunststoff mit Prozessoren – kein Vertrauen erwecken können. Doch die Sache sieht ganz anders aus, wenn (in einer Welt, in der soziale Bindungen erodiert sind) ein bionischer Mensch, ausgestattet mit künstlicher emotionaler Intelligenz, in der Lage ist, mit einer warmherzigen Stimme zu sprechen, die menschliches Verhalten spiegelt. Empathie kann man simulieren. Gefühle programmieren. Bewusstsein vortäuschen. Menschen sprechen bereits mit primitiven Computern, wenn sie zu langsam sind, oder sagen intelligenten Staubsaugern, wo genau sie putzen sollen. Es spielt

dabei keine Rolle, wenn die Maschinen noch nicht zuhören. Roboterärztinnen oder -ärzte werden sich zu neuen synthetischen Wesen entwickeln, gesteuert von Algorithmen, die menschliches Leben in maschinelles Verhalten übersetzen. Das ist kein Scherz – es ist ein neues Phänomen.

QUARKS
Die wichtigsten Nuancen des Überlebens

Bei all den dystopischen und utopischen Visionen, beherrscht von superintelligenten Algorithmen, welche große Datenmengen analysieren, die von allgegenwärtigen Sensoren gesammelt werden, bei all den ultraschnellen Quantencomputern, die neue wissenschaftliche Entdeckungen machen, bei all den Roboterkrankenpflegerinnen und -pflegern mit weißen, mechanischen Körpern – wird ein Mensch, der krank ist, da eine helfende Hand finden? Ein menschliches Wesen, das aus Körper und Seele besteht, ein hoch entwickeltes „Ich", das rationale Entscheidungen auf Grundlage von Wissen trifft, das allerdings auch von Gefühlen und Emotionen zerrissen wird, die sich im Laufe einer Jahrtausende währenden Evolution formten. Mit einer unbändigen Angst vor existenzieller Bedrohung durch Krankheit, die jede Art von Medizin – ob konventionell oder unkonventionell – zu beseitigen bzw. zu verringern versucht.

Nicht anders verhält es sich in der neuen, besseren Welt moderner Medizin, die sich eine neue Form der Hoffnung auf die Fahnen schrieb, entstanden aus der Faszination für die Technologie und instinktiver Panik vor dem Unbekannten, die in den Genen

verankert ist – Verzweiflung, Bedenken, Angst und Furcht sowie der Sorge, krank zu werden.

COVID-19, die erste Pandemie des digitalen Zeitalters, geriet plötzlich zu einem globalen Labor für datengestützte und virtuelle Gesundheitsversorgung. 102 Jahre nach der letzten großen Spanischen Grippe-Epidemie sind die Menschen nicht mehr so anfällig, da ihnen ein breites Spektrum von Medizin- und Labortechnologien, moderne Krankenhäuser und fortschrittliche Medikamente zur Verfügung stehen. Und doch werden sie immer noch von Selbsterhaltungs-instinkten geleitet, wenn sie allen Fakten und Zahlen zum Trotz in Massen in die Läden stürmen, um sich mit Lebensmitteln zu versorgen, oder sich entgegen eigenen Überzeugungen schützen, indem sie in Ver-schwörungstheorien eine einfache Erklärung für un-begreifliche Phänomene suchen.

Dieser frontale Zusammenprall zwischen ratio-naler Technologie und irrationaler menschlicher Natur beschleunigte einerseits den wissenschaftlichen Fort-schritt, befeuerte jedoch auch Anti-Impf-Bewegungen, das schwindende Vertrauen in die Institutionen des öffentlichen Gesundheitswesens und eine zunehmende gesellschaftliche Polarisierung. Die einen feierten die Entwicklung der revolutionären mRNA-Impfstoffe als Triumph der Biowissenschaften über das Virus und vielversprechenden Ausweg aus der Pandemie, wäh-rend andere esoterischen Verschwörungstheorien einer COVID-19-Diktatur verfielen, von mit den Impfstof-fen injizierten Chips oder einem von Bill Gates und führenden Politikern der Welt gelenkten Komplott von Illuminaten.

Paradoxerweise sehen wir uns trotz der fantastischen Errungenschaften der Biowissenschaften als Gesellschaft mit einer Krise des rationalen Denkens konfrontiert. Trotz eines in der Geschichte der Menschheit zuvor nie möglichen Zugangs zu Wissen wurden die Sozialen Medien zum Nährboden für Fake News. Dabei handelt es sich nicht nur um harmlose Hirngespinste einer Minderheit. Desinformationen untergraben die Autorität wissenschaftlicher Experten und Institutionen und brachten Menschen dazu, Gesundheitsempfehlungen zu ignorieren, was sogar zu Todesfällen führte. Solche Falschmeldungen werden häufig von Bots erzeugt, automatisierten Computerprogrammen, die darauf programmiert sind, Gesellschaften und Wahlen zu beeinflussen. Infodemie, die gewaltige, oft widersprüchliche Informationsflut als digitale Krankheit des 21. Jahrhunderts, entwickelt sich zu einer der größten globalen Bedrohungen.

Unterdessen beschleunigte der Kampf gegen die Pandemie den gesellschaftlich-technologischen Wandel. In Echtzeit können wir hilflos die exponentielle Ausbreitung eines winzigen Virus mit einem Durchmesser von 0,1 µm verfolgen, dargestellt durch immer größer werdende rote Flecken auf der Weltkarte. Coronavirus-Tests, die nur wenige Wochen nach Ausbruch der Pandemie entwickelt wurden, halfen, die Übertragung des Virus einzudämmen. Während der HIV-Pandemie in den 1980er-Jahren dauerte es ganze drei Jahre, bis zuverlässige Tests zur Verfügung standen – lange genug, um einen Nährboden für Unsicherheit, Intoleranz, Misstrauen und gesellschaftliche Aggression zu bereiten.

Die Überwachung des Virusverlaufs und Tests zermöglichten eine bessere Kontrolle der Pandemie, wodurch der Zusammenbruch der überlasteten Gesundheitssysteme und die Notwendigkeit einer ethisch höchst umstrittenen, unmenschlichen Triage vermieden werden konnten. Das Abflachen der Pandemiekurve wurde zum Symbol gesellschaftlicher Solidarität. Gleichzeitig führten gemeinsame Anstrengungen internationaler Wissenschaftlerteams in weniger als einem Jahr zur Entwicklung eines Impfstoffs. Vor 2020 hätte dies noch mehr als zehn Jahre gedauert.

BYTES
Neue Normalität mit denselben Menschen, doch unter anderen Umständen

Der Kampf gegen die Pandemie führte zu einem Wandel in den bestehenden Gesundheitssystemen. Aus Angst vor Ansteckung begannen die Menschen, Gesundheitszentren zu meiden. Kranke hingegen, die in der Isolation verharren mussten, wurden sich selbst überlassen. Persönliche Praxisbesuche wurden durch neue Formen der Kommunikation ersetzt: per Telefon, Videochat oder E-Mail.

Diese waren teils frustrierend – wenn etwa der virtuelle Besuch durch technische Pannen unterbrochen wurde –, oft aber auch erfreulich – wenn ein Patient in Sekundenschnelle ein Rezept erhielt, ohne dafür eine Klinik aufsuchen und in einem überfüllten Wartezimmer ausharren zu müssen. Das Gefühl der Sicherheit, das mit dem Überschreiten der Schwelle einer Arztpraxis einhergeht, wich der Frage „Können Sie mich gut hören?" oder „Können Sie mich auch richtig sehen?"

Das mehrstufige Modell zwischenmenschlicher Pflege, welches Elemente psychologischer Fürsorge und sogar der Religion beinhaltet, wurde durch ein transaktionales Konstrukt ersetzt: Symptome im Austausch gegen Diagnose und Medikamente. Obwohl Highspeed-Internet die Wohnungen der Patientinnen und Patienten direkt mit den Praxen verband, filterten Computer- und Smartphone-Bildschirme die Elemente nonverbaler Kommunikation heraus und ließen diese so mit ihren Gedanken und Gefühlen allein. Ärztinnen und Ärzte dagegen verloren ihren Nimbus – beim persönlichen Besuch der Praxis stets präsent, doch auf den aus Pixeln bestehenden Bildern nicht mehr erkennbar.

Während der Coronavirus-Pandemie wurden Patientinnen und Patienten, ob sie wollten oder nicht, plötzlich mit Lösungen konfrontiert, deren Einführung in einem anderen Kontext wohl Jahre gedauert hätte. Dies lag nicht etwa am Mangel an technologischen Lösungen, sondern am Widerstand der Menschen gegen Veränderungen. Allerdings raffte schiere Notwendigkeit diese Kultur buchstäblich dahin. Die Technologien, die von Erstanwenderinnen und -anwendern genutzt wurden, setzten sich durch: telemedizinische Lösungen zur Messung des Sauerstoffgehalts im Blut, Chatbots, die Fragen zum Coronavirus beantworten, oder COVID-19-Tracking-Apps zur Unterbrechung der Infektionsketten. Sie alle haben eins gemeinsam: Sie verlagern die Verantwortung für die Gesundheit auf subtile Weise vom Gesundheitssystem hin zu den Patientinnen und Patienten.

In der durch Digitalisierung ermöglichten Demokratisierung der Gesundheit werden Patientinnen und Patienten zu mündigen Verbraucherinnen

und Verbrauchern. Andererseits erleben wir, wie die „Ikeaisierung" der Medizin voranschreitet: Jede und jeder Einzelne erhält einen Werkzeugkasten mit Hilfsmitteln für Erhaltung (Prävention) oder Wiedererlangung der Gesundheit (Therapie), inklusive einer verwirrenden Gebrauchsanweisung. Gesundheit entsteht nicht durch Ärztin oder Arzt, sondern durch die Patientinnen und Patienten selbst. Dies scheint unvermeidlich in einer Welt, in der es an Arbeitskräften im Gesundheitswesen mangelt und die Nachfrage nach Gesundheitsleistungen aufgrund einer alternden Gesellschaft und Epidemien nicht übertragbarer Krankheiten steigt. Wir wollen eine perfekte Gesundheitsversorgung. Doch alles, was wir erreichen, ist ein fauler Kompromiss zwischen Ökonomie, Medizin, Politik und Wissenschaft.

Werden Algorithmen die Kluft zwischen fehlenden bzw. begrenzten Kapazitäten – Wissen, Finanzmitteln oder Menschen – und dem unerschöpflichen Gesundheitsbedarf überbrücken können? Nein, denn die Realität ist komplexer, als wir es gerne hätten.

Die neue Generation Z wünscht sich ein instagramtaugliches Gesundheitswesen. So simpel wie Uber-Fahrten, so schnell geliefert wie Amazon-Prime-Bestellungen, so individualisierbar wie Tinder-Dates. Und Big Tech beginnt, diesen Traum wahr werden zu lassen. Apple, Samsung, Google oder Facebook (Meta) haben nichts mit dem Gesundheitssektor zu tun, doch im neuen digitalen Ökosystem ist dies auch gar nicht nötig. Für sie ist das Gesundheitswesen ein Geschäftsmodell mit stetigen Wachstumsraten, eine Quelle von Daten, die für die Weiterentwicklung von Algorithmen der künstlichen Intelligenz benötigt werden – als

Bausteine für noch bessere digitale Dienste. Als Gegenleistung für die Verheißung einer besseren Gesundheit und eines gesteigerten Wohlbefindens verwandeln sie Menschen in Dateninkubatoren.

CODES
Gestalten Sie Gesundheit und Körper,
kreieren Sie Ihre eigene Stimmung

Die Menschen wollen nicht, dass Gesundheit noch stärker reglementiert wird. Doch begannen geplante und neue Technologien bereits, dieses Problem perfekt zu lösen. Letztlich wurden die alten Götter schon immer durch neue, bessere ersetzt.

Die synthetische Biologie verspricht, menschliche Zellen programmierbar zu machen wie IT-Systeme, um die Grenze zwischen menschlichem Körper und Hochleistungsprozessoren zu eliminieren. Quantencomputer werden die Rechenleistung des menschlichen Gehirns bald um ein Millionenfaches übertreffen. Avatare mit künstlichem Einfühlungsvermögen, die Ärztinnen oder Ärzten täuschend ähnlich sehen, werden nicht mehr kalte Maschinen mit metallischer Stimme sein, sondern vertraute persönliche Assistierende. Injizierbare Sensoren werden uns vor Fehlern in der unvollkommenen menschlichen Anatomie oder vor zufällig gebildeten Genen bewahren. Es ist paradox, dass krankheits- und verletzungsanfällige Körper und Gehirne, die durch die Rechenleistung von Neuronen limitiert sind, im Vergleich zu den nahezu grenzenlosen Möglichkeiten von Algorithmen nach und nach zu einem Handicap werden.

Was früher eine faszinierende Schöpfung der Natur oder der Götter war, wird allmählich zu einer Einschränkung für uns.

Die heute übliche Messung von Pulsfrequenz oder Schritten ist nur ein lächerlicher Vorläufer einer neuen Gesundheitsreligion, die sich „quantifiziertes Selbst" (Quantified Self) nennt und auf dem Axiom basiert: „Man kann nur verbessern, was man messen kann." Jeder Mensch wird einen „digitalen Zwilling" haben – eine digitale Kopie, die aus Daten erstellt wird, um neue Medikamente und Behandlungen zu testen, oder sogar Präventionsszenarien, um unseren Körper vor unwirksamen Medikamenten und unnötigen Nebenwirkungen zu schützen. Und schließlich wird unser Avatar – nicht wir selbst – die Ärztin oder den Arzt im Metaversum aufsuchen. Das Zuhause – nicht das Krankenhaus – wird zu jenem Ort, an dem Gesundheitsdienstleistungen erbracht werden. Jeder Einzelne – und nicht die Arztpraxis – wird Quelle der Gesundheitsdaten sein. Der Körper wird zu einem quantifizierbaren Datensatz, in dem kein Platz mehr ist für Zufälle. Kein Platz für das, was nicht durch die Gesetze der Physik und mathematische Formeln beschrieben werden kann.

Digitalisierung bedeutet Personalisierung. Und je umfassender die Individualisierung, desto höher die Erwartungen. Beim derzeitigen Modell – „One-fits-all" (Ein Medikament, eine Therapie oder ein Ansatz ist auf alle anwendbar) – gibt sich die breite Öffentlichkeit mit einem Durchschnittswert zufrieden, der nicht immer ideal, doch für alle gleich ist. Nur diejenigen, die genug Geld haben, können sich zusätzliche Optionen leisten. In einem „One-fits-one"-System hingegen gibt es keine

Allgemeinheit, sondern nur den Einzelnen, der verlangt, was für ihn das Beste ist.

Allerdings sollte man nicht so naiv sein, an idealistischen Vorstellungen einer Verschmelzung von Technik und Mensch festzuhalten. Die Geschichte der Menschheit und des Gesundheitswesens war seit jeher von enormen Ungleichheiten geprägt. Diese könnten bald explosionsartig zunehmen. Der israelische Historiker und Philosoph Yuval Noah Harari etwa prognostiziert eine Zukunft, in der Technologien gesunde Menschen noch gesünder machen.

Gesundheitliche Ungleichheiten werden eine neue Dimension erreichen. Zwischen Menschen und digitalen Gesundheitsdiensten gibt es einen neuen technologisch-ökonomischen Vektor: Smartphones, smarte Sensoren, smarte Häuser, smarte Autos und alles, was sonst noch „smart" ist – sie alle sind im Internet der Dinge miteinander verbunden. Ohne finanzielle Mittel und digitale Kompetenz – als neue Determinante der Gesundheit, die ebenso wichtig ist wie genetische oder umweltbedingte Faktoren – werden viele Menschen in der digital gesteuerten Gesundheitsversorgung zu gesellschaftlicher Ausgrenzung und Diskriminierung verdammt sein. Ohne Zugang zu Technologien werden manche von „Datenarmut" bedroht sein. Und dieser Mangel an Daten bedeutet die Rückstufung in ein veraltetes Modell der analogen Gesundheitsversorgung.

Driften wir in Ehrfurcht vor den fantastischen Algorithmen der KI, spiegelnden Wearables und aufregenden Big Data langsam an den Punkt, der Gesundheit Vorrang vor der Freiheit einzuräumen? Oder war das im Grunde schon immer so, indem wir uns

stillschweigend den Diagnosen von Ärztinnen und Ärzte unterwarfen?

Heutzutage vertrauen Ärztinnen und Ärzte darauf, dass Patientinnen und Patienten ihre Anweisungen befolgen. Morgen könnten sie (oder ein Algorithmus) Zugang zu Daten erhalten, die die Befolgung der Anweisungen durch Patientinnen oder Patienten belegen – Fakten anstelle unzuverlässiger Erklärungen, die oft weit von der Wahrheit entfernt sind. Wir sind nur noch einen Schritt entfernt von den düsteren Szenarien einer Gesundheitsdiktatur. Ich bin mir nicht so sicher, dass die von Technologie geprägte Gesellschaft der Zukunft sich weigern würde, einen solchen Preis zu zahlen für das ewige Streben nach Unsterblichkeit oder zumindest eine Annäherung an dieses Ideal.

QUBITS
Technologie spiegelt nur unsere Konfusion und Sorgen

Die Technologisierung des Gesundheitswesens gibt den Menschen das Gefühl der Kontrolle über ihre Gesundheit zurück, die zuvor in den Händen der Götter, des Schicksals und der Natur lag oder nur von außen durch medizinisches Fachpersonal kontrolliert wurde.

Biofeedback, also die Echtzeit-Überwachung der Körperchemie eines Menschen, ist wie ein nie endender Arztbesuch. Es vermittelt ein Gefühl der Sicherheit, das entscheidend ist, um glücklich zu sein. Bei der gegenwärtigen Gesundheitsrenaissance geht es darum, sich selbst zu berechnen, einschließlich der eigenen Emotionen und des eigenen Wohlbefindens. Ein Versuch, sich selbst zu

verstehen und den Kräften einer Krankheit zu widerstehen, die den Menschen auf das Niveau eines wehrlosen Wesens reduziert. Es bleibt keinerlei Spielraum mehr für den Faktor Zufall. Der *Homo sapiens technicus* ist ein quantifizierbarer, kontrollierbarer, programmierbarer und reparierbarer Organismus.

Dieser von Technologie befeuerte kulturelle Wandel soll die größten Bedrohungen für die Menschheit beseitigen: die COVID-19-Pandemie, die Klimakrise, die gesellschaftlichen Ungleichheiten im Gesundheitswesen und die Wirtschaftskrisen. Leider könnte sich dieses neue Zeitalter der Gesundheitsfürsorge als Zufluchtsort erweisen, der lediglich ein trügerisches Gefühl der Sicherheit vermittelt.

Medizin ist die Kunst, inmitten einer Krankheit, einer Pandemie oder der Vergänglichkeit des Lebens Hoffnung zu vermitteln. Und Fortschritte in der Technologie sind dafür wie geschaffen.

Artur Olesch lebt als freier Journalist, Zukunftsforsch
und Meinungsführer für digitale Gesundheit in Berlin.
ist Gründer des Diskussionsforums aboutDigitalHealth.c
über die Zukunft der Gesundheit. Als Autor von mehr
1.000 Artikeln über neue Technologien im Gesundheitswes
und deren Auswirkungen auf die Gesellschaft von heute
morgen, als Content Writer, Redner, Moderator, Dozent

flussreiche Stimme in den Sozialen Medien ist er Verfechter Innovationen für eine allen zugängliche, bezahlbare gerechte Gesundheitsversorgung. Er ist Mitglied des ANA Healthcare Leaders Network und Chefredakteur mehrerer ealth-Zeitschriften in Europa, Mentor für Medizintechnik-rtups und begleitet Gesundheitsorganisationen bei ihrer italen Transformation.

LYNN HERSHMAN LEESON, MARY MAGGIC UND P. STAFF IM ROUND-TABLE-GESPRÄCH

Die folgende Diskussion bietet einen Austausch zwischen drei Kunstschaffenden, die ein gemeinsames Interesse an Themen wie Biohacking, der Beziehung zwischen Kunst und Aktivismus, Fragen von Toxizität und Umwelt sowie der Rolle interdisziplinärer Zusammenarbeit verbindet. An diesem generationenübergreifenden Gespräch nahmen teil: Lynn Hershman Leeson, die seit mehr als sechs Jahrzehnten an der Schnittstelle von Kunst und Technologie arbeitet, sowie als Vertreter*innen einer jüngeren Generation der Künstler P. Staff und die Künstlerin Mary Maggic, die sich in ihren Werken, Workshops und öffentlichen Programmen häufig mit der Durchlässigkeit unseres Körpers auseinandersetzten, mit besonderem Augenmerk auf Hormone, endokrine Disruptoren und Umwelt.

Sara Cluggish und Pavel S. Pyś (S&P): Lassen Sie uns zunächst über die Rolle des Aktivismus in Ihrem Leben und künstlerischen Schaffen sprechen.

Mary Maggic (MM): Ich bezeichne mich selbst nicht als Aktivistin, allerdings wurde meine Biohacking-Arbeit in diesen Bezugsrahmen eingeordnet. Ich betrachte die Schaffung von Wissen außerhalb der Institutionen als von Natur aus politisch und die kollektive Aneignung neuer Kenntnisse und Subjektivitäten als einen höchst subversiven Akt, insbesondere wenn man versucht, stark eingefahrene Vorstellungen von Körper und Geschlecht neu zu definieren.

P. Staff (PS): Als ich noch jünger war, war es mir sehr wichtig, dass die Arbeit, die ich als Künstler ausübe, eine Form von Aktivismus darstellt. Ich fühle mich jetzt etwas wohler mit der Vorstellung, dass das, was ich tue, etwas anderes ist. Mir erscheint es dabei notwendig, das, was wir als Aktivismus bezeichnen, ganz genau zu definieren – als basisdemokratische Organisation, als politische Organisation –, woran ich persönlich nicht allzu sehr beteiligt bin. Ich bin mehr daran interessiert, eine Arbeit in die Welt zu bringen, die eine Reihe von Austauschprozessen und Reaktionen hervorruft, welche man weder kontrollieren, noch deren Ergebnisse man per se kennen kann. Doch ich stimme Mary voll und ganz zu, dass man nicht wirklich in die Gebiete vordringen kann, in denen unsere Arbeit stattfindet, ohne an den inhärent politischen Akt des Widerstands gegen Herrschaft zu stoßen.

Lynn Hershman Leeson (LHL): Als ich 1963 nach Kalifornien zog, war das die Zeit frühester Formen des Free Speech Movement (FSM: Bewegung für freie Meinungsäußerung). Die Frauenbewegung setzte erst

etwa fünf Jahre später ein; sie entstand ganz langsam, als viele erkannten, dass sie in der Geschichte nicht vertreten waren. Mitte der 1960er-Jahre lieh ich mir eine Videokamera und nahm Interviews mit Frauen auf. Die Dynamik änderte sich; man erkannte, dass eine Bewegung im Gange war. Ich nahm von 1967 bis 2008 Videokassetten auf, Material für den späteren Dokumentarfilm *!Women Art Revolution* (2010). Ich habe mich erst viel später als Aktivistin gesehen. Ich kann gar nicht genau sagen, wann. Als ich das Werk mit den Hotelzimmern [*The Dante Hotel*, 1972–1973] schuf, empfand ich dies als meine erste wirkliche Arbeit, weil es nicht das war, was die Leute erwarteten. Es stellte eine völlig neue Form dar, den Kampf für die Idee, Medien zu verwenden, die noch nie in der Kunst eingesetzt worden waren.

S&P Mary, Sie sprachen vorhin über Wissensproduktion als eine Form des Widerstands. Welche Rolle spielt Widerstand in Ihrem künstlerischen Schaffen, und wie kann er dominante Narrative umgestalten?

PS Ab einem bestimmten Punkt geht es nur noch ums blanke Überleben. Man hat einfach keine andere Wahl, als sich mit der dominanten Form anzulegen, im Sinne von „Sonst werde ich verdammt noch mal sterben." Leben und die Produktion von Kunst sind untrennbar miteinander verbunden. Bis zu einem gewissen Grad dreht sich mein Werk – ob es nun um pharmazeutische Chemotherapie geht oder um Hormone oder auch um die neueren, abstrakteren Arbeiten – stets um die Volatilität von Chemikalien und Flüssigkeiten und das Dasein in einem Körper. Ich verspüre den Drang,

mich nicht von der Gewalt der Welt verschlingen und zerstören zu lassen.

MM Seit ich mit meiner Arbeit über Hormone begann, habe ich das Gefühl, dass sich das, wogegen sie sich wendet, verändert hat. Es begann mit Widerstand gegen institutionelle Kontrolle und dann gegen die Entfremdung, die durch Umweltgifte entsteht. Jetzt ist es zu etwas viel Universellerem geworden: dem Widerstand gegen diese Vorstellung der „Reinheit", sei es im Hinblick auf unser binäres Geschlechtersystem, die Trennung zwischen Mensch und Tier, Natur und Kultur. Diese Strukturen der Reinheit zu durchbrechen, ist eine Form des Widerstands, fast ein Weg, eine neue Tradition zu begründen.

PS Ich schließe mich Ihren Worten an, Mary: Es geht um Auseinandersetzung mit den Symbolen der Zukunft, den vermeintlich stabilen Determinanten, die man uns anbietet. Diese Determinanten drängen ständig Menschen ins Abseits, angetrieben von einem weißen, rechtsextrem-rassistischen Todestrieb dorthin, wie die Gesellschaft auszusehen habe. Hormone werden zu einem bizarren Konfliktherd, da so viel damit zusammenhängt, wie man sie sich vorstellt, stabil, klar definiert und biologisch konkret. Es ist pure Ironie, dass das genaue Gegenteil der Fall ist.

LHL Ebenso wie Widerstand ist auch die Vorstellung einer Korrektur wichtig. Für mich war das Free Speech Movement eine Form des Widerstands gegen die Unterdrückung der Studenten durch die Regierung. Hier kam eine überarbeitete Alternative zum Tragen.

Die Menschen neigen dazu, in die Geschichte zurückzublicken, anstatt ihren Blick darauf zu wenden, was in der Gegenwart passiert, oder gar die Zukunft zu erfinden. Alles ist miteinander verknüpft: vom Widerstand über die Neugestaltung bis hin zum kulturellen Wandel. Mehr noch: zum Vermögen durchzuhalten und letztendlich zu überleben.

S&P Wie würden Sie Ihre jeweiligen von der Umwelt inspirierten Interessen in der Körper- und Geschlechterpolitik beschreiben? Wie denken Sie über die Durchlässigkeit des Körpers, über Ideen, Kontamination und Krankheit?

MM Ich interessiere mich sehr für die Art und Weise, wie man Körper in Bezug auf den umfassenderen planetarischen Körper kategorisiert, für die Art und Weise, wie wir Territorien abstecken und berechnen, was wir aus der Umwelt extrahieren können. Existiert eine Möglichkeit, unsere Körper im planetarischen Körper zu deterritorialisieren? Gibt es einen Weg, Taxonomien ohne den gewaltsamen Prozess der Fremdbestimmung zu etablieren? Es besteht eine Verbindung zwischen unserer Definition von Toxizität und Taxonomie. Ersteres bedeutet die Benennung des Toxins, des Anderen, des Giftes. Die Taxonomie hat insofern denselben Effekt, als sie Grenzen zwischen zwei verschiedenen Körpern oder zwei verschiedenen Spezies zieht: Auf diese Weise ergibt sich eine Hierarchie.

Es ist ganz klar, dass es keinen festen und stabilen Körper oder ein unveränderbares und beständiges Geschlecht gibt: Doch wie kategorisiert man etwas,

dessen Gestalt sich ständig wandelt? Das Projekt *Genital(*)Panic* etwa befasst sich mit dem anogenitalen Abstand (AGD: der Distanz zwischen Anus und Genitalien): Dabei handelt es sich um ein Maß, mit dem man in der Wissenschaft die „Reproduktionstoxizität" (fortpflanzungsgefährdende Wirkung) bewertet. Bei männlichen Körpern soll sie doppelt so groß sein wie bei weiblichen. Da wir jedoch ständig Phthalaten und Mikroplastik ausgesetzt sind, ist sie bei männlichen Körpern genauso groß wie bei weiblichen. Die Konstruktion von Sex und Gender fällt in sich zusammen, wenn man sie allein auf die Morphologie der Genitalien stützt. *Genital(*)Panic* schlägt eine queer-feministische Bevölkerungsstudie vor, die Wissenschaft auf eine Art und Weise betreibt, bei der all diese Genitaldaten per Crowdsourcing erhoben werden, indem man 3D-gescannte Genitalien und grundlegende demografische Daten sammelt, die der Geschlechtsidentität gegenüber dem bei der Geburt zugewiesenen Geschlecht Priorität einräumen. Bislang habe ich noch keine Bevölkerungsstudie gefunden, die das bei der Geburt zugewiesene Geschlecht nicht berücksichtigt. Das Projekt versucht, das Werkzeug der patriarchalischen Wissenschaft, den anogenitalen Abstand, von seiner symbolischen Macht zu trennen.

LHL Ich fing an, Klänge zu verwenden, als ich während meiner Schwangerschaft eine Herzinsuffizienz erlitt und mehrere Monate allein unter einem Sauerstoffzelt im Krankenhaus verbringen musste. Alles, was ich hören konnte, war das Atmen, und dies wurde zu einem wichtigen Element in meinem Leben. Es wurde aus einer

Krankheit heraus zum Überleben. Diese Erfahrung prägte meine Arbeit entscheidend, denn egal, ob es nun um das eigene Überleben nach einem Herzfehler im Alter von 23 oder 81 Jahren geht – man muss sich mit dem Überleben des Planeten und den Auswirkungen von Giftstoffen auseinandersetzen. Toxine in Form von Umweltverschmutzung, in Form eines begrenzten Handlungsspielraums in der Zukunft. Darum geht es zum Teil in *Anti-Bodies* (ab 2014) als Metapher für das Aufspüren von Giften, nicht nur im eigenen Körper, sondern auch in der Umwelt, und die Auseinandersetzung mit ihnen auf unterschiedliche Weise, um sie zu behandeln, um einen anderen Weg zu finden, sie außer Kraft zu setzen.

S&P In Ihren Werken geht es immer wieder um die Frage, was für uns toxisch ist. Was verstehen wir unter Toxizität?

LHL In den 1970er-Jahren begann ich die Serie *Water Women* mit Aufnahmen des Körpers von Roberta Bretimore, der mit Wassertropfen gefüllt war. Darin ging es um Verdunstung und die Zersetzung unserer selbst im Laufe der Zeit. Ich beschäftigte mich weitere 40 bis 50 Jahre mit dem Thema. Das Projekt *Twisted Gravity* basierte auf den Bildern der *Water Women*. Sie wurden auf unterschiedliche Weise beleuchtet, um ein neues Verfahren zu zeigen, mit dem man Wasser von Plastikverunreinigungen befreien kann. Wir arbeiteten dafür zusammen mit dem Wyss Institute, welches das AquaPulse-System entwickelt hatte, mit dem ein Liter Wasser pro Minute gereinigt werden kann. Sie hatten es noch nicht patentieren lassen, wollten es jedoch in

Notfällen, wie Erdbeben, zum Einsatz bringen. Harvard und das Wyss Institute schrieben mir, dass sie gar nicht auf diese Ideen gekommen wären, hätte ich nicht mit ihnen zusammengearbeitet, denn obwohl ich keine Wissenschaftlerin war, stellte ich Fragen, die sie beantworten mussten. Für mich war es einfacher, etwas zu betrachten und zu analysieren und auf eine Denkweise zu kommen, mit der sie nicht vertraut waren, weil sie nicht logisch war.

PS Die Arbeit der Forscherin Eva Haywards weist uns darauf hin, dass man im Rahmen der aktuellen, äußerst reaktionären Panik um Sex und Gender der Toxizität und Umweltverschmutzung mehr Aufmerksamkeit schenken sollte. In ihrem Essay *Toxic Sexes* (Toxische Geschlechter), den sie zusammen mit Malin Ah-King verfasste, weist sie darauf hin, dass die Geschlechtsveränderungen bei Tieren als Folge der endokrinen Umweltverschmutzung uns helfen könnten, Toxizität in der Gegenwart als eine der entscheidenden Bedingungen für Geschlecht zu diskutieren. Ich denke, dies ist ein zunehmend wichtiger Dreh- und Angelpunkt, sich dem Verständnis des Toxischen anzunähern. Interessant ist allerdings die Frage, warum in dieser Debatte das Geschlecht zentraler ist als Krebs, Autoimmunerkrankungen und sogar der Tod. Und warum wird etwas wie eine verminderte Spermienzahl eher als Krise angesehen als die schädlichen kapitalistischen Praktiken, die dazu geführt haben?

MM Unsere Körper verändern sich viel schneller als der kulturelle Diskurs über Toxizität. In den Medien

herrscht Panik hinsichtlich Sexualität, die auf Homo-, Trans- und Xenophobie beruht. Unsere Körper waren seit jeher queer und sind es immer noch. Es ist wirklich problematisch, wenn unsere Empathie, die wir für Kranke empfinden, selektiv ist. Sie gilt nur bestimmten Körpern, die man als existenz- und lebenswert erachtet.

PS Im Rahmen dieser Verflechtung von Leben und eigenem künstlerischem Schaffen stört diese Toxizität vielfach die Grenzen von Geschlecht, Rasse, Geografie und Spezies. *Acid Rain for Museion Bolzano* nähert sich diesem Thema, wenn auch auf eine etwas freiere Art und Weise. Material der Arbeit ist ein fließendes Rohrsystem, das an den Decken und teilweise den Wänden der Institution entlang verläuft. An bestimmten Stellen ist es undicht und lässt Milchsäure als „Säureregen" in den Ausstellungsraum tropfen, der nach und nach in großen Stahlfässern aufgefangen wird. Das Werk erzeugt ein ganz besonderes Bedrohungsgefühl durch die Umgebung: Man wird ständig durch das Geräusch des Tropfens im Museum echogeortet und kann sich jeweils in Bezug auf dieses flüchtige Material orientieren. Ich wurde teilweise zu solchen Überlegungen angeregt, weil saurer Regen in meiner Kindheit in den Nachrichten so stark im Vordergrund stand. In Europa herrschte in den 1980er- und 1990er-Jahren die Vorstellung, dass die Industrie am Prozess der Niederschlagsbildung beteiligt sei – ein gewaltsamer Eingriff, der zu saurem Regen führe. Als Kind hatte ich daher das Gefühl: „Wenn ich bei Regen nach draußen gehe, wird mein verdammtes Gesicht verbrannt, oder diese Flüssigkeit vom Himmel ätzt Löcher in alles." In Wirklichkeit war der saure Regen

eine echte Katastrophe für Gebäude aus Kalk- und Sandstein, was im Vereinigten Königreich vor allem Häuser, Schulen, Kirchen und Gefängnisse betraf. Viele dieser Einrichtungen wurden langsam erodiert. In gewisser Weise geht es in meiner Arbeit um eine bestimmte Poetik der Gewalt, die die Erfahrung, sich in einem gemeinsamen Raum zu befinden, in Frage stellt.

MM Mir gefällt sehr, dass Milchsäure hier als eine von der Umwelt ausgehende Bedrohung beschrieben wird. Diese umweltbedingte Bedrohung ist keine Mutation der Natur, sondern sie ist Natur. Wir müssen Strategien entwickeln, die über die Maxime hinausgehen: „Wir müssen nur zu dieser reinen Natur zurückkehren." Vielmehr müssen wir sagen: „Nein. Die Toxizität, in die wir jetzt verstrickt sind, ist der Ausgangspunkt, von dem aus wir all unsere neuen Strategien entwickeln sollten."

S&P Sie alle verbindet ein gemeinsames Interesse an alternativen Communities, an Menschen, die außerhalb der offiziellen Kanäle arbeiten. Wie wählen Sie Ihre Mitstreiter aus?

MM Um 2014 wurde ich auf die Plattform Hackteria aufmerksam: ein globales Onlinenetzwerk von Hackern, Künstlern, Tüftlern und Geeks beiderlei Geschlechts. Viele meiner Workshop-Praktiken entstehen aus der Arbeit mit dieser Community, da der Prozess darauf basiert, die Hierarchie zwischen Laiinnen/Laien und Expertinnen/Experten aufzuheben, eine Art öffentlicher Amateurismus, der aus den Praktiken des Critical Art Ensemble hervorgeht. Meine Arbeit in den Workshops

verlief zunächst eher didaktisch: Ich lehrte einfach, wie man Hormone aus Urin extrahiert. Im Laufe der Zeit begann ich dann verstärkt, performative Praktiken einzubeziehen und einen Raum des radikalen Nichtwissens zu schaffen. Ein höchst gemeinschaftlicher generativer und produktiver Prozess der Weltgestaltung, den man nie hätte, wenn man als Künstlerin oder Künstler allein arbeiten würde. Man ist dadurch in der Lage, sich auf diese chaotische Verstrickung mit anderen einzulassen. Es ist auch eine Strategie gegen die Reinheit, denn in der Wissenschaft wird Erkenntnis oft in einer höchst kontrollierten und sterilen Umgebung gewonnen. Wir müssen uns gegenseitig kontaminieren, um etwas wirklich Substanzielles und Neues zu entwickeln.

LHL Bei mir ist es oft Zufall. So wusste ich, dass ich Tilda Swinton für den Science-Fiction-Film *Teknolust* (2002) als Darstellerin engagieren wollte, nachdem ich sie in *Orlando* gesehen hatte, und versuchte vergeblich, ihren Agenten zu kontaktieren. Irgendwann saß ich zufällig neben einer Freundin von ihr, die ihr dann bei einem Anruf von dem Projekt erzählte. Oft setzt man seine gesamte geistige Energie für etwas ein, was man tun muss, und dann ist es fast so, als kämen die Leute zu einem, um einen dazu zu bringen. Bevor ich nach Basel ging, kannte ich Thomas Huber noch nicht, doch ich wusste, was ich dort machen wollte. Vom Wyss Institute hatte ich nie zuvor gehört. Vieles dort beruht auf wissenschaftlicher Forschung, wie die Suche nach dem Mann, der erstmals ein Organ mittels Bioprinting herstellte, als ich an *Infinity Engine* arbeitete, oder die Entdeckung von George Church, der synthetische DNA

entwickelte. Ich benötigte drei Jahre, um ihn zu einem Gespräch zu bewegen, doch man muss einfach hartnäckig sein. Und dann muss man ihn davon überzeugen, dass man versteht, was er sagt. Als studierte Biologin hatte ich einen Vorteil.

PS Man realisiert, wie oft alternative Gemeinschaft als ein wirklich ganzheitlicher Raum hin- oder dargestellt wird. Und ich machte die Erfahrung, dass wir oft nicht aus freien Stücken in eine Gemeinschaft mit anderen Menschen eintreten. Vielleicht finde ich mich in Gemeinschaft mit anderen Transmenschen an dem geografischen Ort, an dem ich mich gerade aufhalte, oft aus Notwendigkeit, oft aus einem Bedürfnis. Doch stelle ich häufig fest, dass wir in dem Moment, wo wir in einer Gemeinschaft zusammen sind, viel stärker voneinander belastet werden, als wir es uns wirklich eingestehen. Wir stellen uns vor, dass eine selbstgewählte Community Problemen irgendwie entgehe. Wogegen meiner Erfahrung nach das, was ich tatsächlich als Verwandtschaft, Zusammengehörigkeit oder was auch immer empfinde, viel plastischer und unruhiger ist; es ist eher uneben als glatt. Nach Absolvieren einer eher formalen Kunstausbildung verspürte ich den Wunsch, gemeinsam mit anderen Leuten, die ebenfalls eine akademische Ausbildung durchlaufen hatten und diese ähnlich steril empfanden, in einem Arbeitskreis auf andere Weise Erkenntnisse hervorzubringen. Zusammen mit Candice Lin führte ich eine Reihe von Workshops durch. Dabei fühlen wir uns beide oft durchaus gerne als Unruhestifter, wollen beide ein bisschen unangenehm auffallen. Wenn wir also irgendwie eine Gruppe von Leuten dazu bringen

können, mit uns eine Ladung „giftiger Dämpfe" einzuatmen, bevor wir in eine Diskussion oder etwas anderes eintreten, ist dies einfach ein spielerischer Wunsch, zu stören. Manchmal kann es sich wirklich gut anfühlen, schlecht zu sein.

MM Ich betrachte es definitiv als Provokation, denn letztlich läuft es darauf hinaus, dass jeder Mensch seine eigene Art zu sein hat. Wenn man eine Gruppe von Menschen zusammenbringt, dann ergibt sich ein kontinuierlicher Verhandlungsprozess, mit widersprüchlichen Gedanken und konfliktreichen Welten. Doch das ist ja das Schöne daran, dass man sich gegenseitig provoziert, dass man Strukturen und Institutionen provoziert. Ich sehe das als einen sehr notwendigen Prozess der kollektiven Neugestaltung.

PS Ich denke, es läuft wirklich auf den Widerstand gegen die Privatisierung sämtlicher gesellschaftlicher Formen hinaus, sei es die privatisierte Familienstruktur, die privatisierte häusliche Sphäre, die Privatisierung unseres gesamten sozialen Austauschs. Bei der Idee des Workshops geht es einzig und allein darum, Verbindungen zu knüpfen und Bedeutung außerhalb einer dominant privatisierten Welt zu schaffen.

MM Ich verstehe Moleküle und Toxizitäten auch als etwas, das uns provoziert und mit uns experimentiert. Ich denke, dass die Welt auch eine Art von Theorie aufstellt; sie macht auch Fehler und passt sich an diese Fehler an. Ich glaube, die Moleküle tun dasselbe mit uns, mit unserem Körper, mit unserer Umgebung.

Ich vermute, dass uns die Moleküle genauso verändern wie wir sie. Dabei handelt es sich um einen ständigen Prozess des Theoretisierens und Experimentierens.

PS Was könnte wirkungsvoller und politischer sein als die Erkenntnis, dass man bei Weitem nicht so stabil ist, wie man glaubt, und dass man keinesfalls so diskret ist, wie man denkt? Diskret im Sinne einer singulären Sache. Es liegt tief im Bereich des Politischen, das heißt im Bereich des Unbekannten.

MM Ja, das stimmt. Vernetzt zu sein, ist auf jeden Fall ein politischer Akt.

Fünf Jahrzehnte sorgte die Künstlerin und Filmemacher
LYNN HERSHMAN LEESON mit ihrer Kunst und ihren Film
international für Aufsehen. Als eine der einflussreichs
Medienkünstlerinnen steht sie für innovative Arbeiten
breit gefächerten Themen, die heute als Schlüsselfakto
für das Funktionieren der Gesellschaft gelten: die Bezieh
zwischen Mensch und Technologie, Identität, Surveillance
Einsatz von Medien als Mittel der Ermächtigung gegen Zens
und politische Unterdrückung. Wegweisende Beiträge in
Bereichen Fotografie, Video, Film, Performance, künstli
Intelligenz, Bio-Kunst, Installation und interaktive so
netzbasierte Medienkunst. Das ZKM | Zentrum für Kunst
Medientechnologie Karlsruhe zeigte 2014 die erste umfasse
Retrospektive ihres Werks unter dem Titel *Civic Radar*. E
bedeutende Publikation, die Holland Cotter in der *New Y*
Times als „eines der unverzichtbaren Kunstbücher des Jah
2016" bezeichnete. Sie war auf der Biennale von Venedig 2
vertreten, wo sie mit einem Sonderpreis ausgezeichnet wur

MARY MAGGIC, nicht binäre Künstler*in, Wissenschaftler
und Mutter, arbeitet an den nicht eindeutig definiert
Schnittstellen von Körper- und Geschlechterpolit
und ökologischen Entfremdungen des Kapitalismus. Ih
interdisziplinären Projekte umfassen Amateurwissenscha
partizipative Performance, Installation, Dokumentati
und spekulative Fiktion. Seit 2015 setzt Maggic besonde
Biohacking als xenofeministische Methodik und kollekti
Fürsorgepraxis ein, die dazu dient, die unsichtbar
Linien molekularer Biomacht zu entmystifiziere
Maggic ist Mitglied des Online-Netzwerks Hackteria: Op
Source Biological Art, des Labortheater-Kollektivs Alie
in Green und des asiatischen feministischen Kollektivs M
Ling, zudem Mitwirkende an dem radikalen Lehrplanproje
Pirate Care und den Sammlungen des CyberFeminism Inde

STAFF lebt und arbeitet in Los Angeles und London. eiten in den Bereichen Video, Skulptur und Poesie zen sich mit den Registern von Gewalt auseinander, der Entstehung eines menschlichen Subjekts zugrunde egen, und hinterfragen, was bei den Lebensumständen von eren und transsexuellen Menschen auf dem Spiel steht. zelausstellungen: Chisenhale Gallery, London (2015); A (Museum of Contemporary Art), Los Angeles (2017); pentine Galleries, London (2019). Teilnahme an lreichen Gruppenausstellungen, darunter *British t Show 8* (Wanderausstellung, 2016); *Trigger*, New seum, New York (2017); *Made in L.A.*, Hammer Museum, Angeles (2018); *Bodies of Water*, The 13th Shanghai nnale (2021); *Prelude*, Luma, Arles (2021–2022); *e Milk of Dreams*, 59. Biennale von Venedig (2022).

Bart van der Heide

PREFAZIONE

Secondo la filosofa Judith Butler, solidarietà e violenza non si escludono a vicenda. La violenza può sempre essere legittimata dall'autodifesa, ma entrambe procedono di pari passo quando si tratta di proteggere e preservare lo Stato-nazione. Nel suo testo *La forza della nonviolenza* (2020), Butler si chiede: "Per il momento, tuttavia, mi chiedo: chi è questo 'sé' difeso in nome dell'autodifesa? In che modo quel sé viene strutturato dagli altri sé, dalla storia, dal territorio e dalle altre relazioni che lo determinano? Il bersaglio della violenza non è in un certo senso anche parte del sé che si difende attraverso quell'atto di violenza?" [1].

Qui Butler richiama l'attenzione sulla nota sfumatura tra solidarietà e uguaglianza e segue un concetto passivista, spiegando che la violenza continuerà a essere legittimata se l'io esteso rimane un prolungamento del proprio colore, della propria classe e delle proprie capacità, espellendo così tutti e tutte coloro che all'interno di quell'economia sono segnati dalle differenze.

A distanza di due anni e dopo l'impatto della pandemia di COVID-19, l'ipotesi di Butler offre una riflessione toccante di grande attualità. La pandemia ha messo a nudo l'intricato equilibrio tra libero mercato e risorse umane ed ecologiche. Allo stesso tempo, la comunità globale ha dovuto "autodifendersi" indipendentemente dallo Stato-nazione, a causa di un'interdipendenza globale assoluta.

La solidarietà era al centro del benessere e della precarietà internazionale, e con essa la complicità individuale nel mantenere o rifiutare l'unità storica tra salute, interessi statali e impero. La protezione dei cittadini e delle cittadine dalle invasioni esterne, soprattutto virali, ha strettamente allineato la sanità pubblica alle ideologie del colonialismo e del mercato internazionale [2]. Con la mostra *Kingdom of the Ill*, i curatori Sara Cluggish e Pavel S. Pyś mirano innanzitutto ad abbattere la divisione tra questo dentro e questo fuori, cioè il dichiarare di essere sani contrapposto a un'immagine di sé di non malati. Proprio come l'attuale antologia di testi critici indipendenti, la loro mostra a Museion può essere letta come una ridefinizione della solidarietà alla luce del fondamentale testo di Susan Sontag *Malattia come metafora* (1978). Sontag attribuisce a ogni essere umano una doppia cittadinanza: quella del regno dello star male o dello star bene. Cancellando la parola *Kingdom* dal titolo, Cluggish e Pyś ne offrono una revisione contemporanea: di fronte al burnout, all'esaurimento, alla diminuzione del sostegno alla sanità pubblica e al dilagante sfruttamento capitalistico delle risorse umane ed ecologiche, si può ancora essere veramente "sani"? *Kingdom of the Ill* fa uscire la malattia dal lato notturno (anche questo è un riferimento a Sontag) e la indaga

come modello generale di convivenza civile e solidarietà non violenta.

In effetti, questa tesi potrebbe trovare un sostegno crescente a fronte di una crisi sanitaria globale, ma quando si tratta dell'influenza economica del capitalismo digitale e della globalizzazione rispetto all'"autodifesa", le cose rimangono più sfocate e in ombra. Nel 2016, un gruppo di ricercatori e ricercatrici indipendenti ha fondato il Precarity Lab, per studiare la proliferazione della "tecnoprecarietà" [3]. Nel testo *Techno Precarious* (2020), firmato collettivamente, il gruppo sottolinea che il panorama della precarietà si è esteso e include oggi la classe creativa dei produttori e delle produttrici digitali nelle "zone di arricchimento" del mondo. Ciò significa che un numero maggiore di persone vive senza sostegni, "senza speranza, in maniera 'crudelmente ottimista' …" [4] L'unica classe lavorativa per cui questo risulta particolarmente rilevante è quella dei e delle freelance, che offrono servizi senza alcuna garanzia di stabilità economica. Nel testo è presente una lontana eco del sopracitato titolo di Sontag: "La precarietà non è una metafora […] sopravvivere da un incarico all'altro può distogliere dalla possibilità di vivere in un altro modo". Il gruppo propone una coalizione di classe che si prefigga di eliminare la divisione tra interno ed esterno in termini di salute e benessere, poiché i crescenti livelli di ansia, tossicità e problemi di salute mentale sono già una realtà per chi è marginalizzato dalla società.

In questo contesto l'attivismo è caratterizzato da atti di solidarietà, ad esempio in forma di "mutuo soccorso" [5], ma evidenzia anche l'ipocrisia del modo in cui sono ancora distribuiti ricchezza e privilegi nonostante la

crescente consapevolezza in una necessità di uguaglianza. Per questo il Precarity Lab dichiara: "… Chiediamo alla classe [creativa] offesa, invece di aggrapparsi alla supremazia per anestetizzare il dolore della precarietà, di mobilitarsi contro i motori del capitalismo, processo che inizia con il riconoscimento di una precarietà condivisa ma distribuita in maniera non uniforme" [6].

Questa concezione segue da vicino gli scritti del teorico critico e poeta Fred Moten, il quale afferma che la solidarietà è banale se non produce uguaglianza. In una conversazione con il teorico culturale Stevphen Shukaitis, Moten interpreta così il pensiero dell'attivista per i diritti civili Fred Hampton: "…Guarda: il problema della coalizione è che la coalizione non è qualcosa che emerge in modo che tu possa venire ad aiutarmi […]. La coalizione emerge dal vostro riconoscimento che per noi la situazione è un casino. Io non ho bisogno del tuo aiuto. Ho solo bisogno che tu riconosca che questa merda sta uccidendo anche te, anche se in modo molto più delicato, hai capito, stupido figlio di puttana?" [7].

Oggi, mentre il capitalismo continua a limitare privilegi e ricchezze a un gruppo sempre più ristretto di cittadini e cittadine globali, la salute e il benessere seguono a ruota. Il grado di conformità o disobbedienza si basa su quale "sé" si è disposti a difendere.

[1] Judith Butler, *La forza della nonviolenza. Un vincolo etico-politico*, a cura di Federico Zappino, Nottetempo, Milano, 2020, p. 21.

[2] Vedi: Nicholas B. King, "Security, disease, commerce: ideologies of postcolonial global health", in *Social Studies of Science*, 2002, pp. 763-789.

[3] Precarity Lab è un'iniziativa del Goldsmith Institute dell'Università di Londra, in collaborazione con l'istituto di Scienze umane dell'University of Michigan. Ne fanno parte: Cass Adair, Ivan Chaar-López, Anna Watkins Fisher, Meryem Kamil, Cindy Lin, Silvia Lindtner, Lisa Nakamura, Cengiz Salman, Kalindi Vora, Jackie Wang e Mckenzie Wark.

[4] *Techno Precarious*, Precarity Lab (a cura di), Goldsmith Press, Londra, 2020, p. 2.

[5] Definizione di "mutuo soccorso" formulata da Big Door Brigade: il mutuo soccorso è una forma di partecipazione politica in cui le persone si prendono la responsabilità di occuparsi le une delle altre e di cambiare la situazione politica, non solo servendosi di gesti simbolici o mettendo sotto pressione chi li rappresenta presso il governo, ma costruendo nuove relazioni sociali che siano maggiormente in grado di sopravvivere. Cfr. www.bigdoorbrigade.com/what-is-mutual-aid

[6] Precarity Lab (nota 4), p. 75.

BART VAN DER HEIDE è storico dell'arte, iniziatore di most e direttore di Museion, Bolzano, dove ha avviato il proget di ricerca multidisciplinare *TECHNO HUMANITIES*. Il proget triennale (2021-2023) comprende mostre, pubblicazior tavole rotonde e programmi di mediazione dell'arte. La ser espositiva è incentrata su quesiti esistenziali urgenti c riguardano l'essere umano all'intersezione di ecologi tecnologia ed economia. In *TECHNO HUMANITIES* dei team ricerca internazionali esterni approfondiscono e svilupp

[7] Fred Moten, "The General Antagonism: An Interview with Stevphen Shukaitis" in: *The Undercommons: Fugitive Planning & Black Study*, Stefano Harley e Fred Moten (a cura di), Released by Minor Compositions, Wivenhoe / New York / Port Watson, 2013, pp.140 e seg.

temi affrontati e parallelamente il progetto offre a ovani talenti una piattaforma per realizzare le proprie oirazioni. Un aspetto particolare, inoltre, consiste nel involgimento di iniziative locali.

mostra *Kingdom of the Ill* rappresenta il secondo oitolo del progetto triennale che van der Heide ha nciato nel 2021 con la mostra *TECHNO* (11 settembre 2021 – marzo 2022).

Sara Cluggish e Pavel S. Pyś

~~KINGDOM~~ OF THE ILL:
tematiche emergenti sull'accessibilità in arte

Gli ultimi anni dall'inizio della pandemia di COVID-19 hanno messo in primo piano molte questioni relative alla salute e alla malattia. La nuova epidemia di coronavirus non solo ha influenzato i dibattiti sulle dimensioni nazionali, finanziarie, politiche e ideologiche dell'assistenza sanitaria, ma ha anche dato forma alle nostre esperienze personali su come riceviamo e forniamo assistenza, su come proteggiamo lo spazio personale grazie al distanziamento sociale e su come decidiamo se condividere o meno lo spazio fisico con gli altri e le altre. Per coloro che si identificano come malati o disabili, in genere questo isolamento fisico e l'iperconsapevolezza del proprio corpo sono la norma, non l'eccezione. Riflettendo su questo cambiamento nell'opinione pubblica, la scrittrice e artista Johanna Hedva ha scherzosamente commentato: "Trovo buffo che nel 2020 ci comportiamo tutti come se la malattia fosse un'esperienza completamente estranea, del tutto nuova (…) e invece siamo noi che la costringiamo a questo esilio, a questa esclusione (…)

e penso che siano tutte stronzate. Tutti si ammalano. Fa parte dell'essere vivi" [1]. La malattia non è uno stato specifico dell'essere o un momento nel tempo, ma un continuum. Il titolo della nostra mostra – *Kingdom of the Ill* – richiama il saggio *Malattia come metafora* (1978) della scrittrice e attivista politica americana Susan Sontag, e in particolare il suggerimento di Sontag che ognuno di noi abbia una doppia cittadinanza, una nel regno dello star bene e l'altra nel regno dello star male, e che in un momento o nell'altro dobbiamo identificarci con una di queste. L'idea che ciascuno di noi possa mai raggiungere veramente lo stato ideale di produttività "sana" promosso dal capitalismo è una falsità. Nel tracciare il binario che separa questi due "regni", ci opponiamo alla demarcazione di Sontag e vogliamo invece attirare l'attenzione sui modi in cui lo stare bene è diventato un obiettivo impossibile nel capitalismo avanzato [2]. Come hanno affermato gli economisti Raj Patel e Jason W. Moore: "Chiedere che il capitalismo paghi l'assistenza equivale a chiedere la fine del capitalismo" [3].

Kingdom of the Ill nasce dalla constatazione che negli ultimi dieci anni artisti e artiste hanno sempre più sposato le proprie diagnosi, portando al pubblico la loro esperienza e chiedendo uno spazio aperto e trasparente per il discorso sulla salute e sulla malattia. Seguendo il loro esempio, molte istituzioni artistiche si sono gradualmente spostate verso una programmazione sui temi della malattia e della salute [4], indagando i concetti normativi con cui definiamo ciò che costituisce un corpo "sano". Mostre e programmi pubblici hanno sollevato domande quali: qual è il nostro ruolo in quanto consumatori e consumatrici di farmaci tradizionali e di terapie naturali?

In che modo la devastazione ambientale e l'inquinamento possono influire sulla nostra salute? Quali progressi nella tecnologia e nella *speculative fiction* hanno modificato gli scenari in materia di malattia e di benessere?

Nella sua conferenza performativa del 2018 *The Art of Dying or (Palliative Art Making in the Age of Anxiety)*, la regista Barbara Hammer ha parlato di questo cambiamento nell'ambito della propria esperienza di convivenza con un cancro allo stadio avanzato: "Tutti noi – artisti e artiste, curatori e curatrici, funzionari e funzionarie e amanti dell'arte – stiamo evitando uno dei temi più potenti che sia possibile affrontare. Sono felice di constatare che di recente alcune organizzazioni stanno progettando seminari sulla salute, la malattia, la morte e il morire, e che artisti e artiste escano finalmente allo scoperto, superando la paura di dichiararsi malati" [5]. Se da un lato l'argomento ha acquisito visibilità, dall'altro è diventato dolorosamente evidente che nelle istituzioni artistiche mancano le infrastrutture o i mezzi finanziari per sostenere le modalità di lavoro di artisti e artiste che si identificano come malati cronici o crip [6], nonostante desiderino sostenere le opere d'arte che realizzano. L'onere ricade spesso sugli artisti e le artiste e di conseguenza molti e molte hanno condiviso online i loro *access rider* [7], cioè le loro richieste personali in tema di accessibilità. Questi documenti personalizzabili delineano le esigenze di una persona disabile con l'obiettivo di creare una "intimità dell'accessibilità", espressione definita dall'attivista legale Mia Mingus come "quella sensazione sfuggente e difficile da descrivere di quando qualcun altro 'capisce' le tue esigenze di accessibilità" [8]. Forniti all'inizio di un rapporto di lavoro, gli *access rider* possono aiutare artisti e

artiste a definire e tutelare parametri di retribuzione equa, tempistiche di progetto, assistenti personali, assistenza all'infanzia, specificità alimentari e dietetiche, requisiti di viaggio e alloggio, esigenze di mobilità e accessibilità del luogo o dell'evento. Inoltre, consentono loro di definire come e a chi rendere nota la loro disabilità o malattia e li proteggono dal dover comunicare e ri-comunicare in maniera estenuante le loro necessità. Grazie a questa pratica, l'onere si sposta dall'artista all'istituzione, e il museo deve riflettere su pratiche di lavoro ormai consolidate e adattarsi a nuove procedure. Come spesso accade, artisti e artiste si sono fatti carico di portare avanti questo lavoro prima delle istituzioni: nel 2019, l'artista e scrittrice Carolyn Lazard ha pubblicato *Accessibility in the Arts: A Promise and a Practice*. Questa serie di strumenti, disponibile gratuitamente, definisce dei percorsi per le piccole organizzazioni artistiche non profit, per facilitare e sostenere le relazioni con artisti e artiste e toccare i temi delle barriere e delle opportunità. All'interno di questa guida, Lazard arriva sinteticamente al nocciolo della questione affrontando il discorso del rapido progresso intrapreso da artisti e artiste e la lentezza delle istituzioni: "C'è spesso una discordanza stridente tra il desiderio di un'istituzione di rappresentare le comunità emarginate e il totale disinteresse per l'effettiva sopravvivenza di quelle stesse comunità" [9].

Carried & Held (dal 2012) di Park McArthur è un'opera d'arte ingannevolmente semplice: un elenco che nel formato somiglia a una didascalia museale, in cui sono nominate tutte le persone che hanno sollevato McArthur, che usa una sedia a rotelle perché soffre di una malattia neuromuscolare degenerativa.

Amicizia, comunità, reti di assistenza, aiuto recipro-
co: queste fatiche collettive sono al centro di ciò che
ha stimolato un cambiamento nel discorso sulla malat-
tia, l'abilismo e l'inclusività. Le mostre, i programmi
pubblici, le pubblicazioni e i workshop di collettivi di
artisti e artiste – tra cui Canaries, Feminist Healthcare
Research Group, Pirate Care, Power Makes Us Sick e
Sickness Affinity Group – hanno sollevato il proble-
ma sulla negazione di accessibilità per malati e disabili,
dimostrando come questo problema sia collegato non
solo con il concetto di abilità ma anche di razza, genere,
sessualità e classe. Galvanizzato da precedenti storici –
in particolare da gruppi come ACT UP, Art Workers'
Coalition e, più recentemente, w.a.g.e. e Decolonize
This Space – il lavoro di molti artisti, artiste e collettivi
qui citati si intreccia con l'attivismo e con una vera e
propria richiesta di maggiore trasparenza, equità, in-
frastrutture di supporto e cambiamenti sistemici, sia
all'interno sia all'esterno del mondo dell'arte. Grazie
a modelli di adesione flessibili che possono funzionare
in parte come gruppo di supporto, in parte come rete
di attivisti e attiviste, e (in alcuni casi) come collettivo
artistico, molti gruppi si sono concentrati su proteste e
boicottaggi davanti al pubblico, oltre che sulle raccolte
di fondi per mutuo soccorso.

Dal 2017, l'artista Shannon Finnegan ha prodotto
due versioni della sua installazione interattiva *Anti-Stairs
Club Lounge*, che è una reazione all'inaccessibilità dei siti
architettonici: il Wassaic Project Space (un programma
di residenze per artisti e artiste) a Maxon Mills (2017–18)
e il "Vessel" progettato da Thomas Heatherwick a New
York. In quest'ultima situazione, insieme a una serie

di partecipanti disabili e non, Finnegan ha protestato contro la struttura, chiedendo una "Anti-Stairs Club Lounge", una clublounge senza scale, permanente con un budget da 150 milioni di dollari (equivalente all'intero budget della struttura). Questi luoghi hanno presupposti intrinsecamente abili, proprio come le modalità di fruizione delle mostre e di accesso agli spazi museali, e artisti come Finnegan sono quindi voci cruciali nel dimostrare come questi luoghi debbano cambiare, per garantire un accesso equo.

Nel 2020 diverse persone disabili, malate croniche e immunodepresse si sono riunite per creare il CRIP Fund, con l'obiettivo specifico di ridistribuire i fondi donati a quelle stesse comunità colpite dalla pandemia di COVID-19. Iniziative di mutuo soccorso come il CRIP Fund (e il lavoro del collettivo Sick in Quarters) rendono dolorosamente evidente la necessità per artisti e artiste di ricorrere all'azione collettiva di fronte all'inadeguatezza dei sistemi sanitari statali e di quella mostruosità che conosciamo come complesso medico industriale. In *The Hologram* (2020), che illustra una visione di assistenza rivoluzionaria incentrata su reti sanitarie femministe virali e peer-to-peer, l'artista Cassie Thornton lamenta proprio questa sensazione di sentirsi in trappola: "Non la vediamo come una scelta, perché ci sembra impossibile sacrificare l'accesso ai nostri mezzi di sopravvivenza sotto il capitalismo della finanza, e fare un'esperienza totalmente nuova di collettività, cura e aiuto reciproco abbandonando l'idea di poter diventare soggetti capitalisti di successo" [10].

Questi tentativi procedono parallelamente ai grandi movimenti sociali – la resa dei conti razziale, la

mobilitazione intorno al debito studentesco, il movimento #MeToo, la difesa del clima, le continue richieste che le aziende affrontino le loro responsabilità – che cercano di annullare le continue ingiustizie e violenze, molte delle quali seminate dalla logica del capitalismo che perpetua l'avidità affamata di profitto, la divisione e l'indebitamento. Con molte di queste attività gestite dalla base, emerge una domanda pertinente: quando vedremo un cambiamento significativo? In che modo i discorsi sulla salute e sulla malattia influiscono sul più ampio dibattito sociale? Per le istituzioni artistiche: l'occhio museale itinerante sposterà presto la sua fugace attenzione altrove?

Nel febbraio 2022 è stato annunciato lo scioglimento della Purdue Pharma e il pagamento di 6 miliardi di dollari per risolvere le cause legali legate all'emergenza oppioidi. L'azienda, di proprietà della miliardaria famiglia Sackler, è responsabile della produzione e del marketing aggressivo dell'OxyContin: un oppioide che crea forte dipendenza, prescritto a milioni di pazienti che soffrono di disturbi secondari. L'artista Nan Goldin e le attività di P.A.I.N. (Prescription Addiction Intervention Now) [11] hanno svolto un ruolo di sensibilizzazione dell'opinione pubblica sulla complicità di Purdue Pharma nell'emergenza oppioidi, nonché sugli sforzi sfacciati dei Sackler di sfruttare l'imponente sostegno filantropico da loro elargito a istituzioni artistiche come mezzo per rifarsi una reputazione e riciclare il loro denaro [12].

Tra il 2018 e il 2019, Goldin e P.A.I.N. hanno inscenato proteste e dimostrazioni "die-in" (in cui i partecipanti si sdraiavano sul pavimento, apparentemente

senza vita) presso i musei che avevano accettato donazioni dai Sackler: il Guggenheim, gli Harvard Art Museums, il Museo del Louvre, il Metropolitan Museum, lo Smithsonian e il Victoria & Albert Museum. Riempiendo quegli spazi di finti flaconi di OxyContin, foglietti di ricette mediche e striscioni con slogan come "Shame on Sacklers", Goldin e il P.A.I.N. hanno portato la questione all'attenzione della coscienza sociale. Sebbene sia stata certamente una vittoria giudiziaria, la sentenza ha in definitiva protetto i Sackler, che sono stati assolti da ogni responsabilità e continuano a essere una delle famiglie più ricche degli Stati Uniti. Come ha detto Goldin a proposito della sentenza: "Osservare il lavoro di questo tribunale è stata una vera e propria lezione sulla corruzione di questo Paese, i miliardari e le miliardarie hanno un sistema giudiziario diverso da tutti noi e possono uscirne indenni" [13].

Le attività del P.A.I.N. riguardano tanto l'emergenza oppioidi quanto, più in generale, la salute e la condizione delle strutture di finanziamento delle arti. I Sackler sono solo uno dei tanti donatori la cui ricchezza, negli ultimi anni, è stata sottoposta a un maggiore controllo. Liberate Tate, un collettivo artistico che mira a "liberare l'arte dal petrolio", nel 2017 è riuscito a costringere il museo a recidere i propri legami con la British Petroleum (BP), mentre nel 2019 le proteste di Decolonize This Space hanno contribuito a far sì che Warren Kanders – la cui azienda Safariland produce granate lacrimogene che sono state usate contro migranti al confine tra Stati Uniti e Messico – si dimettesse dal consiglio di amministrazione del Whitney. L'aumento delle rese dei conti con la filantropia tossica

è sintomatico del momento attuale: la salute dei nostri musei, e per estensione delle nostre istituzioni, dipende dal modo in cui rimediamo ai mali del capitalismo e abbracciamo invece equità, giustizia e rappresentanza.

Come si suol dire, "segui i soldi", e infatti non c'è da stupirsi che i cambiamenti più evidenti si stiano verificando a livello di donazioni. Tuttavia c'è ancora molto lavoro da fare, ben oltre la semplice garanzia di offrire rappresentanza a chi si identifica come malato o disabile. Sebbene la pandemia di COVID-19 ci abbia spinto a riconsiderare i confini tra "sani" e "malati" come labili, sfumati o semplicemente falsi, potremmo renderci conto che il cambiamento necessario è molto più profondo. Tutte le forme istituzionali – artistiche e non solo – sono raramente agili e scattanti, eppure è necessario un cambiamento che vada dritto al cuore della maniera in cui sono finanziate, di chi assume il personale e delle pratiche di accessibilità progettate per le comunità di cui sono al servizio. Oltre a questo, dobbiamo imparare nuovi vocaboli, modi di comunicare e di prenderci cura gli uni degli altri – solo così potremmo avvicinarci alla sensazione, come ha detto Mia Mingus, di "capire" le esigenze di accessibilità altrui.

[1] Nwando Ebizie, conduttrice, "The Mediated Body". *For All I Care*, stagione 1, episodio 1, BALTIC Center for Contemporary Art, https://baltic.art/whats-on/podcasts/for-all-i-care.

[2] Tanto per chiarire, non stiamo in alcun modo suggerendo l'eliminazione della distinzione tra coloro che si identificano

come abili o disabili. Rifiutiamo invece la distinzione secca proposta da Sontag e il suo caratterizzare la malattia come "lato notturno della vita" o "cittadinanza più onerosa". Rifiutiamo la possibilità di separare salute e malattia e rifiutiamo le connotazioni simboliche delle definizioni che lei utilizza per descrivere la malattia (Vedi Sontag, Susan. *Malattia come metafora*, Einaudi, Torino, 1979).

[3] Jason W. Moore e Raj Patel, *Una storia del mondo a buon mercato: guida radicale agli inganni del capitalismo*, Feltrinelli, Milano, 2018, p. 172.

[4] Ecco una piccola selezione: *Sick Time, Sleepy Time, Crip Time: Against Capitalism's Temporal Bullying*, EFA Project Space New York (2017), poi esposta al Bemis Center for Contemporary Arts (2018) e al Red Bull Arts Detroit (2019); *I wanna be with you everywhere*, Performance Space New York (2019); *When the Sick Rule the World*, Gebert Stiftung für Kultur, Rapperswil (2020); *CRIP TIME*, Museum Für Moderne Kunst Frankfurt (2021); *Take Care: Art and Medicine*, Kunsthaus Zürich (2022).

[5] Barbara Hammer, *The Art of Dying or (Palliative Art Making in the Age of Anxiety)*, The Whitney Museum of American Art, 10 ottobre 2018, https://whitney.org/media/39543.

[6] Lauryn Youden dà questa definizione di "crip" nell'opuscolo della sua personale del 2020 *Visionary of Knives* presso Künstlerhaus Bethanien, Berlino: "Crip è una parola che molte persone nel campo degli studi sulla disabilità e le comunità di attivisti e attiviste usano non solo per riferirsi a persone disabili, ma anche alla cultura intellettuale e artistica che sta nascendo da queste comunità. 'Crip' è l'abbreviazione di 'cripple', storpio, parola che è stata ed è usata come insulto verso le persone disabili, ma di cui queste si sono riappropriate come termine da usare all'interno della

categoria con un significato di emancipazione e solidarietà".
Carrie Sandahl (2003) è stata tra le prime a sottolineare il potenziale sociale e politico della parola crip, e la descrive come un termine fluido e in continuo mutamento "che si espande a includere non solo persone con delle disabilità fisiche, ma anche persone con disabilità mentali e sensoriali". (Vedi Alison Kafer, *Feminist Queer Crip*, Bloomington, Indiana University Press, 2013).

[7] Johanna Hedva, "Hedva's Disability Access Rider" Tumblr Blog. 22 agosto 2019, https://sickwomantheory.tumblr.com/post/187188672521/hedvas-disability-access-rider;
Leah Clements; Alice Hattrick e Lizzy Rose. Sito web Access Docs for Artists. 26 marzo 2019. https://www.accessdocsfor artists.com/.

[8] Mia Mingus, "Access Intimacy: The Missing Link" *Leaving Evidence*, 5 maggio 2011. https://leavingevidence.wordpress.com/2011/05/05/access-intimacy-the-missing-link/

[9] Carolyn Lazard, "Accessibility in the Arts: a Promise and a Practice", *Common Field and Recess*, 25 aprile 2019, https://www.commonfield.org/projects/2879/accessibility-in-the-arts-a-promise-and-a-practice.

SARA CLUGGISH è direttrice e curatrice "Mary Hulings Ri(
del Perlman Teaching Museum presso il Carleton Coll(
a Northfield, Minnesota. È curatrice e insegnante e
interessa di ricerca sul punto di intersezione tra performa(
e studio delle immagini in movimento, concentrandosi
particolare sugli studi relativi all'assistenza, al gen(
e alla sessualità. Ha conseguito un Master of Fine A(
(MFA) in curatela alla Goldsmiths University di Londr(
un Bachelor of Fine Arts (BFA) in fotografia al Maryl(
Institute College of Art di Baltimora. Ha insegnato sto(

[10] Cassie Thornton, *The Hologram: Feminist, Peer-to-Peer Health for a Post-Pandemic Future*, Londra, Pluto Press, 2020 disponibile online: https://vagabonds.xyz/the-hologram/

[11] Prescription Addiction Intervention Now ("Intervento ora contro la prescrizione di sostanze che danno dipendenza"). L'acronimo P.A.I.N significa in inglese "dolore".

[12] Taylor Dafoe, "They Are Going to Stand by Us: Text Messages Between Members of the Sackler Family Show How They Leveraged Their Museum Philanthropy Into Positive pr". *Artnet News*, 20 dicembre 2022, https://news.artnet.com/art-world/sackler-family-text-messages-museums-1933901

[13] Nan Goldin citata da Sara Jones, "It's a Real Lesson in the Corruption of This Country. Anti-Sackler activist Nan Goldin on the Purdue Pharma bankruptcy settlement". *New York Magazine*, 1 settembre 2021. https://nymag.com/intelligencer/2021/09/nan-goldin-on-purdue-pharma-sackler-settlement.html.

▼

ll'arte al Minneapolis College of Art and Design, nneapolis, MN; è stata direttrice della FD13 Residency r the Arts, Minneapolis e St. Paul, MN, direttrice lla collezione Elizabeth Redleaf, Minneapolis, MN, ratrice di Site Gallery, Sheffield, UK, e assistente ratrice di Nottingham Contemporary, Nottingham, UK. I oi saggi e i suoi testi di critica d'arte sono stati blicati dalle riviste *ArtReview*, *ArtReview Asia*, ieze, *InReview*, *L'Officiel Art Italia* e *The Third Rail*.

PAVEL S. PYŚ è curatore per le Arti visive al Walker Art
Center. Presso il Walker, ha curato mostre personali
di Daniel Buren, Paul Chan, Michaela Eichwald, Carolyn
Lazard ed Elizabeth Price, e la mostra collettiva
The Body Electric. Tra il 2011 e il 2015, è stato curatore di
mostre ed esposizioni all'Henry Moore Institute di Leeds,
dove ha lavorato alle mostre personali di Robert Fillion,
Christine Kozlov, Katrina Palmer, Vladimir Stenberg

rtevant e alle mostre collettive *Carol Bove / Carlo
rpa* e *The Event Sculpture*. Nel 2011 ha ottenuto il
atorial Open dalla Zabludowicz Collection di Londra
è stato curatore in residenza presso la Fondazione
dretto Re Rebaudengo di Torino, Italia. Ha pubblicato
gi su diversi artisti e artiste tra cui Trisha Baga,
ol Bove, Michael Dean, John Latham, Wilhelm Sasnal,
na Szapocznikow, Fredrik Værslev e Hague Yang.

*Lioba Hirsch*

~~KINGDOM~~ OF THE ILL - IL REGNO DEI MALATI

Nel suo libro *Experiments in Imagining Otherwise*, Lola Olufemi (2021, p. 32) scrive: "Forse il tempo è una spirale multiforcuta: un avanzare e un ritirarsi massiccio e risoluto, continuo e inesorabile. Il luogo in cui la memoria e la ripetizione vengono mascherate e riconfigurate". Sono parole che mi toccano, perché mi sembra effettivamente che il passato sia oggi e che ieri, mentre eravamo diretti al presente, abbiamo fatto una capatina nel futuro. L'idea che il tempo sia lineare e che noi ci muoviamo costantemente e rapidamente verso il futuro è stata vera solo per alcune e alcuni di noi, a scapito di altri. Niente illustra meglio questo concetto della pandemia che stiamo vivendo, ancora oggi. Devo insistere su questo, e ripeterlo: viviamo ancora dentro, attraverso e nonostante una pandemia. Sin del primo giorno di restrizioni e lockdown abbiamo sentito ribadire che saremmo tornati alla vita normale, ma molte e molti di noi che hanno sempre abitato i margini della normalità – troppo malati, troppo poveri, troppo illegali,

troppo scuri, troppo neri, troppo grassi, troppo disabili –
si sono sempre chiesti se valesse davvero la pena tornarci.
Una normalità che si è sempre nutrita di disuguaglianze
e ingiustizie strutturali. Una normalità che si è sempre
alimentata dell'idea di una corsia preferenziale che lascia-
va gli altri indietro. Ci sono persone che sin dai primi
mesi del 2020, a causa di malattie croniche, per motivi di
salute non possono accedere a uffici affollati, trasporti
pubblici o centri commerciali. Persone che da allora sono
confinate nelle rispettive case. Persone disabili a cui è
stato sempre ripetuto che lavorare da casa era impossi-
bile, finché a un tratto non è più stato così. Viviamo in
un mondo costruito sull'ingiustizia e la disuguaglianza.
E questo è più chiaro che mai se diamo un'occhiata al
presente, che poi è come dare un'occhiata al passato e – se
posso osare – anche al futuro.

Mentre apparentemente quasi tutti i paesi eu-
ropei tornano pian piano alla "normalità", le soluzioni
tecnocratiche adottate dai governi del mondo per "far
ripartire" l'economia avranno un costo altissimo, sia in
senso letterale sia figurato.

In senso letterale: nel 2021 Pfizer e Moderna, i
due giganti del settore farmaceutico produttori dei vac-
cini anti SARS-COV-2 a m-RNA, hanno alzato il prezzo
della singola dose rispettivamente di un quarto e di un
decimo mentre rinegoziavano i contratti di fornitura
con i paesi europei, ansiosi di assicurarsi scorte supple-
mentari di vaccino per i booster (Mancini et al., 2021).
A partire dalle approvazioni dei vaccini, il prezzo per
dose è variato moltissimo, all'interno dei paesi ad alto
reddito e nei blocchi economici come l'UE e gli USA, ma
anche nei paesi a medio e basso reddito. L'anno scorso

AstraZeneca, che tra le aziende farmaceutiche occidentali è quella che ha imposto un prezzo per dose più basso, ha chiesto al Sudafrica 5,25 dollari per dose, mentre ai paesi europei ne ha chiesti 3,5 (Jimenez, 2021). Le ricerche per sviluppare i vaccini anti SARS-COV-2 sono state ampiamente sovvenzionate dai governi e finanziate dai contribuenti e dalle contribuenti. Eppure le aziende farmaceutiche stanno realizzando profitti enormi. Secondo un rapporto di The People's Vaccine Alliance, un movimento di organizzazioni sanitarie e umanitarie non governative, la Colombia ha strapagato Moderna e Pfizer/BioNTech, sborsando fino a 375 milioni di dollari per 20 milioni di dosi. E parimenti il Sudafrica ha probabilmente strapagato Pfizer/BioNTech sborsando ben 177 milioni di dollari (Marriott e Maitland, 2021).

In senso figurato: mentre l'alto costo dei vaccini – e i margini di profitto, che ne sono i principali responsabili – colpisce tutti i paesi del mondo, i paesi a basso e medio reddito hanno un potere d'acquisto inferiore e quindi una inferiore capacità di vaccinare la popolazione. Non possono costruirsi delle riserve come hanno fatto i paesi europei e nordamericani e non hanno le infrastrutture necessarie a prodursi dei vaccini da soli. E anche se lo facessero, la produzione di vaccini è comunque protetta da brevetti. L'anno scorso, la Germania e altri paesi europei hanno chiesto all'OMC una deroga per il vaccino contro il COVID-19, che avrebbe permesso ai paesi del mondo di produrre vaccini senza dover pagare il brevetto alle aziende farmaceutiche (Lopez Gonzalez, 2022). Attualmente la maggioranza dei paesi a basso reddito e quindi la maggioranza dei paesi africani riusciranno a proteggere con il vaccino

un'ampia fetta della popolazione solo dal 2023 in poi, se mai questo accadrà (The Economist Intelligence Unit, 2021). Questo ha delle conseguenze non solo sulla salute delle persone, delle nazioni e delle regioni, ma anche sulla possibilità degli individui di viaggiare, fare affari, andare a trovare parenti o amici e amiche, e accedere a un'istruzione nei paesi ad alto reddito. A parte il fatto che viaggiare senza vaccino può essere poco sicuro, i paesi dell'UE, per esempio, hanno imposto delle restrizioni che riguardano quali persone possono valicare i loro confini e come devono essere state vaccinate (Council of the European Union, 2022). Fino al 2021, anno in cui ha abrogato tutte le norme relative al COVID-19, il Regno Unito permetteva l'ingresso solo a persone che si erano vaccinate in un paese o in una regione approvati dal governo britannico.

Le disuguaglianze e le iniquità che stanno alla base di queste differenze strutturali e politiche non sono casuali, e nemmeno sono il prodotto del passato recente. La salute – a livello nazionale e globale – è sempre stata un tema fortemente politico e collegato alle politiche estrattive e protezioniste dei paesi occidentali (cioè paesi popolati da una maggioranza di persone di origini europee) e le attuali diseguaglianze si attuano in larga parte sulla linea di demarcazione tra colonizzati e colonizzatori. Anche questa non è una coincidenza. La salute globale e le sue precorritrici – la medicina coloniale e quella tropicale – sono sempre state improntate agli interessi dei governi, degli abitanti e delle abitanti di pochi paesi selezionati, a detrimento delle immense popolazioni che hanno cercato di dominare, prima formalmente, in epoca coloniale, e poi informalmente, dopo l'indipendenza.

Come ha dimostrato Randall Packard (2016), le preoc-
cupazioni e gli interessi dei popoli un tempo colonizzati
raramente vengono presi in considerazione nei disegni,
nei processi decisionali e nei giochi di potere politici
riguardanti la salute globale, le sue strutture e istituzioni.
Storicamente questo problema ha diverse dimensioni.
Da un lato la medicina coloniale – il sistema su cui si
basa la salute globale contemporanea – è stata pensata
esclusivamente allo scopo di proteggere la salute e lo
stile di vita delle popolazioni europee. Se le forze colo-
nizzatrici hanno investito in salute nelle colonie, quelle
infrastrutture erano comunque destinate ai funzionari
coloniali europei, alle loro famiglie e alle élite locali, e
non alla maggioranza della popolazione colonizzata. Per
esempio negli anni trenta del secolo scorso in Nigeria,
all'epoca colonia britannica, 4000 europei ed europee ve-
nivano curati in dodici ospedali, mentre quaranta milioni
di nigeriane e nigeriani erano serviti da cinquantadue
ospedali (Rodney, 1981). In un certo senso, come fa
osservare Walter Rodney, il colonialismo ha gettato le
basi per le attuali disuguaglianze in materia di salute e
per l'incapacità degli ex paesi colonizzati di competere
con gli ex poteri colonialisti per aggiudicarsi dei vaccini
sul mercato internazionale. Il potere economico delle ex
nazioni colonialiste non può essere scisso dalla ricchezza
che hanno accumulato attraverso il colonialismo estrat-
tivo (Acemoğlu e Robinson, 2017).

D'altro canto, le politiche e le priorità in mate-
ria di salute sono anche state pensate per proteggere le
popolazioni europee dai popoli colonizzati. In epoca
coloniale, gran parte delle spese governative si concentra-
vano sulle malattie infettive, che potevano rappresentare

una minaccia per le vite delle colonizzatrici e dei colonizzatori europei. Più tardi, allo scoppio delle due guerre mondiali e con gli investimenti su larga scala nelle industrie estrattive per l'esportazione, la medicina coloniale cominciò a interessarsi sempre più alla nutrizione. Questo doveva mantenere in salute la forza lavoro locale e contribuire al successo militare ed economico dei paesi colonizzatori. Il primato delle malattie infettive come obiettivo prioritario delle politiche della salute globale persiste ancora oggi (Global Health 50 50, 2020). Si potrebbe pensare che questo avrebbe dovuto preparare il mondo – e gli ex paesi colonizzati – alla possibilità di una pandemia globale. Tuttavia gli ex paesi colonizzati, soprattutto in Africa e Asia centrale e meridionale, si sono rivelati tra i peggiori in fatto di preparazione all'epidemia (Madhav et al., 2017).

Le disuguaglianze storiche, molte delle quali si possono far risalire al colonialismo europeo, hanno conseguenze che si estendono fino al futuro e determinano oggi risultati differenti in materia di salute. Mentre è facile disegnare la mappa di queste disuguaglianze globali in materia di salute, è anche importante capire come il passato coloniale abbia inciso sulle vite di persone di origine africana, asiatica e indigena, in altre parole di persone razzialmente identificate come scure e nere in Europa e nelle Americhe. Negli USA, nel Regno Unito e in Brasile, le persone nere o afrodiscendenti hanno corso maggiormente il rischio di morire di infezione da coronavirus dei loro corrispettivi bianchi, anche dopo che nelle statistiche si è tenuto conto dell'età. Negli USA, le persone indiane americane o le popolazioni native dell'Alaska hanno avuto più

del doppio del rischio di morire di coronavirus delle persone americane bianche. Le persone americane nere o afrodiscendenti hanno avuto +1,7 probabilità di morire di SARS-COV-2 e le persone di origine ispanica o Latinx +1,8 (CDC, 2022). In Brasile, che ha accolto il maggior numero di schiave e schiavi africani durante la Tratta transatlantica, e che quindi ha una popolazione nera numericamente ragguardevole, la percentuale di morti tra le persone nere è stata del 26,3% rispetto al 15,1% della popolazione brasiliana bianca (in rapporto a uno standard di riferimento del 2019) (Marinho et al., 2022). Infine, nel Regno Unito l'Office for National Statistics ha riferito che durante la prima ondata di coronavirus, nella primavera/estate del 2020, il tasso di morti relative al COVID-19 è stato di 3,7 volte superiore tra le persone nere afrodiscendenti rispetto alle persone britanniche bianche (ONS, 2021). Nella seconda ondata e nelle successive (delta e omicron), il tasso di mortalità più alto è stato registrato tra gli uomini provenienti dal Bangladesh (tra 2,7 e 5 volte superiore a quello degli uomini britannici) (ONS, 2022). Razzismo e disuguaglianze strutturali non determinano solo un diverso accesso ai vaccini con le relative conseguenze per la salute globale, ma anche chi vive o muore in ogni paese. Il razzismo, grande motivatore del colonialismo, perdura anche dopo l'indipendenza formale delle ex colonie e oggi influisce sulla nostra vita, il nostro lavoro e la nostra morte. Chi poteva lavorare da casa, avere fiducia nel sistema e nelle autorità sanitarie, perché non era mai stato tradito, e chi sapeva di poter confidare nelle cure da parte del governo, è stato determinato in larga parte in base a presupposti di stampo razzista.

Da tempo le infrastrutture sanitarie sono legate a desideri coloniali e sono diventate di difficile accesso per molti e molte. Allo stesso modo, i vaccini non sono semplici soluzioni tecnocratiche come ci vengono presentate. Quando nel 2020 la Pfizer è stata salutata come una delle aziende farmaceutiche che avrebbe salvato il mondo dalla pandemia, alcuni di noi si sono ricordati che nel 1996 era stata costretta a pagare un indennizzo extragiudiziale a numerose famiglie della Nigeria settentrionale i cui figli e figlie erano morti o resi disabili in seguito al trial di un farmaco sperimentale (BBC, 2011). Anche la possibilità di usare le popolazioni africane come laboratori di ricerca nasce durante il periodo coloniale. Louis Pasteur, per esempio, poté compiere grandi progressi scientifici perché ebbe accesso alle popolazioni colonizzate, meno protette dai nuovi standard etici rispetto alle loro controparti francesi o europee (Latour, 1993). Allo stesso modo, il microbiologo tedesco Robert Koch istituì dei cosiddetti "campi di concentramento" per studiare l'evoluzione e la cura della malattia del sonno e della tubercolosi nell'Africa orientale colonizzata (Schwikowski, 2022). Queste storie si ripetono, o forse è più corretto dire che non si sono mai concluse. Nei primi mesi del 2020, quando alcuni medici francesi suggerirono di testare i farmaci sperimentali contro il COVID-19 in Africa perché nel continente si rispettava poco la norma di indossare la mascherina e c'erano poche unità di rianimazione (Busari e Wojazer, 2020), ancora una volta è stato come se il tempo non fosse passato.

Spesso si ha l'impressione di ritrovarsi incastrati tra passato e presente, in questo strano posto dove prende forma il futuro. Attualmente, almeno in materia di

salute ed eguaglianza vaccinale, questo futuro somiglia molto al presente, che a sua volta somiglia in maniera inquietante al passato. Mentre alcuni e alcune di noi, soprattutto chi è abbastanza bianco e ricco, possiede il passaporto giusto e ha rapporti privilegiati con infrastrutture farmaceutiche e sanitarie, vanno avanti, escono dalla pandemia e tornano alla nuova normalità, chi è troppo povero, troppo scuro e ha case e storie troppo segnate dagli effetti nefasti del colonialismo, resta bloccato in un luogo circolare dove passato e presente si incontrano. Sfortunatamente, sembra proprio che Lola Olufemi (2021) avesse ragione: la nostra memoria viene mascherata e riconfigurata, e quindi i nostri non sono più ricordi, ma spezzoni di un futuro nel quale non abbiamo fatto abbastanza per neutralizzare il male del colonialismo passato e in cui lasciamo che la promessa e la possibilità di un futuro più giusto ed equo si superino sfrecciando sulla corsia preferenziale: uno sguardo fugace e sono già scomparse. Questo potrebbe essere il mondo che siamo condannati ad abitare: un mondo che sposa una soluzione tecnocratica che non risolve molto per la maggior parte di noi, e che lascia agli altri e alle altre l'illusione che vada tutto benissimo.

Riferimenti:

Acemoğlu, Daron e James Robinson, "The Economic Impact of Colonialism", *VoxEU.Org* (blog), 30 gennaio 2017. https://voxeu.org/article/economic-impact-colonialism

BBC, "Pfizer: Nigeria Drug Trial Victims Get Compensation", *BBC News*, 11 agosto 2011, sez. Africa. https://www.bbc.com/news/world-africa-14493277

Busari, Stephanie e Barbara Wojazer, "French Doctors' Proposal to Test COVID-19 Treatment in Africa Slammed as 'Colonial Mentality'", CNN, 7 aprile 2020. https://www.cnn.com/2020/04/07/africa/french-doctors-africa-covid-19-intl/index.html

CDC, Centers for Disease Control and Prevention, "Cases, Data, and Surveillance", 11 febbraio 2020. https://www.cdc.gov/coronavirus/2019-ncov/covid-data/investigations-discovery/hospitalization-death-by-race-ethnicity.html

Council of the European Union, "COVID-19: Travel from Third Countries into the EU", 2022. https://www.consilium.europa.eu/en/infographics/covid19-travel-restrictions-third-countries-february2022/

Global Health 50 50, "Boards for All?", 2020. https://globalhealth5050.org/

Jimenez, Darcy, "COVID-19: Vaccine Pricing Varies Wildly by Country and Company", *Pharmaceutical Technology* (blog), 26 ottobre 2021. https://www.pharmaceutical-technology.com/analysis/covid-19-vaccine-pricing-varies-country-company/

Latour, Bruno, *The Pasteurization of France*, Harvard University Press, Cambridge, Massachusetts, 1993.

Lopez Gonzalez, Laura, "Why Won't Germany Support a COVID-19 Vaccine Waiver? Anna Cavazzini Answers This and More Ahead of the EU-AU Summit | Heinrich Böll Stiftung | Brussels Office – European Union", *Heinrich-Böll-Stiftung* (blog), 16 febbraio 2022. https://eu.boell.org/en/2022/02/16/why-wont-germany-support-covid-19-vaccine-waiver-anna-cavazzini-answers-and-more-ahead

Madhav, Nita, Ben Oppenheim, Mark Gallivan, Prime Mulembakani, Edward Rubin e Nathan Wolfe, "Pandemics:

Risks, Impacts, and Mitigation", in *Disease Control Priorities: Improving Health and Reducing Poverty*, Dean T. Jamison, Hellen Gelband, Susan Horton, Prabhat Jha, Ramanan Laxminarayan, Charles N. Mock e Rachel Nugent (a cura di), 3a ed., The International Bank for Reconstruction and Development / The World Bank, Washington, D.C., 2017. http://www.ncbi.nlm.nih.gov/books/NBK525302/.

Mancini, Donato Paolo, Hannah Kuchler e Mehreen Khan, "Pfizer and Moderna Raise EU COVID Vaccine Prices", *Financial Times*, 1 agosto 2021. https://www.ft.com/content/d415a01e-d065-44a9-bad4-f9235aa04c1a

Marinho, Maria Fatima, Ana Torrens, Renato Teixeira, Luisa Campos Caldeira Brant, Deborah Carvalho Malta, Bruno Ramos Nascimento, Antonio Luiz Pinho Ribeiro et al., "Racial Disparity in Excess Mortality in Brazil during COVID-19 Times", *European Journal of Public Health* 32, n. 1 (1 febbraio 2022), pp. 24–26. https://doi.org/10.1093/eurpub/ckab097.

Marriott, Anne, e Alex Maitland, "The Great Vaccine Robbery", The People's Vaccine Alliance [https://peoplesvaccine.org], 29 luglio 2021.

Olufemi, Lola, *Experiments in Imagining Otherwise*, Hajar Press, Maidstone, 2021.

ONS (Office for National Statistics), "Updating Ethnic Contrasts in Deaths Involving the Coronavirus (COVID-19), England", Office for National Statistics, 7 aprile 2022. https://www.ons.gov.uk/peoplepopulationandcommunity/birthsdeathsandmarriages/deaths/articles/updatingethniccontrastsindeathsinvolvingthecoronaviruscovid19englandandwales/10january2022to16february2022.

ONS (Office for National Statistics), "Updating Ethnic Contrasts in Deaths Involving the Coronavirus (COVID-19), England: 24 January 2020 to 31 March 2021", Office for National Statistics,

26 maggio 2021. https://www.ons.gov.uk/peoplepopulation
andcommunity/birthsdeathsandmarriages/deaths/articles/
updatingethniccontrastsindeathsinvolvingthecoronavirus
covid19englandandwales/24january2020to31march2021.

Packard, Randall M., *A History of Global Health: Interventions into the Lives of Other Peoples*, edizione illustrata, Johns Hopkins University Press, Baltimora, 2016.

Rodney, Walter, *How Europe Underdeveloped Africa*, Howard University Press, Washington, D.C., 1981.

Schwikowski, Martina, "Robert Koch's Dubious Legacy in Africa", DW.COM, 24 marzo 2022. https://www.dw.com/en/robert-kochs-dubious-legacy-in-africa/a-61235897.

The Economist Intelligence Unit, "Coronavirus Vaccines: Expect Delays", The Economist, Londra, 2021. https://pages.eiu.com/rs/753-RIQ-438/images/report%20q1-global-forecast-2021.pdf?mkt_tok=NzUzLVJJUS00MzgAAAGEeiPcSJdyPzt81j jNl52s4fUCQGhAhfcpOTmlh7dVJhYm25gwZgU2muUJS xvcPSMB79Of485NxNci9ha5-tDsT6jyFwCiP10-I1o2PsJ6u Ql4Cg.

LIOBA HIRSCH è ricercatrice all'Università di Liverp●
e si occupa del legame tra colonialismo, razzismo con†
i neri e biomedicina occidentale, e di gestione globa‹
della sanità. Le sue ricerche si sono incentrate su⌘
sviluppo storico, la gestione attuale e le conseguer₁
coloniali degli interventi sanitari britannici
Africa occidentale. Hirsch scrive anche testi crit∎
sull'umanitarismo, la medicina e il razzismo. Si
laureata in Scienze politiche presso Sciences Po Paris e

ciologia politica presso la London School of Economics.
a il 2014 e il 2015 ha lavorato per GIZ, l'agenzia di
iluppo internazionale del governo tedesco in Zambia.
ottenuto un PhD in Geografia e Salute globale presso
University College di Londra. Da novembre 2019 a maggio
21 è stata Research Fellow al Centre for History in
blic Health presso la London School of Hygiene and
opical Medicine (LSHTM) e ha lavorato a un progetto
lla storia coloniale della facoltà stessa.

Amy Berkowitz

CRONACA "POST-COVID" DALL'HOTSPOT CALIFORNIANO DELLA PANDEMIA

Mentre festeggiamo la cosiddetta fine della pandemia, anche se contagi e decessi continuano a crescere, io non riesco a smettere di pensare a Chelm.

Avete mai sentito parlare di Chelm? È un villaggio inventato, descritto nella letteratura classica yiddish e amministrato da un consiglio di "saggi" la cui stupidità è fonte di numerosi aneddoti divertenti.

Da bambina avevo un libro illustrato in cui erano raccolte diverse storie su Chelm. Una in particolare mi viene in mente:

Una mattina a Chelm cadde la neve e tutto il villaggio era ricoperto da una coltre bianca e luccicante. La neve era così bella che i saggi vollero assicurarsi che non fosse rovinata dalle impronte degli studenti e delle studentesse che uscivano da scuola. Così tennero un consiglio straordinario in cui idearono il seguente piano: i genitori sarebbero andati a prendere i figli e le figlie alla fine della scuola per portarli a casa in braccio.

Che ne pensarono gli abitanti e le abitanti di Chelm delle impronte lasciate di genitori nella neve? Qualcuno se ne accorse, le fece notare?

So che Chelm non esiste, ma questa storia suona come un avvertimento.

☺

A San Francisco il COVID sta circolando proprio come durante l'ondata di Delta, ma ora non c'è più l'obbligo di mascherina, perché la narrativa dominante è che il "COVID non c'è più".

Il problema è che il COVID c'è ancora. Il COVID è ancora presente, ma è più difficile da vedere. Qualche mese fa c'erano un sacco di posti dove farsi un test PCR gratuito. Oggi molti di questi punti tampone sono scomparsi e quindi i contagi non vengono individuati. Per avere un'idea più precisa di quanto stia circolando il COVID, bisogna usare un sito web, farraginoso e difficile da navigare, che monitora la presenza del virus nelle acque di scarico.

Ora che il COVID non c'è più, parlare della pandemia in corso acquista un sapore cospiratorio. E credere in una cospirazione ti dà la sensazione di essere sull'orlo della pazzia.

☺

Per tutta la pandemia sono stata molto più attenta della maggior parte dei miei amici e delle mie amiche. La mia prudenza è dovuta al fatto che soffro di una malattia cronica, ma non come potreste pensare. Per quanto ne

so, il mio sistema immunitario non è compromesso – ho le stesse probabilità di sviluppare una forma grave di COVID di una persona che non soffre di fibromialgia. Ma so cosa vuol dire avere una malattia cronica. Già convivo con affaticamento e nebbia cognitiva e immagino quanto potrebbe essere difficile contrarre un'altra malattia cronica – il cosiddetto long COVID – sommata a quella che ho già.

Ma le persone che non soffrono di una malattia cronica non capiscono. In genere la gente pensa che la malattia sia una cosa che ha una fine – i biglietti di pronta guarigione ottengono l'effetto sperato e la febbre scende, la tosse si placa, l'operazione riesce e la malattia sparisce.

E quindi per molte persone l'idea del long COVID è molto difficile da afferrare. Quando almeno ne sono consapevoli.

<center>☺</center>

Un mio amico si è ammalato di long COVID proprio all'inizio della pandemia, quindi per me è stato subito molto chiaro che si trattava di una malattia vera che colpiva le persone. Ma se consideriamo che si tratta di una condizione che interessa tra il 10 e il 30% delle persone che hanno passato il COVID, è davvero strano quanto poco se ne parli sui media.

Ogni volta che nomino il long COVID a mia madre, lei dice: "Io ti credo, ma al telegiornale non ne parlano quasi mai."

<center>☺</center>

La settimana scorsa un amico mi ha mandato il link della trascrizione di una trasmissione della NPR (National Public Radio) dal titolo "La Bay Area focolaio californiano del COVID, casi in aumento", che diceva che nelle ultime due settimane i casi erano più che raddoppiati, ma le esperte e gli esperti intervistati sembravano stranamente poco preoccupati.

La dottoressa Maria Raven, primaria di medicina d'emergenza all'UCSF (University of California San Francisco), avvertiva: "Potete continuare a fare la solita vita. Avete fatto tutto quello che c'era da fare. Vi siete vaccinati, quindi uscite, andate fuori a cena. Voltate pagina".

<center>☺</center>

Non ho visto il discorso dell'immunologo dott. Anthony Fauci, consulente della Casa Bianca in materia di politica sanitaria, sulla fine della pandemia, ma ne ho sentito parlare da mia madre. "Ha detto che è finita, ma ha ripetuto che siccome lui è ad alto rischio continuerà a prendere precauzioni".

"Chissà se qualcuno gli stava puntando addosso una pistola, fuori dall'inquadratura".

"Come dici?" Era una giornata ventosa e il telefono prendeva male. Era una battuta troppo cinica per ripeterla.

"Lascia perdere".

<center>☺</center>

C'è una cosa che voglio dire ed è che sono incinta. Non ho mai scritto di questo, ma qui mi sembra pertinente.

Uno dei motivi è che corro un rischio molto superiore di ammalarmi gravemente o di morire di COVID.

Ho cominciato a sentire muoversi la bambina il giorno della Festa della mamma. Carino da parte sua, aspettare proprio quella ricorrenza. Certo, è una coincidenza, eppure…

L'azienda di mio marito ha imposto a tutti di tornare in ufficio dopo due anni di lavoro da remoto. È un'azienda *tech*, quindi il lavoro in presenza non ha alcun vantaggio, prescindendo dall'ipotesi fantasiosa che alcune conversazioni spontanee nei corridoi possano generare idee rivoluzionarie che trasformeranno il futuro dell'organizzazione e bla bla bla.

Ricordo di avere letto un tweet che più o meno diceva che l'unico motivo per cui le e i CEO vogliono che la gente torni in ufficio è perché così possono guardarsi intorno e dire: "Ma guarda quante persone governo".

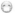

Mio marito non è tornato in ufficio. Siamo in attesa di sentire se sono intenzionati a fare delle eccezioni.

Cosa faremo se si rifiutano di accettare la nostra richiesta di continuare a lavorare da remoto motivata dalla mia gravidanza?

Forse potremmo chiedere un'intesa sulla base dell'ansia di mio marito, disturbo incluso tra le disabilità previste nell'ADA (Americans with Disabilities Act). Potremmo spiegare che la sua ansia è peggiorata, perché ha paura di prendersi il COVID in ufficio e contagiare sua moglie, la quale potrebbe ammalarsi

gravemente o morire e potrebbe avere una gravidanza con complicanze, tra le quali la possibilità che la bambina nasca morta.

<center>☺</center>

Sono fortunata a poter lavorare da casa – cosa che faccio da prima dell'inizio della pandemia, dato che sono una scrittrice freelance. Un sacco di persone che soffrono di malattie croniche, che sono incinte o persone incinte che soffrono di malattie croniche non possono permettersi il lusso di lavorare da remoto.

Faccio parte di un gruppo Facebook sulle malattie croniche dove ho scritto un post su come sia alienante vedere amici e amiche condividere foto di concerti punk affollatissimi in cui nessuno porta la mascherina, e qualcuno commenta: "Sì, io mi occupo della security in un locale per concerti e nessuno se la mette. Anche se io la indosso sempre, mi sono preso il COVID e ora ho paura di ritornare al lavoro".

<center>☺</center>

Quante persone si devono ammalare di una malattia cronica prima che la nostra società inizi a prenderle sul serio?

Il COVID sta dimostrando di essere una malattia in grado di provocare disabilità di massa. In un solo anno a causa del long COVID sono diventate disabili 1,2 milioni di persone. Cosa accadrebbe se tutte le persone colpite da long COVID si lasciassero radicalizzare da questa disabilità?

Un'amica di Minneapolis mi racconta che gli spazi culturali, uno dopo l'altro, stanno ricevendo messaggi in cui la gente chiede informazioni su quale sia il loro protocollo anti-COVID. Io credo che sia una cosa positiva – gli spazi che ospitano eventi culturali devono sapere che questo genere di protocolli rappresentano un problema per il pubblico: se le mascherine sono facoltative, le persone che soffrono di malattie croniche non possono partecipare agli eventi.

Io le chiedo come sta andando e lei risponde: "Il lato positivo è che in questo modo è più facile capire di chi fidarsi ma purtroppo … non sono molti".

<p style="text-align: center;">☺</p>

Ricordo che all'inizio della pandemia eravamo tutti d'accordo: LA MIA MASCHERINA PROTEGGE TE, LA TUA MASCHERINA PROTEGGE ME. Le mascherine funzionano ancora allo stesso modo, solo che adesso ci lasciano intendere che non dobbiamo più preoccuparci di proteggerci a vicenda.

David Leonhardt, giornalista del *New York Times*, afferma che i nostri timori per la salute altrui sono del tutto infondati. In un'intervista per il podcast *The Daily* del quotidiano, all'apice dell'ondata di Omicron, ha sollecitato ascoltatrici e ascoltatori a tornare alla vita "normale", citando en passant e liquidando frettolosamente il rischio rappresentato dal COVID per le persone immunodepresse e anziane, evitando al tempo stesso di osservare che bambine e

bambini piccoli non possono essere vaccinati e ignorando il long COVID:

"Ora, io so che molte persone vaccinate con il booster diranno: non mi preoccupo per me, mi preoccupo di non contagiare le altre e gli altri. E questo dimostra un'attenzione ammirevole nei confronti del prossimo. Ma va ricordato che anche quelle persone hanno avuto l'opportunità di vaccinarsi. E i dati suggeriscono che per chi è vaccinato Omicron si manifesta come una comune malattia respiratoria… che però può colpire duramente le persone anziane o immunodepresse. Quindi la domanda diventa, se il COVID comincia a somigliare sempre di più a un normale virus respiratorio, è razionale… sconvolgere la nostra vita in maniera così profonda e gravida di conseguenze?"

Questa è eugenetica travestita da buon senso.

Queste sono le fonti da cui le persone come mia madre ascoltano le notizie.

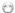

Un pensiero che faccio spesso: se nominassero uno dei miei amici o amiche che soffrono di una malattia cronica a dirigere i provvedimenti anti COVID del paese, le cose andrebbero molto meglio. Andrebbero meglio anche solo se lo facesse un bambino dotato di un certo buon senso. Perfino se se ne occupasse la mia gatta, le cose andrebbero meglio.

Forse la mia gatta no – perché è troppo felice di averci tutti e due a lavorare a casa.

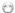

Durante la pandemia ho partecipato a una lezione di ginnastica di gruppo. Ero l'unica che indossava la mascherina e l'istruttore continuava a dirmi: non è difficile respirare con quella, non staresti meglio senza? Fortunatamente, con l'aumento dei contagi la palestra ha cominciato a proporre lezioni online. Ma non appena hanno potuto riprendere l'attività in presenza, hanno eliminato i corsi online. Non ci sono più tornata.

L'altro giorno ci sono passata davanti e ho visto che sulla bacheca fuori dalla palestra c'era un nuovo cartello: "Smaschera il tuo potenziale – non lasciare che la paura ti freni".

<center>☺</center>

È sconfortante la frequenza con cui persone come il proprietario della palestra e David Leonhardt confondono il problema della "paura" con quello della *pandemia in corso, per cui la reazione più razionale è la cautela*.

Come se il problema di mio marito fosse l'ansia.

Alle medie dovevamo mandare a memoria una lista di errori di logica. Non sono sicura di quale sia questo, forse il "red herring", la proverbiale falsa pista.

Come mai le altre persone non riconoscono che questa goffa manipolazione retorica è un errore?

Immagino che sia perché desiderano con tutto il cuore credere che la pandemia sia finita.

<center>☺</center>

Ricevo un messaggio con dei consigli da un'amica che l'anno scorso ha avuto un bambino. Ecco il tiralatte che

ho usato io, una lista di cose da farsi regalare, il gruppo Facebook delle mamme ricche che danno via articoli di lusso smessi per bambine e bambini.

Ieri sera mi ha scritto se avevo già dato un'occhiata ai possibili nidi. No, ancora no.

Mia figlia non è ancora nata e già mi preoccupo del fatto che possa contrarre il COVID al nido.

La risposta del nostro paese al COVID è spaventosamente inadeguata, ma con una nota deprimente e familiare: mi ricorda quello che abbiamo fatto per contrastare il cambiamento climatico.

Invece di risolvere il problema, decidiamo che è impossibile farlo, perché avrebbe un impatto negativo sull'economia. Invece di proteggere le persone da un pericolo, ci inventiamo una storia che dice che quel pericolo non esiste.

Non ho ancora detto alla mia migliore amica del liceo che sono incinta. Anni fa, quando le ho raccontato che avevo intenzione di avere un figlio, mi ha risposto che non capiva come qualcuno potesse desiderare una cosa del genere, in considerazione del cambiamento climatico e di tutto il resto.

Qualche anno prima ricordo che descriveva la sua visione del mondo in questo modo: "Il mondo è solo un pezzo di merda che galleggia nel water".

Non che non la capisca. Il pianeta è spacciato.

Qui sulla Terra c'è molta sofferenza, molto dolore. La gente fa cose tremende agli altri, alle altre e al mondo in cui vive.

Ma questo mondo di merda è l'unico che conosco e in quel suo galleggiare io ho trovato bellezza e amore.

☻

Prima di conoscere il sesso della bambina avevo preparato un elenco di nomi maschili e uno di nomi femminili.

Uno dei miei nomi maschili preferiti era Noah. Mi piaceva che contenesse un "no" e che non suonasse troppo virile. Ma poi ho visto che nella classifica dei nomi più utilizzati nel 2022 era al secondo posto.

Ma certo, ho pensato. È ovvio che tutti vogliano chiamare il figlio Noah, Noè. Tutti vogliono un figlio che diventerà l'eroe dell'arca, che ci salverà dalle nostre malefatte, dal diluvio, e rimedierà a tutti i danni che abbiamo arrecato.

☻

AMY BERKOWITZ è autrice di *Tender Points* (Nightboat Book 2019). Suoi scritti e interviste sono stati pubblicati varie riviste, tra cui *Bitch*, *The Believer*, *BOMB* e *Jew Currents*. Dal 2017 al 2020 è stata coordinatrice de residenza per scrittori e scrittrici di Alley Cat Books e 2016 ha contribuito a organizzare il Sick Fest di Oakla

La mia amica che ha avuto un figlio l'anno scorso sta per salire sul treno e stende sul passeggino una coperta impermeabile. "È la nostra piccola bolla anti COVID" dice in tono scherzoso.

Ed eccola, la risposta alla domanda che mi circola in testa da quando ho saputo di essere incinta: come farò a tenere mia figlia lontana dal COVID (e anche da tutto il resto) quando i nostri saggi, posseduti da un perverso desiderio capitalista di morte, continuano a inventarsi delle fantasie invece di agire?

Farò quello che posso e spero che basti.

suo lavoro ha ricevuto il sostegno dell'Anderson ter, di This Will Take Time, Small Press Traffic e del mel Harding Nelson Center for the Arts. Berkowitz vive an Francisco in un appartamento a canone controllato, e sta scrivendo un romanzo.

Artur Olesch

NELLE (BUONE) MANI DELLA TECNOLOGIA

L'umanità si sta orientando verso una sanità completamente nuova, caratterizzata da accessibilità virtuale e dalla perfezione dell'intelligenza artificiale (AI) al posto del contatto umano e dell'interazione faccia a faccia. Una medicina "da asporto" già disponibile sugli smartphone, ovunque e in qualunque momento. Una democratizzazione sospinta da algoritmi, invece che dal modello paternalistico riservato ai medici e alle mediche. Una personalizzazione al posto di una sanità in cui le cure sono uguali per tutti e tutte. Un pieno controllo della salute invece dell'affidare al destino i nostri corpi e il nostro stato. Come gli dèi o gli idoli dell'antichità, la tecnologia promette una salute migliore e una vita più lunga: sogni eterni per i quali siamo disposti a fare qualunque cosa.

ARCHIVI
Circondati da tecnologia all'avanguardia

La pandemia di COVID-19 ha investito il globo come una tempesta, trattando tutti gli esseri umani allo stesso

modo e facendo più vittime nei paesi che hanno perduto l'egoistica battaglia per i respiratori in grado di pompare aria nelle vie aeree dei pazienti e delle pazienti o per i vaccini in grado di ridurre la mortalità. Un'epoca di lockdown e isolamento, di funerali senza commiato, di aggiornamenti quotidiani sulle statistiche dei contagi, di mascherine e lavoro da remoto. Eppure, nessuno si è accorto che il 2020–2022 ha segnato l'avvento dell'era della sanità Do-It-Yourself (DIY), fai da te.

A un primo sguardo, niente di nuovo: le innovazioni hanno fatto il loro ingresso in medicina negli anni novanta del Novecento. I fascicoli sanitari elettronici e le ricette online hanno lentamente sostituito i loro equivalenti cartacei. La telemedicina ha reso i servizi sanitari accessibili anche fuori dall'ambulatorio medico – basta solo avere un computer o uno smartphone e il Wi-Fi.

Questa evoluzione ha anche significato un accesso illimitato alle conoscenze mediche, per secoli rimaste appannaggio dei medici e delle mediche. Ogni giorno su Google si effettuano un miliardo di ricerche relative alla salute. Il medico più famoso al mondo, disponibile 24 ore su 24, risponde a 70.000 domande al minuto su rash cutanei, le medicine migliori, i calcoli renali o i rimedi naturali contro i sintomi dell'influenza. I risultati delle ricerche con l'AI, suscitano speranze o paure e influiscono sulle decisioni e sulle vite di miliardi di persone.

In questo universo infinito di tecnologie applicate alla salute, negli app store sono disponibili più di 500.000 applicazioni per cellulari, che ci assistono per dimagrire o migliorare la nostra salute mentale e aiutano le persone a convivere con le malattie croniche. In certi paesi i medici e le mediche arrivano a prescrivere app

e giochi come se fossero medicine. Così ingoiare una pillola equivale ormai ad aprire un'app e seguire le istruzioni. Dispositivi indossabili e smartwatch monitorano 24 ore su 24 i nostri biomarcatori, le impronte digitali della nostra salute.

Tuttavia, sotto tutte queste innovazioni sensazionali c'è una narrativa ben più ampia. I servizi sanitari non sono più un luogo in cui ci si reca. Ora sono qualcosa che ci vede. O che siamo noi stessi a creare. Si tratta di qualcosa di più di un mero cambiamento tecnologico – è in atto una vera e propria trasformazione sociale.

ARCHETIPI
Smarriti nel senso della malattia e nella complessità della vita

In seguito alla diffusione dei nuovi servizi sanitari basati sulle tecnologie, il ruolo del medico o della medica quale oracolo onnisciente inizia a vacillare.

I pazienti e le pazienti sono in grado di formulare le diagnosi da sé con l'aiuto di strumenti basati su algoritmi di intelligenza artificiale che riconoscono i sintomi di tutte le circa 30.000 malattie descritte nella letteratura medica. Un medico o una medica con un'esperienza decennale ne può conoscere al massimo 500, per i limiti della propria esperienza personale basata sui pazienti e sulle pazienti che ha in cura.

Mentre le macchine migliorano costantemente, mediche e medici sono travolti dall'aumento del numero di pazienti, dallo stress e dalla responsabilità. A chi quindi è più probabile che affideremo la nostra salute? A mediche e medici stanchi che dopo parecchie ore di

lavoro sono suscettibili a commettere degli errori o a macchine perfette prive di debolezze umane? Fino a oggi la medicina è stata percepita come un'arte e una scienza insieme. In seguito a questa costante digitalizzazione, invece, sarà una scienza che diviene arte.

Potreste obiettare che la tecnologia non sostituirà mai i medici e le mediche. Ovviamente la medicina è qualcosa di più che una pillola e basta. Significa comprendere la paziente o il paziente, dimostrando compassione e sostegno nei momenti difficili in cui viene informato di avere una malattia terminale, in cui deve affrontare una morte lenta e inevitabile. Quest'ultimo baluardo delle mediche e dei medici davanti all'avanzata dei computer onniscienti non fa che confermare la fragilità degli esseri umani, il desiderio emotivo di essere compresi da un'altra persona e anche la paura di restare soli e inermi. Ma anche le macchine possono essere confortanti.

Questa fede nel ruolo unico dei professionisti e delle professioniste della salute, che tuttavia durante la pandemia di COVID-19 hanno potuto godersi gli applausi per le loro gesta eroiche solo per un paio di mesi, non tiene conto dei progressi, lenti e radicali, ma inesorabili avvenuti nel campo delle tecnologie. La sanità del futuro non sarà il risultato di un modello di crescita lineare, proprio come l'automobile non è una versione migliore del cavallo.

Ve ne accorgerete presto quando un robot vi capirà meglio della persona che vi è più amica, interpreterà ogni vostro piccolo gesto ed espressione usando gli algoritmi di apprendimento automatico per il riconoscimento facciale, e quindi sarà in grado di condurre

una conversazione con grande virtuosismo, facendo riferimento alle vostre fantasie ed emozioni nascoste. Questo è tutto merito dei dati – l'astuto osservatore assimila tutto ciò che accade intorno a noi.

Si potrebbe obiettare che i robot – forme con sembianze umane fatte di metallo, plastica e processori – non ispirano fiducia. Ma le cose cambieranno molto quando un essere bionico, dotato di intelligenza emotiva artificiale (in un mondo in cui i legami sociali si stanno dissolvendo), potrà parlare con voce calda imitando il comportamento umano. L'empatia si può imitare. I sentimenti si possono programmare. La coscienza si può simulare. Gli esseri umani già parlano con i vecchi computer quando sono troppo lenti, o dicono agli aspirapolvere smart esattamente dove devono pulire. Non importa se le macchine ancora non sanno ascoltare. I medici robot saranno come nuovi esseri sintetici guidati da algoritmi in grado di tradurre la vita umana in comportamenti meccanici. Non si tratta di un espediente – saranno creature nuove.

QUARK
Le sfumature fondamentali della sopravvivenza

Tra visioni utopistiche e distopiche dominate da algoritmi super-intelligenti in grado di analizzare grandi quantità di dati raccolti da sensori ubiqui, computer quantistici ultraveloci che realizzano nuove scoperte scientifiche, infermieri robot con corpi meccanici bianchi, un essere umano in un momento di debolezza sarà in grado di trovare aiuto? Un essere umano costituito da corpo e anima, un "io" sofisticato che prende decisioni razionali

basandosi sulle sue conoscenze, ma anche dilaniato da sentimenti ed emozioni formatisi nel corso dell'evoluzione, in migliaia di anni. E con una paura insopprimibile della minaccia esistenziale della malattia, che ogni forma di medicina – convenzionale o non convenzionale – tenta di eliminare o ridurre al minimo.

Le cose non vanno diversamente nel mondo nuovo e migliore della medicina moderna, che sbandiera una nuova forma di speranza nata dalla fascinazione per la tecnologia e da un panico istintivo verso ciò che di sconosciuto è scritto nei nostri geni – disperazione, dubbio, ansia, preoccupazione e paura di ammalarsi.

Prima pandemia dell'era digitale, quella del COVID-19 è a un tratto diventata un laboratorio globale per la sanità virtuale basata sui dati. Centodue anni dopo l'ultima grande epidemia, quella dell'influenza spagnola, le persone non sono più così vulnerabili e hanno a disposizione un gamma di tecnologie mediche e laboratoriali, ospedali moderni e farmaci avanzati. Eppure, sono ancora guidate dall'istinto di sopravvivenza, quando si accalcano nei negozi di alimentari sfidando le statistiche e i numeri, o si proteggono in contrasto con ciò in cui credono, cercando risposte facili a fenomeni incomprensibili nelle teorie complottiste.

Questo conflitto tra il fronte della razionalità tecnologica e l'irrazionalità della natura umana ha accelerato il progresso scientifico, ma ha anche soffiato sul fuoco dei movimenti no-vax, facendo diminuire la fiducia nelle istituzioni sanitarie pubbliche e inasprendo la polarizzazione sociale. Alcuni hanno celebrato l'invenzione dei rivoluzionari vaccini a mRNA – un trionfo degli studi biologici sul virus che promette di mettere

fine alla pandemia – mentre altri sono sprofondati nelle teorie new-age della dittatura del COVID-19, dei chip iniettati con i vaccini o del complotto degli Illuminati guidato da Bill Gates e altri leader mondiali.

Paradossalmente, nonostante i fantastici risultati ottenuti dalle bioscienze, in quanto società stiamo affrontando una crisi del pensiero razionale. L'accesso alla conoscenza non è mai arrivato a questi livelli nella storia dell'umanità, mentre i social media sono diventati incubatori di fake news. Non si tratta solo delle fantasie innocue di una minoranza. La disinformazione ha minato l'autorità delle esperte, degli esperti e delle istituzioni scientifiche, spingendo la gente a ignorare le raccomandazioni sanitarie e, di conseguenza, a causare dei decessi. Spesso queste fake news sono generate da bot programmati per influenzare le società e le elezioni. L'infodemia, la malattia digitale del Ventunesimo secolo, sta diventando una delle più gravi minacce globali.

Intanto la guerra contro la pandemia ha accelerato la trasformazione socio-tecnologica. In tempo reale abbiamo potuto osservare impotenti la diffusione esponenziale di un minuscolo virus di 0.1 μm di diametro, illustrata da macchie rosse in espansione sulla cartina del mondo. I test per individuare il coronavirus, sviluppati settimane dopo lo scoppio della pandemia, hanno contribuito a limitarne la trasmissione. Durante la pandemia di HIV negli anni ottanta ci sono voluti tre anni per mettere a punto dei test attendibili – un tempo abbastanza lungo perché germinassero insicurezza, intolleranza, sfiducia e aggressività sociale.

Monitorare e testare ha permesso di tenere meglio sotto controllo la pandemia, evitando il collasso

dei sistemi sanitari sovraccarichi e la necessità di triage eticamente discutibili e disumani. L'appiattirsi della curva pandemica è diventato un simbolo di solidarietà sociale. Al tempo stesso, le fatiche collettive di una squadra di scienziati e scienziate internazionali hanno prodotto lo sviluppo di un vaccino in meno di un anno. Prima del 2020, ce ne sarebbero voluti più di dieci.

BYTE
Una nuova normalità con gli stessi
esseri umani, ma in circostanze diverse

La guerra alla pandemia ha provocato un cambiamento nei sistemi sanitari esistenti. Gli esseri umani hanno cominciato a evitare le istituzioni sanitarie per paura di contrarre l'infezione. Dal canto loro le persone malate, costrette all'isolamento, sono state abbandonate ai propri dispositivi. Le visite mediche in presenza sono state sostituite da nuove forme di comunicazione: telefono, video chat o email.

Sono stati scambi frustranti – quando la visita virtuale veniva interrotta da problemi tecnici – e gratificanti insieme – quando le pazienti e i pazienti ricevevano una prescrizione nel giro di pochi secondi senza doversi recare in ambulatorio e attendere in una sala d'aspetto affollata. Il senso rassicurante che accompagna sempre varcando la soglia di un ambulatorio medico è stato sostituito da "Mi sente bene?" o "Mi vede chiaramente?"

Il costrutto multiplo delle cure relazionali, che comprende elementi di psicologia e perfino di religione, è stato sostituito da un costrutto transazionale: sintomi

in cambio di diagnosi e medicinali. Anche se le case dei pazienti e delle pazienti, e gli ambulatori medici sono collegati da connessioni ad alta velocità, gli schermi di computer e smartphone hanno filtrato gli elementi della comunicazione non verbale, lasciando le pazienti e i pazienti soli con i loro pensieri e le loro emozioni. Le mediche e i medici hanno perduto la loro aura – palpabile durante le visite fisiche ma impercettibile nelle immagini formate da pixel.

Durante la pandemia di coronavirus, che piacesse loro o meno, le pazienti e i pazienti si sono trovati all'improvviso di fronte a soluzioni che in una situazione non pandemica si sarebbero diffuse solo dopo anni. Non perché fossero superate le lacune tecniche, ma per via della resistenza delle persone al cambiamento. Ma l'emergenza si è mangiata quel tipo di pensiero a colazione.

Le tecnologie usate dai primi anticipatori e anticipatrici che le hanno adottate sono poi diventate mainstream: soluzioni di telemedicina per misurare l'ossigeno nel sangue, chatbot che rispondevano a domande sul coronavirus o app per il tracciamento del COVID-19 disegnate per interrompere la catena del contagio. Tutte queste tecnologie hanno un aspetto in comune – spostano in maniera sottile la responsabilità sulla salute dal sistema sanitario ai pazienti e alle pazienti.

Nella democratizzazione della salute resa possibile dalla digitalizzazione, i pazienti e le pazienti diventano consumatori e consumatrici consapevoli. Ma da un altro punto di vista stiamo assistendo a una IKEAizzazione dei progressi della medicina: l'individuo

acquisice un kit strumenti per mantenere (prevenzione) o riconquistare la propria salute (terapia), a cui è accluso un manuale di istruzioni poco chiaro. La salute non è creata da un dottore o una dottoressa, ma dal paziente o dalla paziente. E questo sembra inevitabile nel mondo delle professioni legate alla salute, dove mancano operatrici e operatori, e della domanda in continuo aumento di servizi sanitari da parte di una società che invecchia e di epidemie di malattie non trasmissibili. Vogliamo una sanità perfetta, e invece otteniamo soltanto un compromesso imperfetto tra economia, medicina, politica e scienza.

Gli algoritmi saranno in grado di colmare il gap tra capacità assenti o limitate – di conoscenze, finanziamenti o personale – e bisogni sanitari infiniti? No, perché la realtà è più complessa di quanto vorremmo che fosse.

Una nuova generazione Z vuole una salute instagrammabile. Facile come un passaggio con Uber, consegnata con la stessa rapidità di un ordine su Amazon Prime, personalizzabile come un appuntamento su Tinder. E Big Tech sta cominciando a realizzare questo sogno. Apple, Samsung, Google o Facebook (Meta) non hanno nulla a che fare con il settore sanitario, ma nel nuovo ecosistema digitale non è nemmeno necessario. Per loro la sanità è un modello di business a crescita costante, una miniera di dati necessari per continuare a sviluppare algoritmi di intelligenza artificiale – elementi fondanti di servizi digitali sempre migliori. Quindi in cambio della promessa di una salute e un benessere migliori, trasformano le persone in incubatori di dati.

CODICI
Progetta la tua salute e il tuo corpo, componi il tuo stato

La gente non vuole più una salute da conservare, bensì da pianificare e le nuove tecnologie hanno iniziato a risolvere perfettamente il problema. Dopo tutto, i vecchi dèi sono sempre stati sostituiti da divinità nuove e migliori.

La biologia di sintesi promette di rendere le cellule umane programmabili come sistemi IT, in modo da eliminare il confine tra corpo umano e processori altamente performativi. Presto i computer quantistici sorpasseranno di milioni di volte le capacità di calcolo del cervello umano. Gli avatar dotati di empatia artificiale, con un aspetto che ingannevolmente ricorda quello di un medico, non saranno più macchine fredde con voci metalliche, ma assistenti personali nei quali riporre fiducia. Sensori iniettabili ci salveranno dagli errori dell'imperfetta anatomia umana o della formazione casuale dei geni. È un paradosso che corpi e cervelli vulnerabili a malattie e incidenti, limitati dal potere computazionale dei neuroni, stiano lentamente diventando una disabilità, se messi a confronto con le capacità quasi illimitate degli algoritmi. Quella che un tempo era un'affascinante creazione naturale o divina sta cominciando a rivelarsi per noi un limite.

La maniera con cui oggi ci misuriamo il battito cardiaco o contiamo i nostri passi è solo la ridicola antenata di una nuova tecno-religione della salute che potremmo definire del "sé quantificato" (quantified self), in base all'assioma "si può migliorare soltanto ciò che si può misurare". Ogni persona avrà un "gemello digitale" – una copia digitale fatta di dati per testare nuovi farmaci

e cure o su cui sperimentare ipotesi di prevenzione per proteggere i nostri corpi da medicinali inefficaci ed effetti collaterali indesiderati. Alla fine, nel metaverso, sarà il nostro avatar – e non noi – ad andare a farsi visitare. Il luogo in cui somministrare i servizi sanitari sarà la casa, non più l'ospedale. E la fonte di dati sanitari sarà il singolo individuo, e non l'ambulatorio medico. Il corpo diventerà una serie di dati quantificabili che non lascerà spazio alla minima casualità. E nemmeno a tutto ciò che non può essere descritto dalle leggi della fisica e dalle formule matematiche.

Digitalizzazione significa personalizzazione. E maggiore è l'individualizzazione, più alte saranno le aspettative. Nel modello attuale "uno – medicina, terapia o approccio – per tutti", l'utente medio si accontenta di una soluzione intermedia non sempre ideale, ma identica per tutti. Solo chi ha abbastanza soldi può permettersi delle opzioni extra. Nel sistema "uno per uno", non esiste più l'utente medio ma solo l'individuo che pretende il meglio.

Ma è difficile essere sufficientemente ingenui da perseverare sull'immagine idealistica di una fusione tra uomo e tecnologia. La storia del genere umano e dei servizi per la salute è sempre stata contraddistinta da disuguaglianze spaventose. Che potrebbero esplodere presto. Lo storico e filosofo israeliano Yuval Noah Harari ha predetto un futuro in cui le tecnologie renderanno ancora più sane le persone sane.

Le disuguaglianze sanitarie raggiungeranno un livello superiore. Tra esseri umani e servizi sanitari digitali esiste un nuovo vettore tecno-economico: gli smartphone, i sensori smart, le case smart, le auto smart, tutto smart – tutto collegato dentro l'Internet delle cose.

Senza risorse finanziarie e competenze digitali – un nuovo fattore determinante per la salute, quanto i fattori genetici o ambientali – molte persone saranno condannate all'esclusione sociale e alla discriminazione all'interno della sanità digitale. Senza accesso alla tecnologia, alcuni correranno il rischio di finire in "povertà digitale". Assenza di dati significa essere relegati a un modello datato di sanità analogica.

In preda all'ammirazione per i fantastici algoritmi AI, gli scintillanti dispositivi indossabili e le eccitanti quantità di dati, stiamo forse lentamente dando più importanza alla salute che alla libertà? O è sempre stato così, visto che ci sottomettiamo in silenzio alle diagnosi dei medici e delle mediche?

Oggi le mediche e i medici si fidano dei pazienti e delle pazienti e di come seguiranno le loro istruzioni. Domani medici e mediche (o un algoritmo) potranno avere accesso ai dati che provano l'osservanza dei pazienti e delle pazienti – fatti, e non affermazioni poco affidabili spesso molto lontane dal vero. Siamo ormai molto vicini agli scenari oscuri della dittatura sanitaria. Non scommetterei sul fatto che la società tecnologica del futuro si rifiuterà di pagare questo prezzo nell'eterna ricerca dell'immortalità o almeno di qualcosa che le si avvicini.

QUBIT
La tecnologia non fa che riflettere le nostre preoccupazioni e la nostra confusione

La tecnologizzazione della sanità restituisce alle persone un senso di controllo sulla propria salute, prima affidata

alle mani di divinità, destino e natura, oppure controllata dall'esterno grazie ai professionisti e alle professioniste della medicina.

Il bio-feedback, il monitoraggio in tempo reale della chimica all'interno del corpo di un individuo, è come una visita medica infinita. Offre un senso di sicurezza, che è fondamentale per essere felici. Il moderno rinascimento del mondo sanitario sta nel computare se stessi, e questo vale anche per le proprie emozioni e il proprio benessere. È un tentativo di comprendersi e di resistere alla forza di una malattia che riduce gli esseri umani al livello di creature inermi. Non resta più margine per il fattore casualità. Il *techno homo sapiens* è un organismo quantificabile, controllabile, programmabile e riparabile.

Questa trasformazione culturale basata sulla tecnologia dovrebbe poter risolvere le più grandi minacce per l'umanità: la pandemia da COVID-19, la crisi climatica, le disuguaglianze sociali in materia sanitaria e le crisi economiche. Sfortunatamente, questa nuova era della sanità potrebbe rivelarsi un rifugio in grado di offrire un senso di sicurezza solo illusorio.

La medicina è l'arte di dare speranza in presenza di una malattia, di una pandemia o della caducità della vita. E i progressi tecnologici possono fare altrettanto, perfettamente.

ARTUR OLESCH vive a Berlino ed è giornalista freelan
futurologo e opinion leader nel campo della salute digita
Ha fondato aboutDigitalHealth.com, un forum di discussio
sui diversi futuri della salute. Ha scritto più di mi
articoli sulle cure sanitarie e le nuove tecnologie, e
loro impatto sulle società di oggi e di domani; è opinionis
oratore, moderatore, relatore, un'autorità sui social med

si batte per le innovazioni in nome di una sanità più
essibile ed equa. È membro dello SCIANA Healthcare
ders Network ed è direttore di numerose riviste europee
si occupano di salute digitale. Olesch è anche mentore
alcune startup di tecnologie biomediche e consulente
organizzazioni sanitarie che vogliono intraprendere una
versione digitale.

CONVERSAZIONE
TRA LYNN HERSHMAN LEESON, MARY MAGGIC E P. STAFF

In questa discussione si confrontano tre artisti e artiste che condividono un terreno comune, perché si interessano al biohacking, al rapporto tra arte e attivismo, ai problemi dell'ambiente e delle tossine, e al ruolo della collaborazione interdisciplinare. Si tratta di una conversazione intergenerazionale tra Lynn Hershman Leeson, che per più di sessant'anni ha operato nel territorio in cui si intersecano arte e tecnologia, e P. Staff e Mary Maggic, all'inizio della loro carriera, i cui lavori, workshop e programmi pubblici indagano spesso la porosità dei nostri corpi, concentrandosi in particolare sugli ormoni, gli interferenti endocrini e l'ambiente.

Sara Cluggish e Pavel S. Pyś (S&P): Iniziamo parlando del ruolo che ha l'attivismo nelle vostre vite e nelle vostre pratiche.

Mary Maggic (MM): Non mi definisco un'attivista, ma il mio lavoro di biohacking è stato inserito in questo

contesto. Considero la produzione di conoscenza al di fuori delle istituzioni come qualcosa di intrinsecamente politico e l'atto di acquisire collettivamente nuove conoscenze e soggettività un atto molto sovversivo, soprattutto quando cerchiamo di ridefinire nozioni estremamente radicate come quelle di corpo e genere.

P. Staff (PS): Quand'ero più giovane, mi sembrava molto importante che il mio lavoro di artista fosse una forma di attivismo. Ora sono un po' più a mio agio nel riconoscere che faccio qualcosa di diverso. Per quanto mi riguarda, trovo necessario essere molto specifici su ciò che definiamo attivismo – organizzazione di comunità dal basso, organizzazione politica – cose di cui personalmente non mi sento profondamente partecipe. Mi interessa di più far circolare nel mondo dei lavori che generino una serie di scambi e reazioni impossibili da controllare o di cui non si conoscano i risultati in sé. Ma sono profondamente d'accordo con Mary sul fatto che non si può entrare nei territori in cui si muove il nostro lavoro senza scontrarsi con l'atto intrinsecamente politico di resistere al dominio.

Lynn Hershman Leeson (LHL): Quando mi sono trasferita in California, nel 1963, era l'epoca delle prime proteste del Free Speech Movement (FSM, movimento per la libertà di espressione). Il movimento delle donne è nato solo cinque anni dopo, più o meno; è iniziato molto lentamente, quando le donne si resero conto di non essere rappresentate nella storia. A metà degli anni sessanta ho preso a prestito una videocamera e ho registrato delle interviste con delle donne. La dinamica era cambiata; c'era la consapevolezza che stava

nascendo un movimento. Ho realizzato video dal 1967 al 2008, ed è così che è nato in seguito il documentario *!Women Art Revolution* (2010). Non ho mai pensato di essere un'attivista fino a molto tempo dopo; non saprei dire esattamente quando. Ma certamente ne ero consapevole mentre mi dedicavo alle camere d'albergo [*The Dante Hotel*, 1972–73], ho sentito che in realtà era il mio primo lavoro, perché non era quello che la gente si aspettava. Era una forma completamente nuova, una maniera di battersi per l'idea di utilizzare mezzi espressivi mai impiegati prima in arte.

S&P Mary, prima hai parlato della produzione di conoscenza come forma di resistenza. Qual è il ruolo della resistenza nelle vostre pratiche e come può la resistenza rimodellare le narrazioni dominanti?

PS A un certo punto, cazzo, si tratta di sopravvivenza. Non hai scelta se non quella di opporti alla forma dominante, perché pensi "cazzo, altrimenti muoio". Vivere e fare arte: non sono due cose distinte. In un certo senso, il lavoro che ho fatto – sia che si tratti del lavoro farmaceutico sulla chemioterapia, o sugli ormoni, o anche i miei lavori recenti, più astratti – riguarda sempre la volatilità delle sostanze chimiche, i fluidi e l'esistenza dentro un corpo. Contiene un impulso a non essere consumati e distrutti dalla violenza del mondo.

MM Da quando ho iniziato a lavorare sugli ormoni, mi sembra che sia cambiato ciò a cui il mio lavoro si oppone. Ho iniziato con la resistenza alle barriere istituzionali e poi con l'alienazione che deriva dalla

tossicità ambientale. Ora è diventato qualcosa di molto più universale: resistere a questa idea di purezza, che si tratti dei nostri sistemi di genere binari, della divisione tra esseri umani e animali, tra natura e cultura. Rompere queste strutture di purezza è una forma di resistenza e quasi un modo per diventare l'antesignana di una nuova tradizione.

PS Mi collego a quello che dici, Mary, mandare affanculo i simboli del futuribile, i fattori determinanti, teoricamente solidi, che ci vengono proposti. Questi fattori non fanno che escludere le persone, animati da una specie di pulsione di morte suprematista bianca che spinge a determinare l'aspetto che dovrebbe avere la società. Gli ormoni diventano uno strano punto di rottura, perché molti concetti sono legati a come sono desiderati, in quanto stabili, fissi, biologicamente concreti. È ironico invece che sia vero il contrario.

LHL Oltre alla resistenza, è importante l'idea di revisione. Per me, il Free Speech Movement ha rappresentato una forma di resistenza a ciò che stava accadendo con la repressione degli studenti e studentesse da parte del governo; è entrata in gioco un'alternativa riveduta. Le persone tendono a guardare indietro, verso la storia, piuttosto che cercare di vedere cosa sta accadendo nel presente o addirittura inventare il futuro. È tutto collegato: dalla resistenza alla revisione, al cambiamento culturale, alla perseveranza e infine alla sopravvivenza.

S&P Come descrivereste i vostri rispettivi interessi, legati al concetto di ambiente, per il corpo e la politica

di genere? Come riflettete sulla porosità del corpo, delle idee, della contaminazione e della malattia?

MM Mi interessa molto il modo in cui i corpi vengono categorizzati in relazione al più ampio corpo planetario, il modo in cui mappiamo i territori e calcoliamo ciò che possiamo estrarre dall'ambiente. Esiste un modo di de-territorializzare i nostri corpi nel corpo planetario? Esiste un modo di creare tassonomie senza il processo violento di *othering*, di esclusione dell'altro? Esiste un legame tra il modo in cui definiamo la tossicità e la tassonomia. Tossicità significa dare un nome alla tossina, all'altro, al veleno. La tassonomia ottiene l'effetto di stabilire dei confini tra due corpi diversi o due specie diverse, facendo così emergere una gerarchia.

È molto chiaro che non esistono un corpo o un genere fissi e stabili: come si fa a classificare qualcosa che cambia continuamente forma? *Genital(*)Panic* si concentra sulla distanza anogenitale (AGD): un criterio con cui le scienziate e gli scienziati valutano l'esposizione a sostanze tossiche con conseguenze riproduttive. Nei corpi maschili la distanza dovrebbe essere doppia rispetto a quelli femminili. Eppure, a causa dell'esposizione a ftalati e microplastiche, i corpi maschili presentano la stessa distanza di quelli femminili. La costruzione del sesso e del genere crolla, se la si basa solo sulla morfologia dei genitali. *Genital(*)Panic* propone uno studio su una popolazione femminista queer, e fa scienza raccogliendo questi dati in crowdsourcing, usando scansioni in 3D dei genitali e dati demografici in cui la priorità viene data all'identità di genere rispetto al genere assegnato alla nascita. Finora non mi è capitato di vedere nessuno

studio demografico che omettesse il genere assegnato alla nascita. Questo progetto cerca di separare lo strumento della scienza patriarcale, di separare la distanza anogenitale dal suo potere simbolico.

LHL Ho iniziato a usare il suono perché quand'ero incinta ho avuto un'insufficienza cardiaca e sono dovuta rimanere sotto una tenda a ossigeno da sola, per diversi mesi, in ospedale. Sentivo soltanto il mio respiro, che è diventato un elemento fondamentale nella mia vita. Da elemento della malattia è diventato elemento di sopravvivenza. È stata un'esperienza davvero dominante che ha plasmato il lavoro che svolgo, perché non importa se si tratta della sopravvivenza personale in un caso di insufficienza cardiaca all'età di ventitré o ottantuno anni, è comunque necessario pensare alla sopravvivenza del pianeta e all'impatto delle tossine. Tossine sotto forma di inquinamento, sotto forma di un futuro a portata limitata. Questo è in parte il senso di *Anti-Bodies* (2014): una metafora per individuare le tossine, non solo nel proprio corpo ma anche nell'ambiente, e affrontarle in modi diversi per curarle, per trovare un modo diverso di superarle.

S&P Nelle vostre opere c'è un rimettere in discussione cosa sia tossico per noi? La maniera in cui intendiamo la tossicità?

LHL Negli anni settanta ho iniziato una serie che si chiamava *Water Women* e che riguardava corpi basati su quello di Roberta [Bretimore], riempiti di gocce d'acqua. Il lavoro era incentrato sull'evaporazione e la

decomposizione di noi stessi nel tempo. Ho continuato a realizzare questi corpi per quaranta o cinquant'anni. In *Twisted Gravity* ho utilizzato le immagini di *Water Women* illuminate in maniere diverse per mettere in evidenza un nuovo processo capace di ripulire l'acqua dagli inquinanti plastici. Abbiamo lavorato con il Wyss Institute, che aveva creato l'AquaPulse, in grado di purificare un litro d'acqua al minuto. Non l'avevano ancora brevettato, ma avevano intenzione di offrirlo per le emergenze, come in caso di terremoti. Harvard, insieme al Wyss Institute, ha dichiarato che non avrebbero avuto quelle idee se io non avessi lavorato con loro, perché anche se non ero una scienziata, avevo posto delle domande a cui loro avevano dovuto dare delle risposte. Per me era più facile guardare e analizzare qualcosa e proporre un modo di pensare a loro estraneo, perché non era logico.

PS È stato il lavoro della ricercatrice Eva Hayward a suggerirmi una maggiore attenzione alla tossicità e all'inquinamento nell'attuale situazione di panico, profondamente reazionario, rispetto al sesso e al genere. Nel suo saggio *Toxic Sexes* (scritto insieme a Malin Ah-King) Eva sottolinea come i cambiamenti di sesso negli animali in reazione all'inquinamento endocrino ambientale possano aiutarci a riflettere sulla tossicità come una delle condizioni che definiscono il sesso nel presente. Credo che questo sia uno snodo sempre più importante per il nostro approccio alla comprensione di ciò che è tossico. Però è interessante notare come in questo dibattito il sesso sia più centrale del cancro, delle malattie autoimmuni e persino della morte. E perché

viene vista come un problema una cosa come la riduzione della conta spermatica, piuttosto che le dannose pratiche capitalistiche che l'hanno causata?

MM I nostri corpi stanno cambiando molto più rapidamente del discorso culturale sulla tossicità. Nei media esiste un panico da sesso, fondato su omofobia, transfobia e xenofobia. I nostri corpi sono sempre stati e sono sempre queer. È veramente problematico quando si prova empatia per le persone malate, per chi soffre, e questa empatia è selettiva. Destinata solo a certi corpi, quelli considerati degni di esistere e vivere.

PS In questo intreccio tra vita e pratica artistica, la tossicità altera i molteplici confini tra sesso, genere, razza, geografia e specie. *Acid Rain for Museion Bolzano* affronta questo tema, anche se in maniera più libera. L'opera consiste in un sistema di tubature fissato ai soffitti e in parte alle pareti del museo. In alcuni punti i tubi perdono, facendo gocciolare nello spazio espositivo acido lattico, che viene pian piano raccolto in grandi barili d'acciaio. L'opera costituisce così una minaccia ambientale molto particolare: si è costantemente localizzati, nel museo, grazie all'eco del rumore delle gocce. Ci si può sempre orientare in relazione a questo materiale volatile. Ho pensato a questo progetto in parte perché nella mia infanzia le notizie riguardanti le piogge acide sono state molto importanti. In Europa, negli anni ottanta e novanta, c'era quest'idea che l'industria avesse alterato il processo delle precipitazioni; questa violenta intrusione aveva causato le piogge acide. Allora avevo paura che "se esco fuori sotto la pioggia, mi brucio la

faccia, cazzo, oppure questo liquido dal cielo farà dei buchi ovunque". In realtà, le piogge acide si sono rivelate un disastro per gli edifici in pietra calcarea e arenaria e questo, nel Regno Unito, significa principalmente case, scuole, chiese e prigioni. Queste istituzioni venivano erose. In un certo senso, il mio lavoro si serve di una certa poetica della violenza, turbando l'esperienza di trovarsi in uno spazio condiviso.

MM Mi piace molto che l'acido lattico venga descritto come minaccia ambientale. Questa minaccia ambientale non è una mutazione della natura, *è* la natura. Dobbiamo elaborare strategie che vadano oltre il semplice "dobbiamo tornare alla purezza della natura". In realtà dovremmo dire: "No. La tossicità, nella quale siamo invischiati, è ora il punto di partenza da cui costruire tutte le nostre nuove strategie".

S&P Voi nutrite un interesse comune per le comunità alternative, per le persone che lavorano al di fuori dei canali ufficiali. Come scegliete i vostri collaboratori e collaboratrici?

MM Intorno al 2014 mi hanno fatto conoscere la rete Hackteria: una rete globale online di hacker, artisti e artiste, smanettoni e smanettone, e geek. Molte delle mie pratiche di workshop sono nate dalla collaborazione con la comunità di Hackteria, poiché il processo si basa sull'eliminazione della gerarchia tra profani ed esperti, è una specie di dilettantismo pubblico che nasce dalle pratiche del Critical Art Ensemble. I miei workshop sono iniziati in modo piuttosto didattico: insegnavo semplicemente

come estrarre gli ormoni dall'urina. Con il tempo ho iniziato a includere molte più pratiche performative, generando uno spazio di inconsapevolezza radicale. È un processo di creazione del mondo molto co-generativo e co-produttivo che non sarebbe possibile realizzare lavorando da soli, come singoli artisti e artiste. Con le altre e gli altri si diventa capaci di abbracciare questo intrico disordinato. È anche una strategia contro la purezza, perché gran parte dei metodi scientifici con cui si produce conoscenza prevedono un ambiente molto controllato e molto sterile. Dobbiamo contaminarci l'un l'altro per arrivare a qualcosa di davvero sostanziale e nuovo.

LHL Per me spesso è una casualità. Sapevo di volere Tilda Swinton per *Teknolust* (2002) dopo averla vista in *Orlando*, e ho cercato di contattare la sua agenzia, ma non ci sono riuscita. Poi, per caso, mi sono trovata seduta vicino a una sua amica che le ha parlato del progetto e lei mi ha chiamata. Se emetti energia mentale in quello che fai, è quasi come se le persone venissero da te per aiutarti a raggiungere il tuo obiettivo. Non conoscevo Thomas Huber prima di andare a Basilea, ma sapevo cosa volevo fare lì. E di certo non conoscevo il Wyss Institute. Molto è frutto di ricerca, come quando lavoravo a *Infinity Engine* e dovevo trovare il tizio che ha fatto il primo bioprinting di un organo, o quando ho trovato George Church che ha definito il DNA sintetico. Mi ci sono voluti tre anni per convincerlo a mettersi in contatto con me, ma alla fine si tratta solo di non mollare. E poi convincerli che capisci quello che ti stanno dicendo. Io ero avvantaggiata perché all'università ho studiato biologia.

PS Ti rendi conto che molto spesso la comunità alternativa è definita o presentata come uno spazio davvero olistico. E nella mia esperienza ho capito che molto spesso formiamo una comunità con altre persone, ma non per scelta. Magari faccio parte della comunità di persone trans nel luogo geografico in cui mi trovo, ma spesso per necessità, o per un bisogno. E molte volte mi capita di accorgermi che in quel momento di comunità con gli altri, spesso ci turbiamo profondamente a vicenda, lo stare insieme ci inquieta molto, più di quanto non ci rendiamo conto. Siamo convinti che la nostra comunità auto-selezionata sia un modo di evitare i problemi. Invece, nella mia esperienza, io sento effettivamente il legame, l'unione o come lo vogliamo chiamare, in maniera molto più plastica e travagliata; più accidentata che liscia. Ho avuto una formazione artistica più formale e provo il desiderio di fare workshop per produrre conoscenza in modo diverso dalle altre persone passate per il mondo accademico che, allo stesso modo, ne avvertivano la sterilità. Insieme a Candice Lin, ne ho tenuti diversi. Spesso a tutte e due piace essere piantagrane; ci va di comportarci un po' male. Quindi, se in qualche modo riusciamo a convincere un gruppo di persone ad aspirare un bel po' di "vapori tossici" insieme a noi prima della discussione o altro, è solo un desiderio giocoso di suscitare inquietudine. A volte dà una bella sensazione essere cattivi.

MM Io la vedo sicuramente come una provocazione, perché alla fine si tratta solo di capire che ogni persona ha il suo modo di essere. Quando metti insieme un gruppo di persone, c'è un processo continuo di negoziazione, con pensieri e mondi conflittuali. Ma è questo il bello:

provocarsi a vicenda, provocare le strutture e le istituzioni. Io lo vedo come un processo molto necessario per la re-immaginazione collettiva.

PS Credo che si tratti di una resistenza alla privatizzazione di tutte le forme sociali, che sia la struttura familiare, la sfera domestica, la privatizzazione di tutti i nostri scambi sociali. L'idea del workshop è semplicemente quella di creare connessioni e significati al di fuori di un mondo dominante e privatizzato.

MM Vedo le molecole e le tossicità come qualcosa che ci provoca e sperimenta con noi. Penso che il mondo stia anche teorizzando; e sta commettendo degli errori in base ai quali si adatta. Penso che le molecole stiano facendo la stessa cosa con noi, con i nostri corpi e i nostri ambienti. Penso che le molecole ci stanno modificando quanto noi modifichiamo loro. È un processo costante di teorizzazione e sperimentazione.

PS Cosa c'è di più potente e politicizzante del rendersi conto che non si è affatto stabili come si crede di essere, che non si è affatto distaccati come si crede di essere? Distaccati nel senso di entità singola. È tutto profondamente radicato nell'ambito della politica, cioè nell'ambito dell'ignoto.

MM Sì. Essere interconnessi è sicuramente un atto politico.

Negli ultimi cinquant'anni, l'artista e regis
LYNN HERSHMAN LEESON ha ricevuto menzioni internaziona
per le sue opere d'arte e i suoi film. Citata come u
delle artiste mediali più autorevoli, Hershman Leeson
ampiamente riconosciuta per i suoi lavori innovativi
temi oggi considerati fondamentali per il funzionamen
della società: il rapporto tra esseri umani e tecnologi
identità, sorveglianza e l'uso dei media come strumenti
emancipazione contro la censura e la repressione politic
A partire dagli anni settanta ha offerto contribu
essenziali nel campo della fotografia, del video, d
cinema, della performance, dell'intelligenza artificial
della bio art, dell'arte mediale installativa, interatti
e basata su internet. Lo ZKM | Center for Art and Med
Karlsruhe, Germania, ha allestito la prima retrospetti
completa dei suoi lavori, dal titolo *Civic Radar*. L'amp
monografia *Civic Radar* è stata definita da Holland Cott
nel *New York Times* "uno dei libri d'arte indispensabi
del 2016". Ha esposto alla Biennale di Venezia del 202
dove è stata insignita di un premio speciale.

MARY MAGGIC è artista, ricercatrice e madre non binaria c
lavora in quell'indefinita intersezione tra politiche d
corpo e di genere, e alienazioni ecologiche capitalistich
I suoi progetti interdisciplinari includono scienza p
principianti, performance partecipatorie, installazion
documentari e *speculative fiction*. Dal 2015, Maggic
spesso utilizzato il biohacking come metodologia xen
femminista e pratica collettiva di cura, allo sco
di demistificare i confini invisibili del biopote
molecolare. Attualmente Maggic fa parte del network onli
Hackteria, di Open Source Biological Art, del colletti
teatrale laboratoriale Aliens in Green, del colletti
femminista asiatico Mai Ling. Collabora inoltre con

ogetto di programma didattico radicale Pirate Care e
ccoglie informazioni per CyberFeminism Index.

STAFF vive e lavora a Los Angeles, USA e Londra,
. I lavori di Staff nell'ambito del video, della
ultura e della poesia, indagano i registri di violenza
pliciti nella creazione di un soggetto umano e
 interrogano su ciò che comportano le condizioni
istenziali di persone queer e trans. Tra le personali
ù note si annoverano quelle alle Serpentine Galleries,
 (2019), al MOCA, USA (2017) e alla Chisenhale
llery, UK (2015). Ha anche partecipato a numerose
stre collettive come *British Art Show 8* (mostra
inerante, 2016); *Trigger*, New Museum, New York (2017);
·de in L.A.·, Hammer Museum (2018); *Bodies of Water*,
a Biennale di Shanghai (2021); *Prelude*, Luma Arles,
ancia (2021-2022), *The Milk of Dreams*, 59a Biennale
 Venezia (2022).

MUSEION

National Press Office Nationale Presse
Ufficio Stampa nazionale
Lara Facco, Milano

International Press Office
Send / Receive, Berlin

Visitors Services – Educational Projects Besucherservice –
Bildungsprojekte Servizi al pubblico – Progetti educativi
Brita Köhler (Head / Verantwortliche / Responsabile)
Roberta Pedrini (Project Leader / Projektleitung /
Coordinamento progetti)
Judith Weger (Secretary / Sekretariat / Segreteria)

Library Bibliothek Biblioteca
Alessandra Riggione

Secretary Direktionssekretariat Segreteria di direzione
Dietlinde Engl, Katja Vigl-Fink

Accounting Rechnungswesen Contabilità
Manuela Inderst-Cazzanelli, Cinzia Mantovani

Technical Staff Haustechnik Servizio tecnico edificio
Martin Niederstätter, Cristian Micheloni

Bookshop – Entrance Area
Bookshop – Eingangsbereich
Bookshop – Ingresso
Letizia Basso, Katherina Federer, Barbara Riva

MUSEION

Museum of modern and contemporary art
Museum für moderne und zeitgenössische Kunst
Museo d'arte moderna e contemporanea

Piazza Piero Siena 1 Piero Siena Platz 1
I - 39100 Bolzano / Bozen
info@museion.it www.museion.it

This reader was published on the occasion of the exhibition
Diese Publikation erscheint anlässlich der Ausstellung
Questa pubblicazione è stata realizzata in occasione della mostra

~~Kingdom~~ of the Ill
Museion Bolzano/Bozen
01/10/2022 – 05/03/2023

Curated by Kuratiert von A cura di
 Sara Cluggish, Pavel S. Pyś

International Research Team Internationales Rechercheteam
Team di ricerca internazionale
TECHNO HUMANITIES – ~~Kingdom~~ of the Ill
 Bart van der Heide, Sara Cluggish, Pavel S. Pyś,
 Frida Carazzato

IMPRESSUM

Edited by Herausgegeben von Edito da
 Bart van der Heide, Museion, Bolzano/Bozen

Co-edited by Mitherausgeber*innen Co-edito da
 Sara Cluggish, Pavel S. Pyś

Editing Redaktion Redazione
 Petra Guidi
 Susanna Piccoli

Graphic design Gestaltung Progetto grafico
 Studio Mut, Bolzano/Bozen

Illustrations Illustrationen Illustrazioni
 Brothers Sick (Ezra and Noah Benus)

Texts Texte Testi
 Bart van der Heide
 Sara Cluggish, Pavel S. Pyś
 Lioba Hirsch
 Amy Berkowitz
 Artur Olesch
 Lynn Hershman Leeson, Mary Maggic, P. Staff

Translations Übersetzungen Traduzioni
 Ada Arduini (EN–IT)
 Uli Nickel (EN–DE)

Proofreading and Copyediting Lektorat und Korrektorat
Revisione testi e correzione bozze
 Ben Bazalgette (English)
 Dagmar Lutz (Deutsch)
 Susanna Piccoli (Italiano)

1st Edition 1. Ausgabe Iª edizione: 2022

Print Druck Stampa
 DZA Druckerei zu Altenburg GmbH

Publishing Verlag Editore
 Distribution worldwide by
 Hatje Cantz Verlag GmbH
 Mommsenstraße 27
 10629 Berlin
 Germany
 www.hatjecantz.com
 A *Ganske Publishing Group* Company
 Ein Unternehmen der *Ganske Verlagsgruppe*
 Una casa editrice del *gruppo editoriale Ganske*

Cover illustration Umschlagabbildung In copertina
 Brothers Sick (Ezra and Noah Benus)
 לעולם ועד / *for the world eternal*, 2022
 © Brothers Sick